Dedicated to all the men and women who judged this and every other journalism contest during the past 50 years

Pictures of the Year
Photojournalism 18

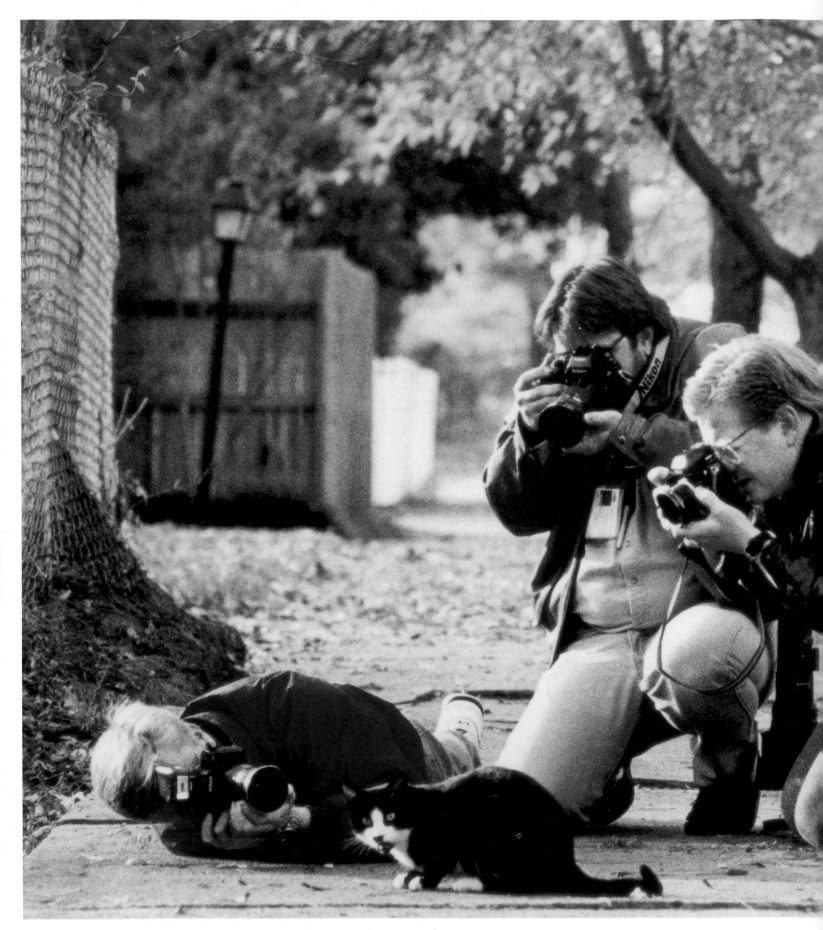

AWARD OF EXCELLENCE, NEWSPAPER CAMPAIGN '92
Michael Nelson, Agence France Presse
Photographers give Socks a taste of fame outside the Governor's Mansion in Arkansas.

AN ANNUAL BASED ON THE
50TH PICTURES OF THE YEAR COMPETITION
SPONSORED BY THE NATIONAL PRESS
PHOTOGRAPHERS ASSOCIATION AND THE
UNIVERSITY OF MISSOURI SCHOOL
OF JOURNALISM, SUPPORTED BY GRANTS
TO THE UNIVERSITY FROM CANON U.S.A.,
INC., AND EASTMAN KODAK CO.

From NPPA's President

Congratulations. You hold a permanent copy of the premier photographs of 1992. They are winners in the 50th Pictures of the Year contest, sponsored annually by the National Press Photographers Association and the University of Missouri School of Journalism.

More importantly, these photographs are history recorded by dedicated photojournalists often working in extremely difficult situations. Examine them today and they will impress you. Return to them later and you will begin to see them differently. They will make a lasting impression on you and the way you make photographs.

This particular book, the 18th in the series, is special because it marks 50 years since the POY contest began. Vice President Albert Gore Jr. and his wife, Tipper, shared their deep commitment to documentary photography by participating in the 50th Anniversary POY Awards ceremony in Washington, D.C. in April, 1993.

In two years, NPPA will celebrate its 50th anniversary. In honor of that, we will publish a special book encompassing photojournalism throughout those 50 years.

But our commitment to the annual best of photojournalism series will also continue. These books have become valuable cornerstones in our profession. Each is a cache where memories are kept, lessons learned, beauty defined, horror revealed, humor captured, and truths told. Books where everyone, photographer or not, young or old, can gain incredible insight.

Welcome to PJ 18! Get a cup of coffee and slide into your easy chair. You're in for a great experience.

— Mary Lou Foy
President, National Press Photographers Association

ISBN (paperback): 1-56138-296-5

Front cover photo by Dan Habib.
Back cover photo by Carol Guzy.

Printed and bound in the United States of America by Jostens Printing and Publishing Division, Topeka, KS 66609. The editor wishes to thank Dave Klene for his cooperation during this project. As usual, he offered guidance and helped NPPA create a quality book.

Canadian representatives: General Publishing Co., Ltd., Don Mills, Ontario M3B 2T6.

International representatives: Worldwide Media Services, Inc., 30 Montgomery St., Jersey City, New Jersey 07302.

This book may be ordered by mail. Please include $2.50 for postage and handling. But try your bookstore first!
Running Press Book Publishers, 125 South 22nd Street, Philadelphia, PA 19103-4399.

Table of Contents

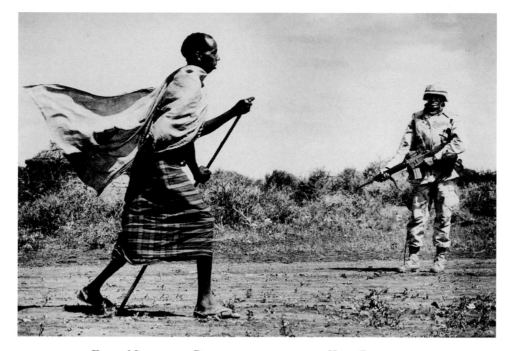

FROM NEWSPAPER PHOTOGRAPHER OF THE YEAR PORTFOLIO
Carol Guzy, The Washington Post
A Somali man walks past Lance Cpl. Larry Hilliard to get his ration of wheat. Hilliard
was one of the U.S. Marines guarding a food shipment in a village near Baidoa.

Staff

EDITOR, DESIGNER
HOWARD I. FINBERG

ASSISTANT EDITOR, DESIGNER
JOE COLEMAN

ASSOCIATE EDITOR, TEXT
PATRICIA BIGGS HENLEY

ASSOCIATE EDITOR, DESIGNER
DIANA SHANTIC

ASSOCIATE EDITOR, DESIGNER
PETE WATTERS

ASSOCIATE EDITOR, DESIGNER
DAVE SEIBERT

ASSOCIATE EDITOR, DESIGNER
CHARLES LEIGHT

ASSOCIATE EDITOR, PHOTO COORDINATOR
MICHAEL SPECTOR

COMPUTER ASSISTANCE
LAURIE HAGAR

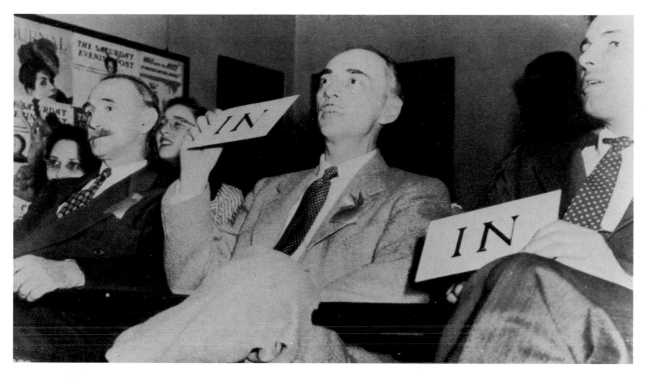

Judges vote on a picture during the first competition. From the left, George Yates, photo chief of the Des Moines Register, John Field, associate editor, Life magazine, Julius Klyman, editor of "Pictures" section in the St. Louis Post-Dispatch.

Why milestones matter: 50 years of judging photos

We like milestones, dates that help us remember: the 10th wedding anniversary, the 45th birthday. Each one is special, but there are some points in life that are extraordinary.

The book you hold reflects one of those unique moments, a half century of a special contest that rewards the best in photojournalism.

That first contest in 1943 grew out of three simple goals:

• Pay tribute to photographers and newspapers, despite war time restrictions.

• Provide an opportunity for photographers to "meet in open competition."

• Compile and preserve a collection of the best of "home front press pictures."

In describing the First Annual Fifty-Print Exhibition (as the Pictures of the Year competition was then called), an unknown author (who I assume is Clifton Edom, one of the contest's founders) makes the following humble suggestion:

"One year or ten years from now, a person interested in news photography will be able to learn something of the style and the techniques of the photographer of 1943-44."

Little did he know what impact this contest would have on

Continued on the next page

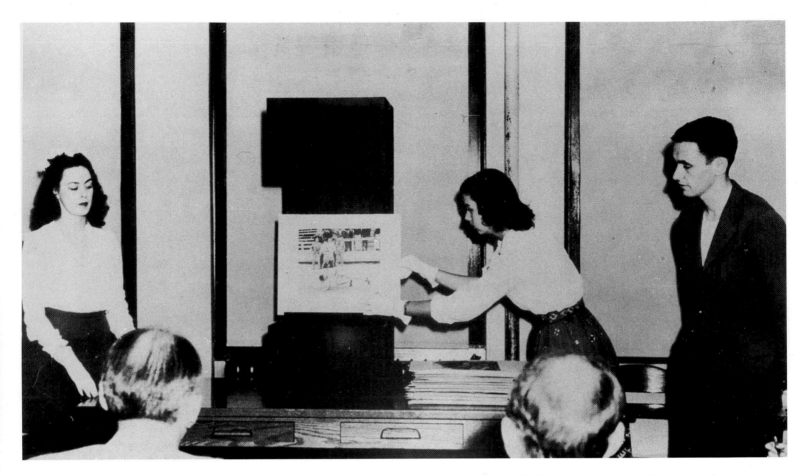

Students of the School of Journalism photography class assist in the judging during the first competition by displaying photos.

Continued from the previous page

journalism and the role of photography within newspapers and magazines.

Nor could he have foreseen the day when technology allows us to look at computer images of the winners sitting in a hotel room halfway around the world and contemplate the impact visuals have had on our society's grasp of today's events.

Looking through the first year's winners, Edom noted that the "News entries pleased the judges better than the feature pictures, although there were twice as many prints submitted in the feature group."

Even 50 years ago, readers looked to visuals to supply crucial pieces of information, the link to an often confusing and contradicting world. News photography was the means of looking at life unfolding, of examining key moments in time.

And back then, "Seeing is Believing," was a phrase that was rock solid. Today, we aren't too sure as even cartoonists make fun of photography's vulnerability to digital manipulation.

That's the real rub about digital manipulation: losing faith in the reality of the moment. How do we celebrate those important events if we don't believe that what we've seen from the past is real?

Looking at William Pauer's (Chicago Daily Times) first place winner of Sewell Avery being carried out of his office, there is no doubt that the picture is real. That certainty provides comfort in a hurried and visually overwhelming world.

— *Howard I. Finberg, PJ Book Series Editor*

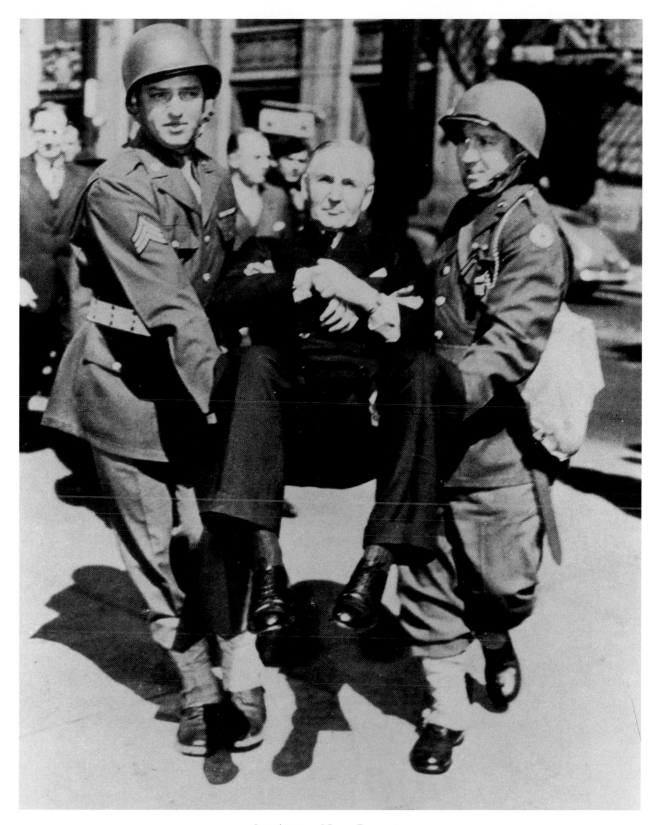

1ST AWARD, NEWS DIVISION
William Pauer, Chicago Daily Times
"Avery gets Bum's Rush" – In 1944, Montgomery Ward President Sewell Avery was carried from the company's Chicago headquarters after refusing an order from the War Labor Board to extend an expired labor contract.

HONORABLE MENTION, FEATURES DIVISION
William Sturm, Chicago Sun
"Gay Rescue" – The original title gives little information.

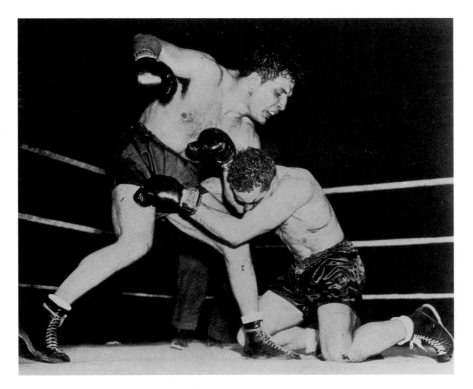

HONORABLE MENTION, NEWS DIVISION
David Mann, Chicago Sun
Lew Woods and Jake La Mote battle to a state of exhaustion.

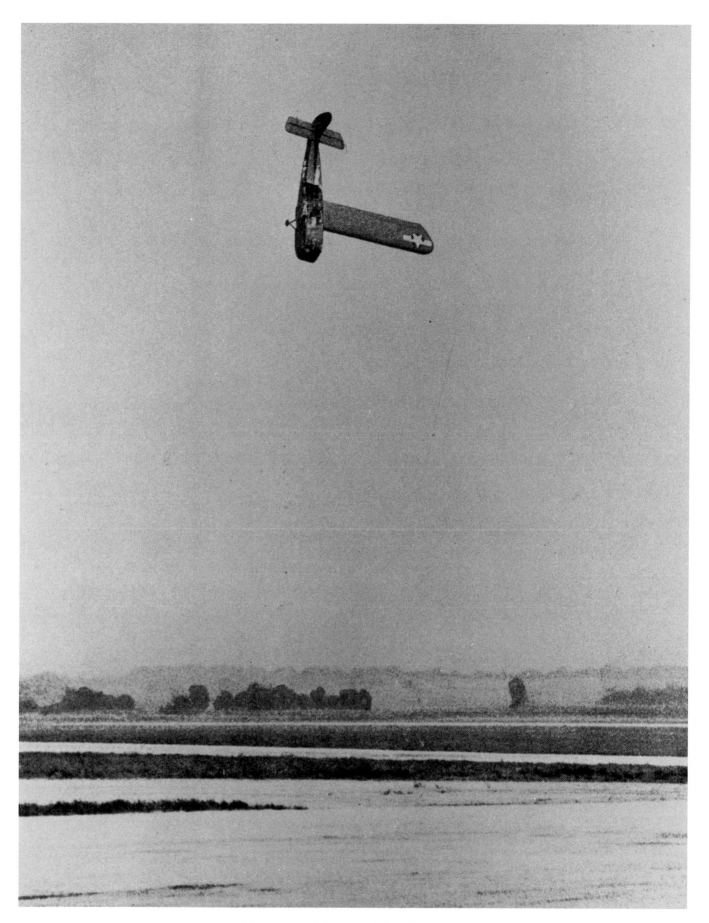

Jack Zehrt, St. Louis Globe-Democrat
A glider crashes toward the ground after falling apart in midair. Ten men, including the mayor of St. Louis, were killed in the accident Aug. 1, 1943, at Lambert Field near St. Louis.

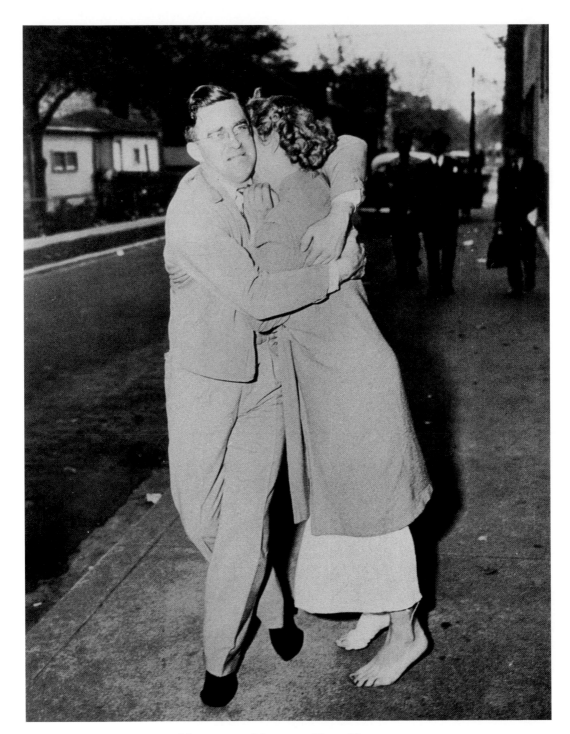

HONORABLE MENTION, NEWS DIVISION
Ralph Frost, Chicago Sun
Glenn Chapman helps his wife away from Albany Park Police Station
after a fire in which their son died, Oct. 12, 1943. Mrs. Chapman
was slightly burned in the blaze.

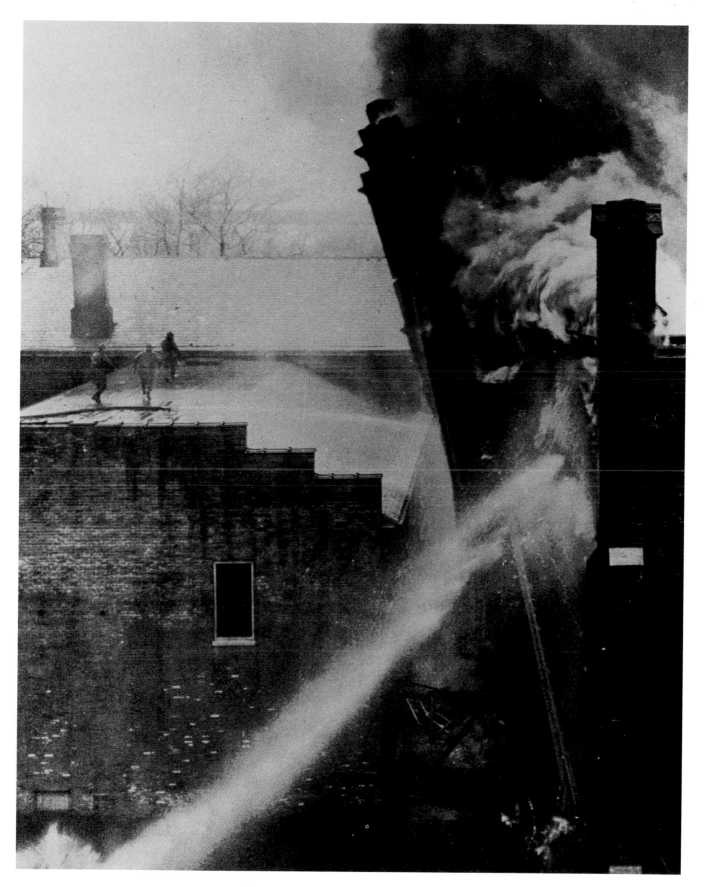

HONORABLE MENTION, NEWS DIVISION
Dwight Boyer, Erie Daily Times
Firefighters flee a rooftop as a church wall begins to collapse
toward them on April 15, 1944, in Erie, Pa.

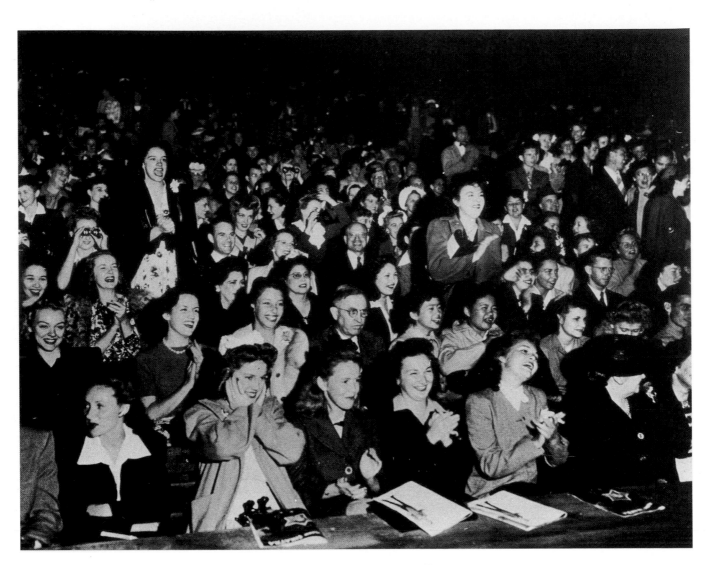

HONORABLE MENTION, FEATURES DIVISION
Ed Parkinson, Los Angeles Examiner
An audience listens to Frank Sinatra sing *You'll Never Know How Much I Care,* at the Hollywood Bowl.

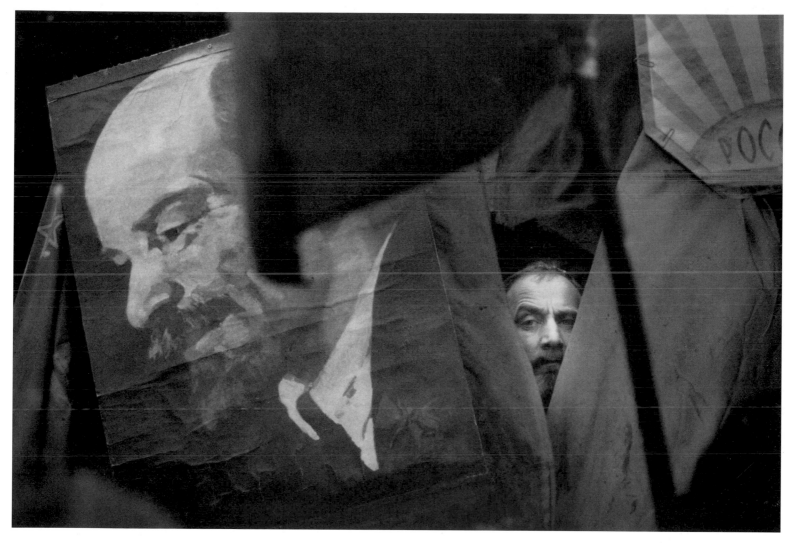

A pro-communist demonstrator peers out from behind flags in a Moscow square during a demonstration against President Boris Yeltsin's reforms.

Mission of Mercy

To protect food and medical shipments being sent to starving Somalis, the U.S. Marines led a U.N.-sponsored military effort dubbed Operation Restore Hope. The humanitarian intervention was especially moving for some African Americans, many of whom had never been to their ancestral land, but who were compelled to feel a kinship to its people.

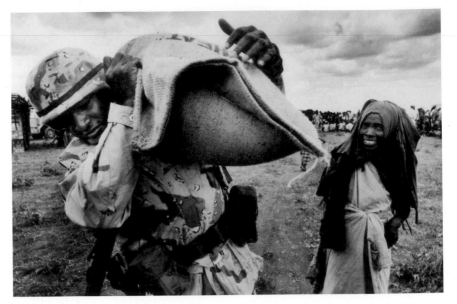

Lance Cpl. Larry Hilliard, USMC, carries a heavy bag of wheat for a Somali woman to her hut in a nearby village.

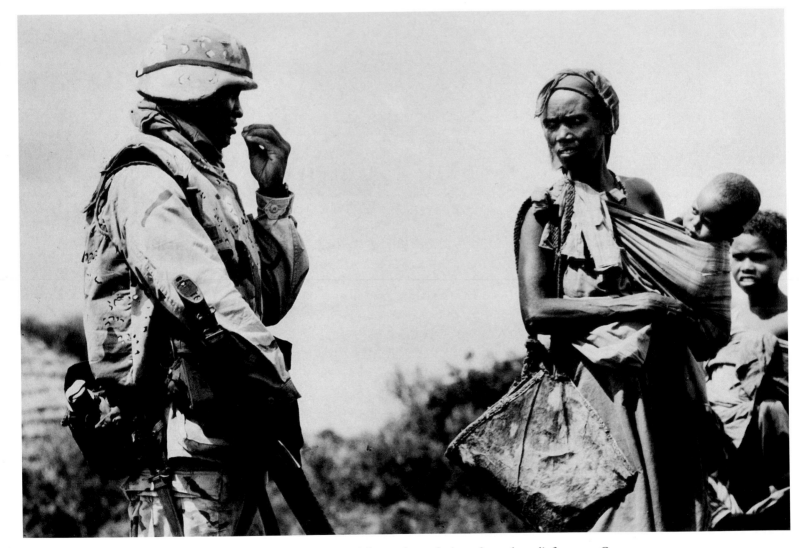

Hilliard gestures to a woman to go pick up a bag of wheat from the relief agency Concern.

NEWSPAPER PHOTOGRAPHER OF THE YEAR • *Carol Guzy, First Place, The Washington Post*

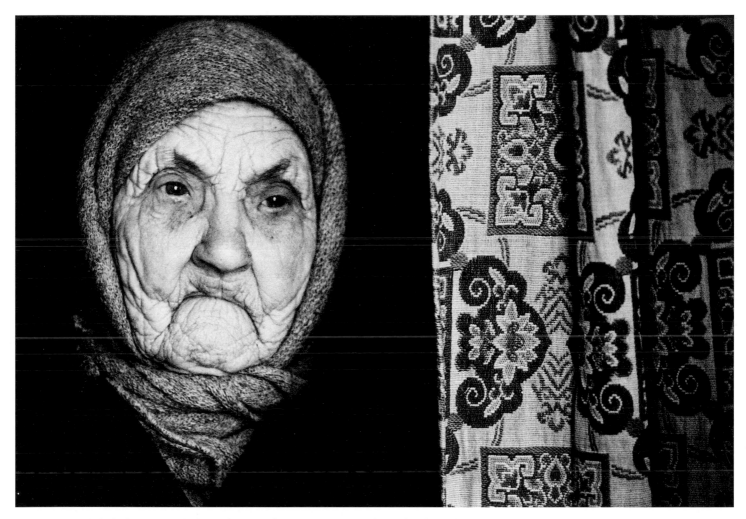

Maria Ivanova, 82, lives alone in the Russian town of Mozhaisk, with no running water.

Russian Babushkas

In Russia, "babushka" means grandmother or old woman. They are at the heart of the country's life, an example of strength for their families as they cook and clean and work to augment their pensions. They can be found in the villages, singing the traditional songs and telling age-old stories, and drinking vodka to stay warm.

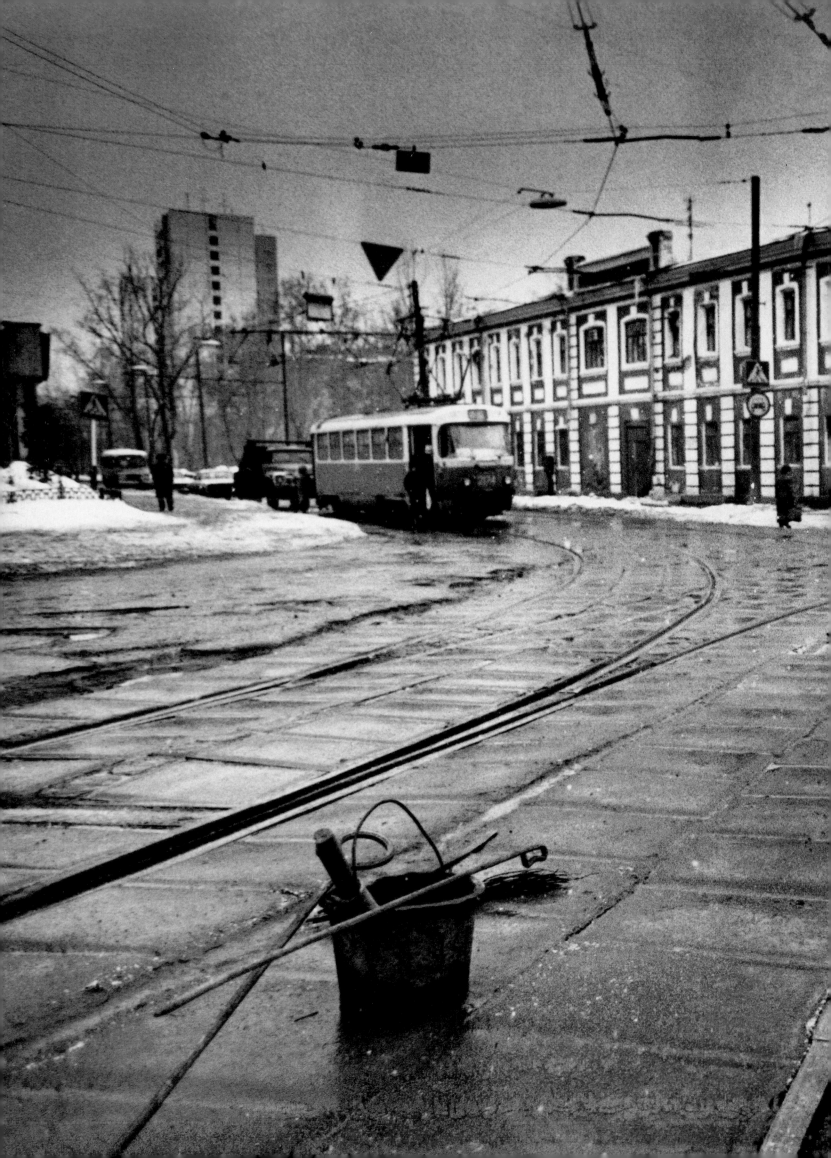

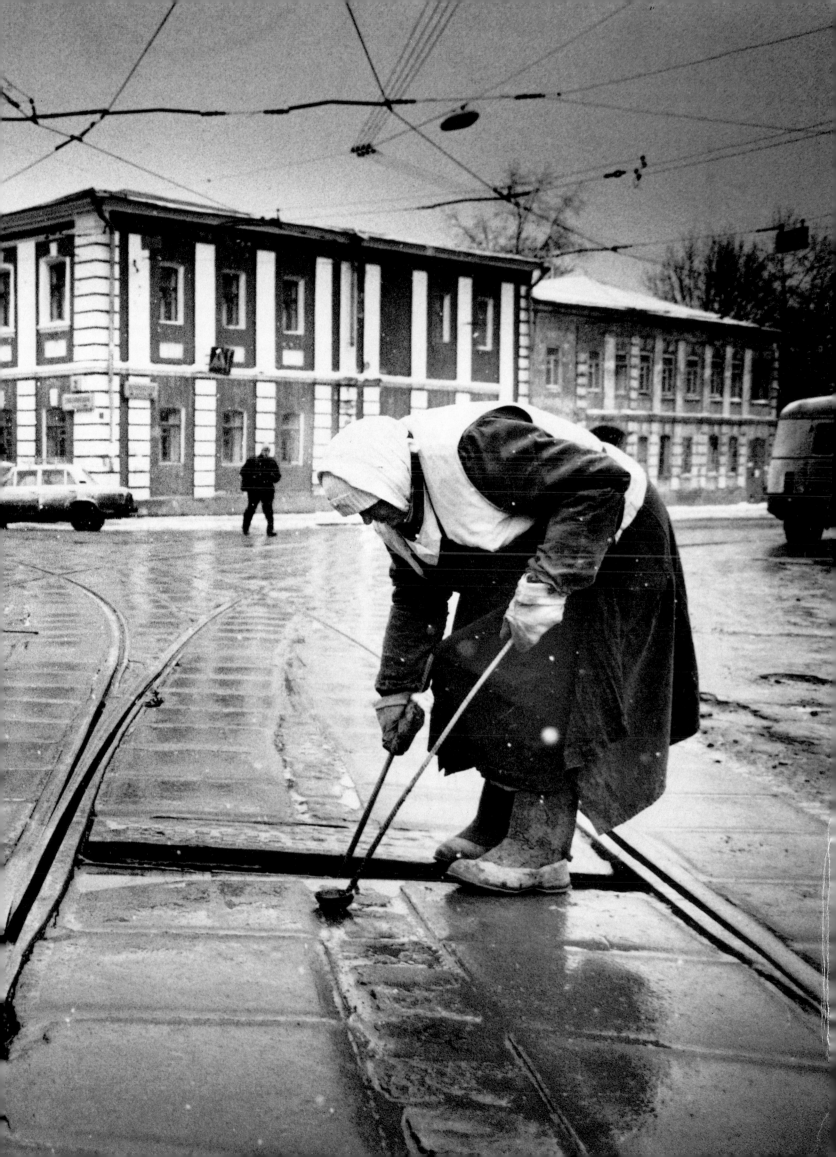

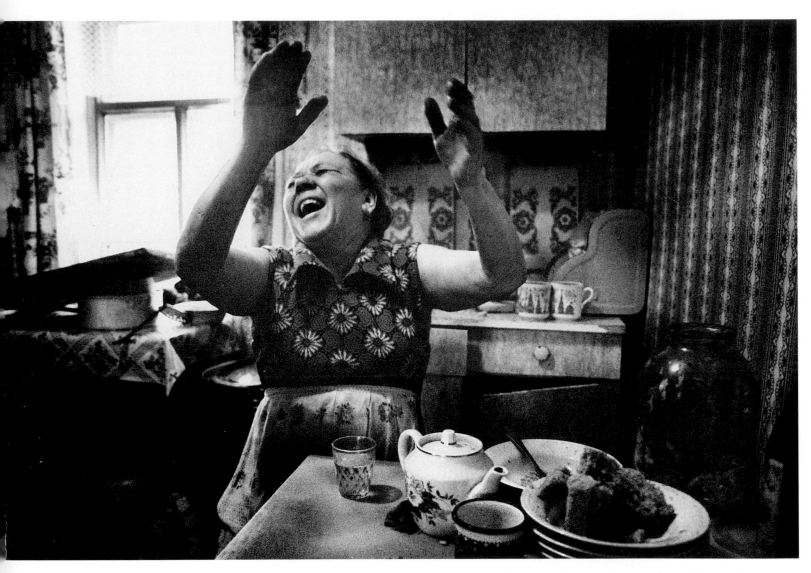

Anna Sidorova, 68, lives with her husband in a small village in Siberia. She toasts friendship between nations, but adds, "We have to work for ourselves. We should not wait for any help from abroad."

Previous page: Pelageya Gorbachev cleans the trolley tracks as she has been doing for the past 50 years. Widowed during World War II, she lives with her son on a meager income.

NEWSPAPER PHOTOGRAPHER OF THE YEAR • *Carol Guzy, First Place, The Washington Post*

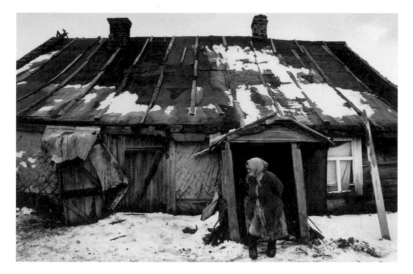

Maria Ostapova, 81, lives alone in a wooden house in Mozhaisk, near Moscow. A social worker brings her bread and milk.

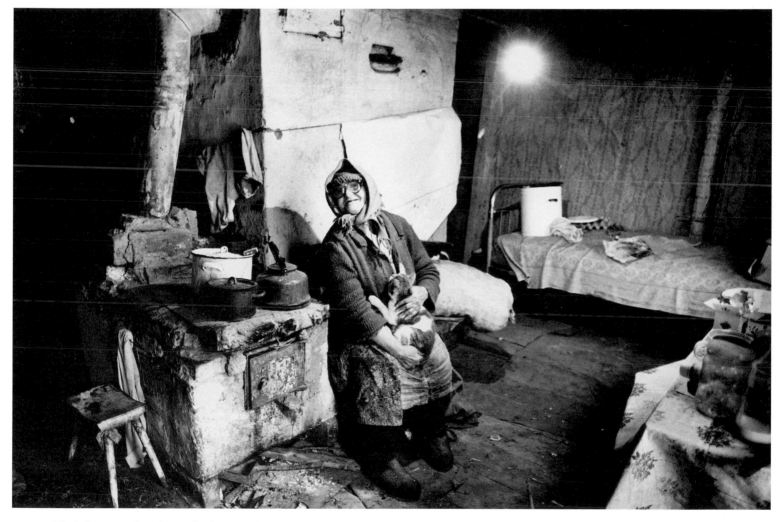

Maria has no television, telephone, radio or newspapers – she doesn't know the name of her country's president. She sits all day with only her cat for company.

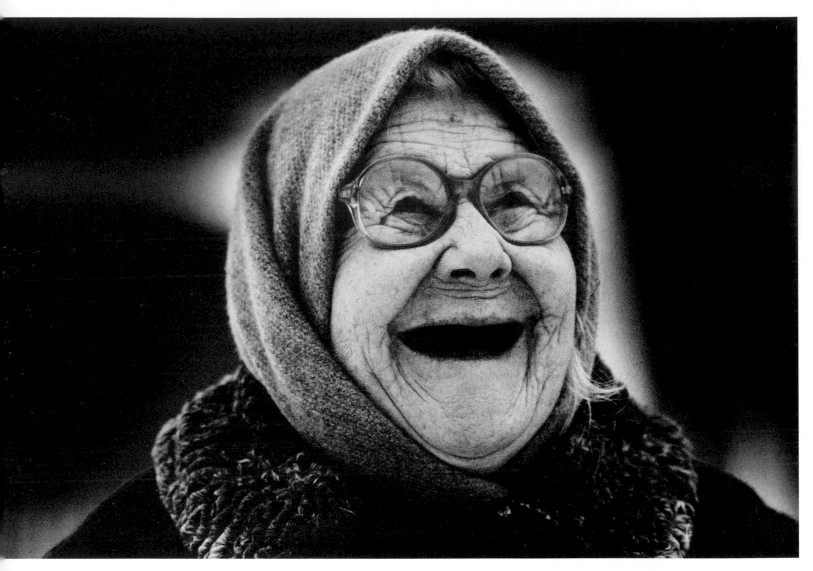

Nastia Zonkina, 85, lives with her son in Mozhaisk, Russia. She braves the bitter winter cold every day to shop for food.

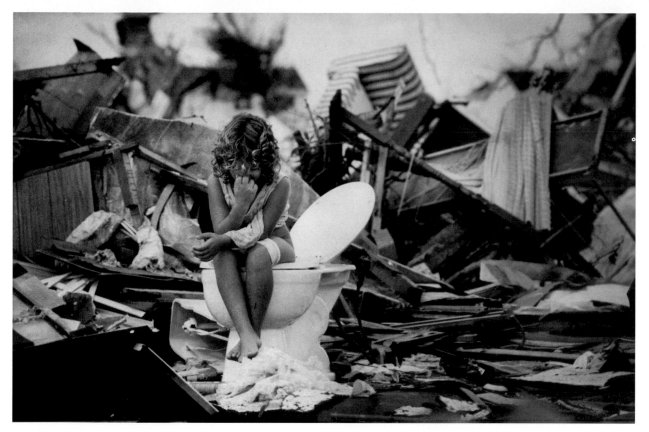

A young girl makes use of a toilet in the rubble of Princetonian Mobile Home Park in Florida after Hurricane Andrew.

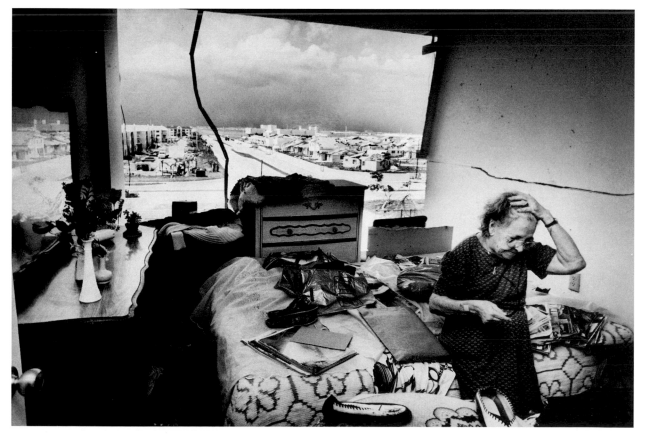

A victim of the hurricane sits in what remains of her apartment in South Dade, Fla.

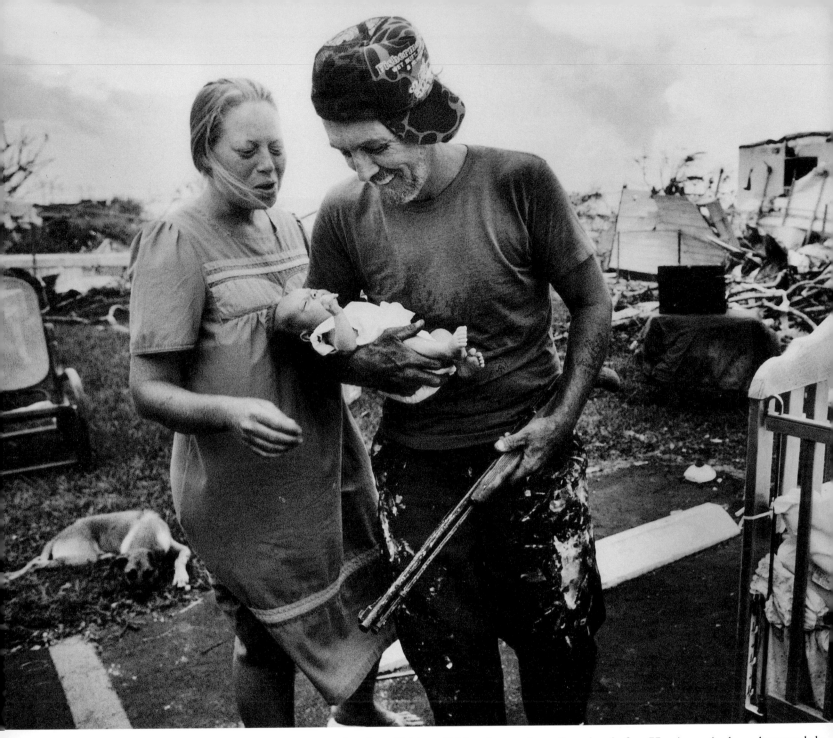

Tommy George and Jackie Cohen admire their infant daughter, Kaitlynn Faith, who was born four days before Hurricane Andrew destroyed the mobile home where they lived. Tommy carries a gun to protect them from looters.

Andrew's Legacy

For Jackie Cohen and Tommy George, life before Hurricane Andrew hit south Florida was not easy. They lived on disability checks as Tommy fought the lure of the bottle. But the birth of their "angel," Kaitlynn Faith, brought new joy into their lives. Four days later, Hurricane Andrew devastated the mobile home park where they lived in Princeton, Fla. With no money for a hotel, Jackie and Tommy pitched a tent near what had been their home. While waiting for relief funds, their resilience and strength kept them going, and their daughter gave them a new will to live. They came to understand that only life itself cannot be replaced.

NEWSPAPER PHOTOGRAPHER OF THE YEAR • *Carol Guzy, First Place, The Washington Post*

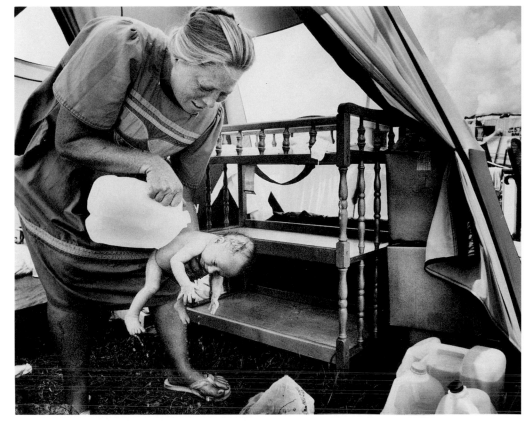

With no running water, Jackie uses a one-gallon jug to bathe Kaitlynn.

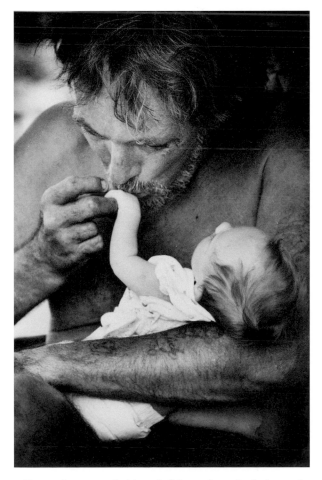

"I got three good things left here: her, the baby and
myself," Tommy says as he cradles Kaitlynn.

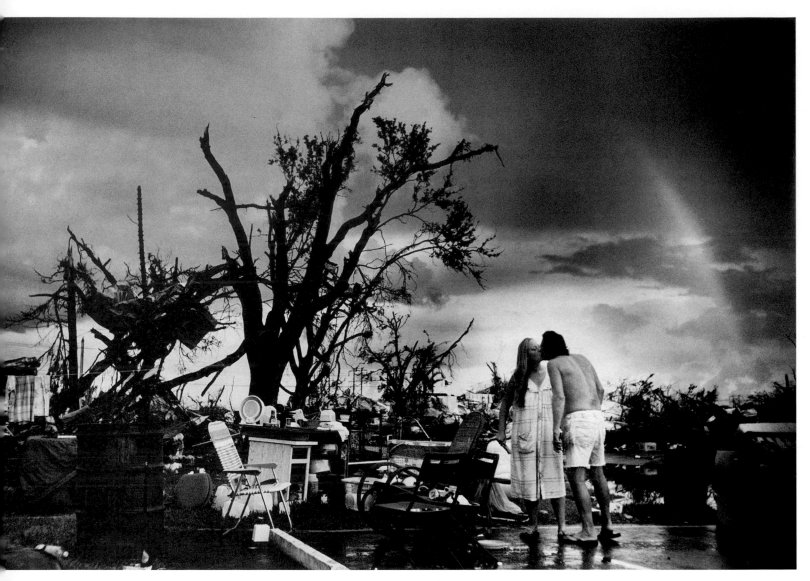

After the storm, a rainbow.

James Nachtwey, First Place, Magnum

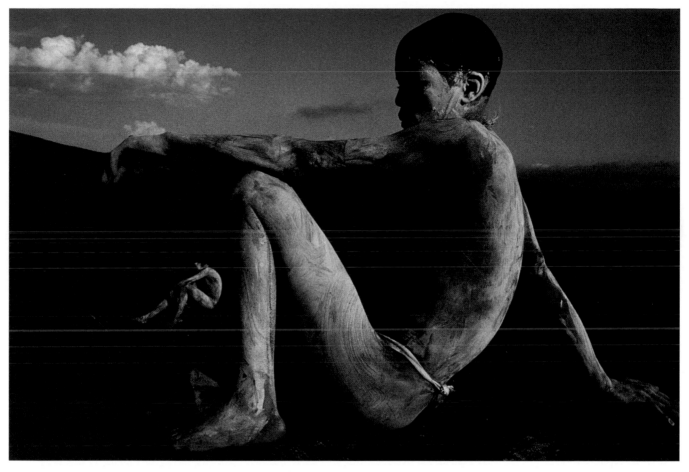

For about a month before their initiation into manhood, young men in South Africa must live outside the village, without clothes, covered in white clay.

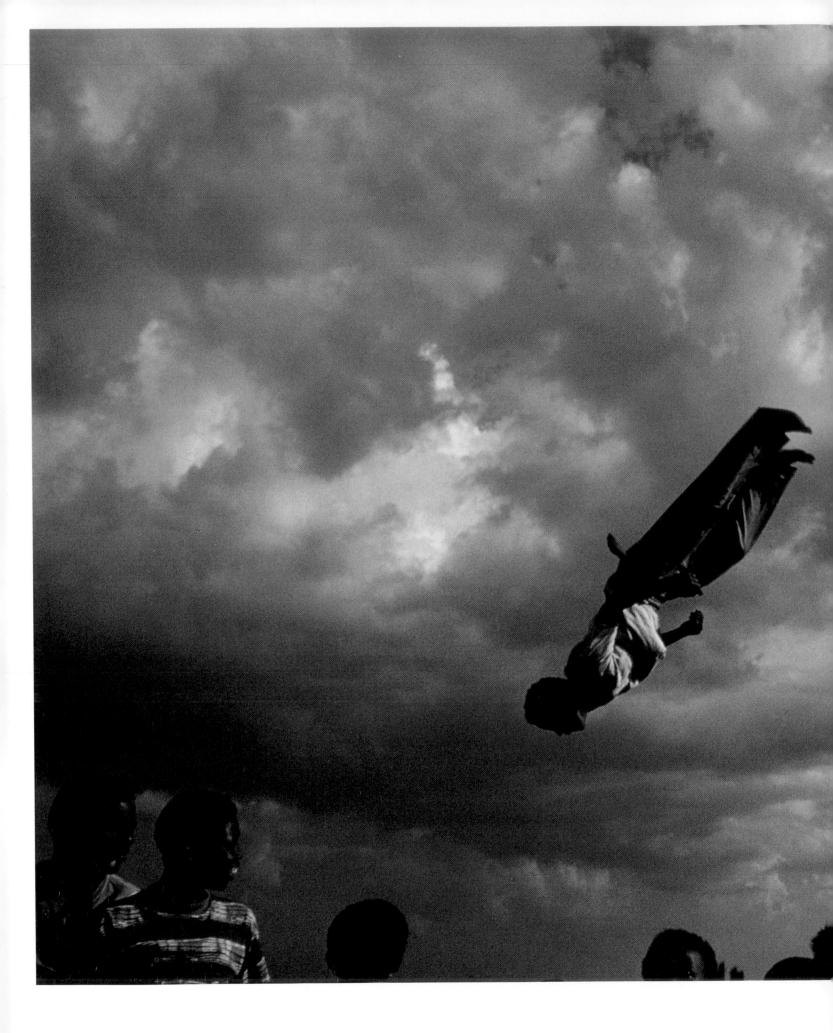

MAGAZINE PHOTOGRAPHER OF THE YEAR • *James Nachtwey, First Place, Magnum*

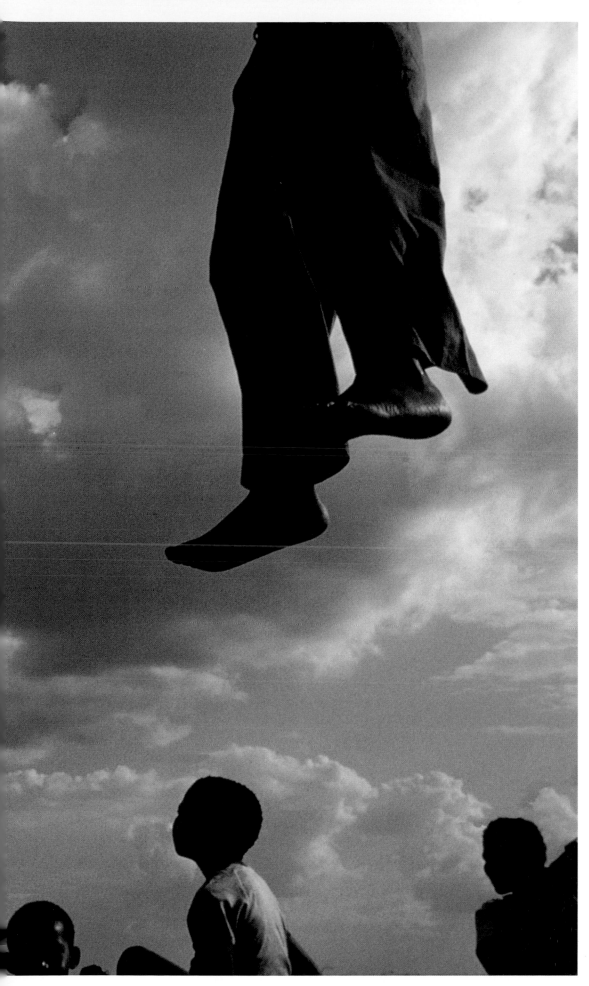

Soweto children play on a trampoline.

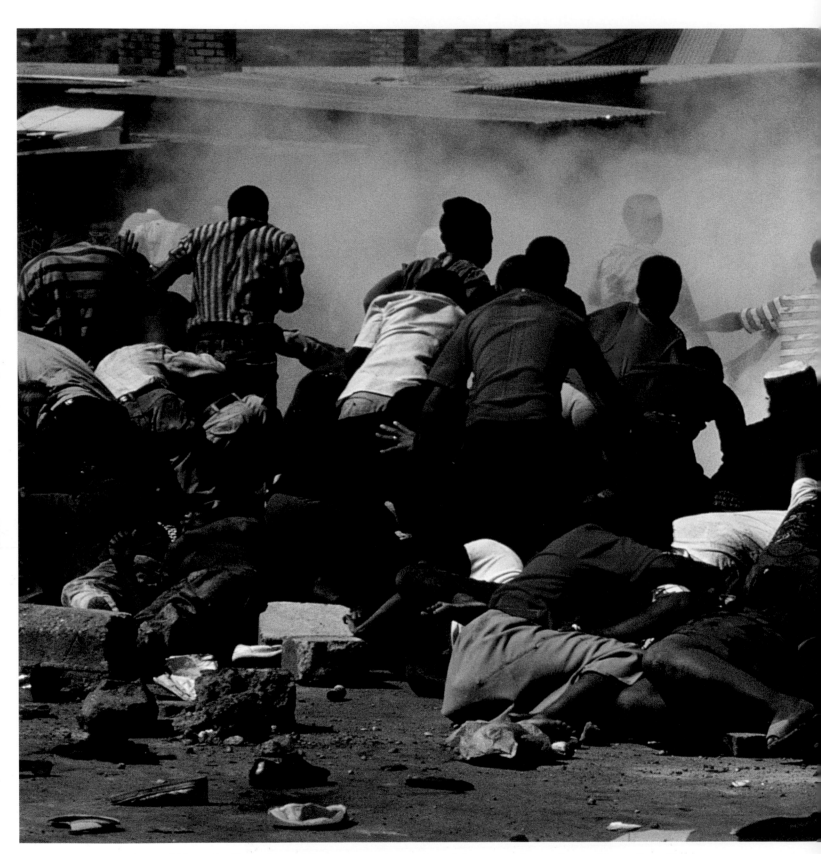

Residents of Alexandra Township, while demonstrating against violence, are shot and gassed by police officers.

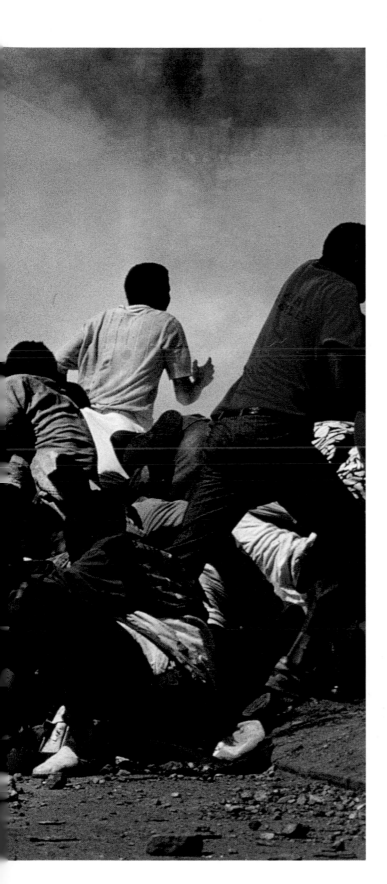

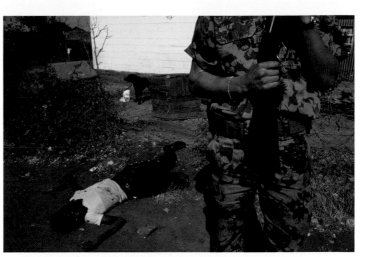

A 13-year-old boy was shot in the back by police during a demonstration against violence in Soweto.

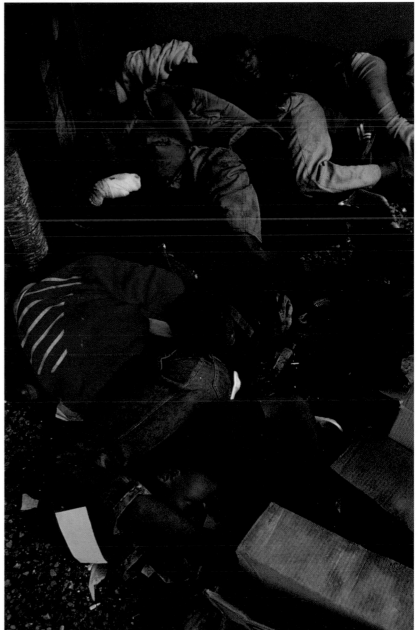

Runaway children huddle together as they sleep on a Johannesburg street.

MAGAZINE PHOTOGRAPHER OF THE YEAR • *James Nachtwey, First Place, Magnum*

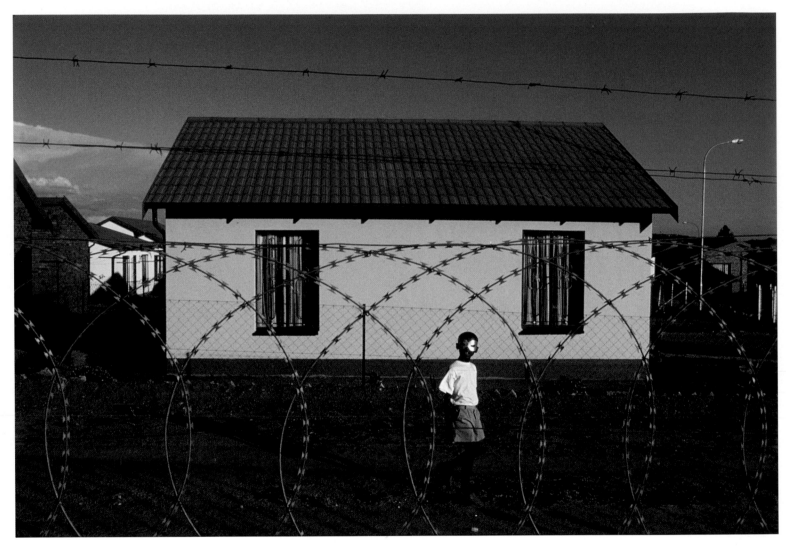

A squatter's camp near Capetown, South Africa.

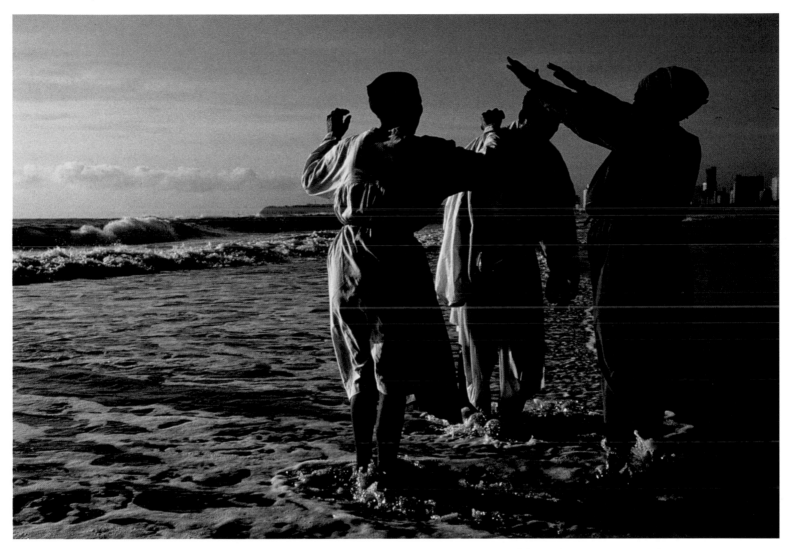

Members of Zionist Christian Church perform an exorcism on the shore of the Indian Ocean in Durban.

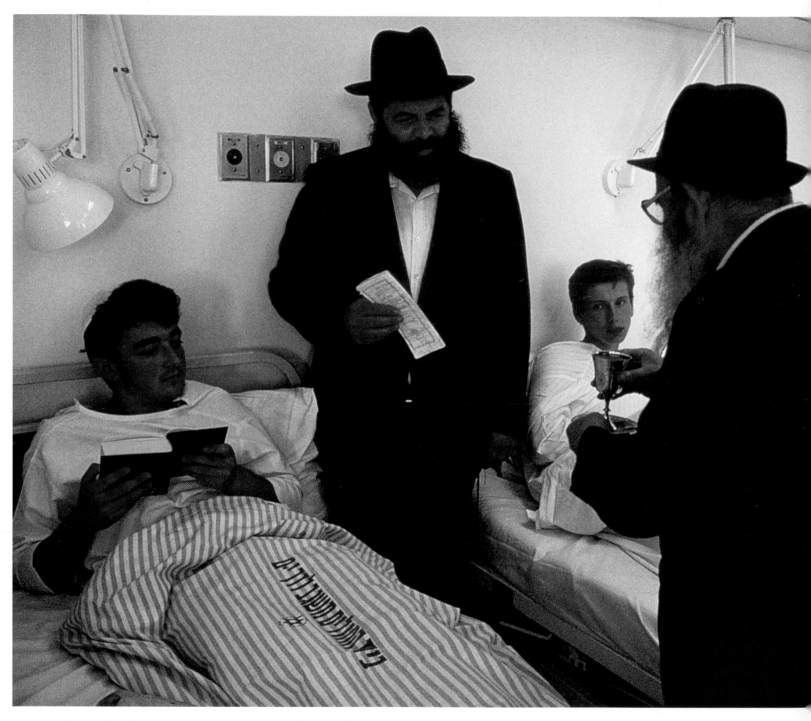

Soviet Jews had scant knowledge of their religion. After immigrating to Israel, these men were circumcized in a ceremony officiated by an Orthodox rabbi.

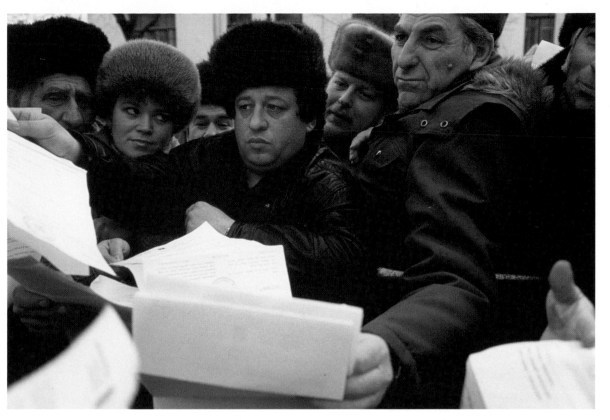

Jews wishing to immigrate wait to get their papers approved at the Israeli consulate.

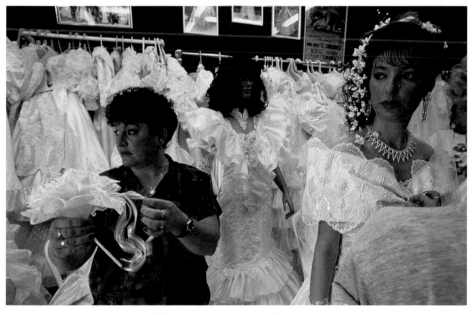

A new immigrant, who will be marrying an Israeli, is fitted for her wedding gown.

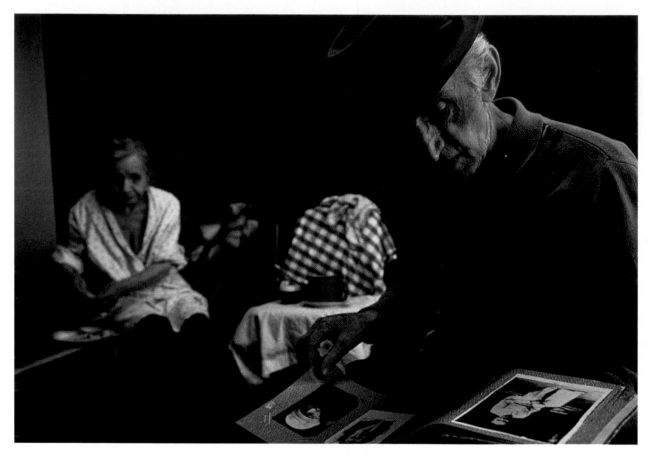

An elderly couple live in a small room in Jerusalem after emigrating from Russia. The man looks at pictures of their life together.

Natalie, 5, doesn't understand why her autistic brother, Nicky, often resists affection.

Reaching Out

Nine-year-old Nicky Spinella of Pittsburgh is autistic. He has never spoken except to say "happy," he seems unaware of his surroundings, does not interact with others, is often incontinent and must be bathed and dressed. At a workshop, Nicky's mother, Marlene, learned a new technique for communicating with autistics, "facilitated communication," that was introduced into this country in 1989 by an Australian researcher. It is not a cure, but rather an aid to reaching autistic children through the use of a keyboard. A parent or teacher supports the arm of the autistic person as he types out a message. Using facilitated communication, Nicky has been able to answer questions and even spelled out "I love you" for his mother.

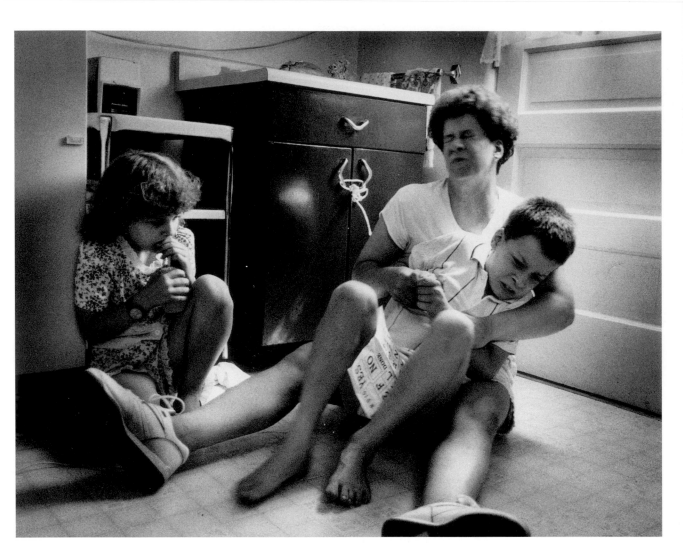

When Marlene first tries "facilitated communication" with Nicky, he flies into a rage.

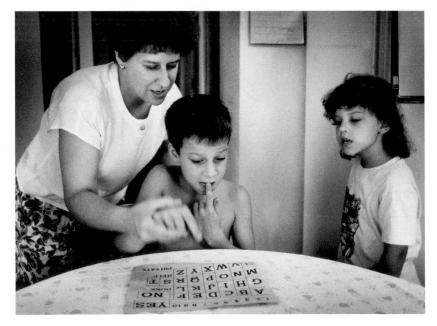

As Nicky becomes accustomed to the communication keyboard, he is able to tell his mother simple things such as what he wants for dinner, when he needs to go to the bathroom, or how he is feeling.

Nicky often takes off running without warning, but Natalie knows enough to keep an eye – and her hands – on him before he gets away.

At Nicky's school, he and the other autistic children rarely socialize. Autism is characterized by, among other things, an inability to feel love or form social attachments, a lack of self-awareness, mental retardation, difficulty understanding speech and an inability to grasp concepts or symbols. Despite this, researchers have found that some autistics can be taught.

NEWSPAPER PHOTOGRAPHER OF THE YEAR, • *Patrick Tehan, Second Place, The Pittsburgh Press*

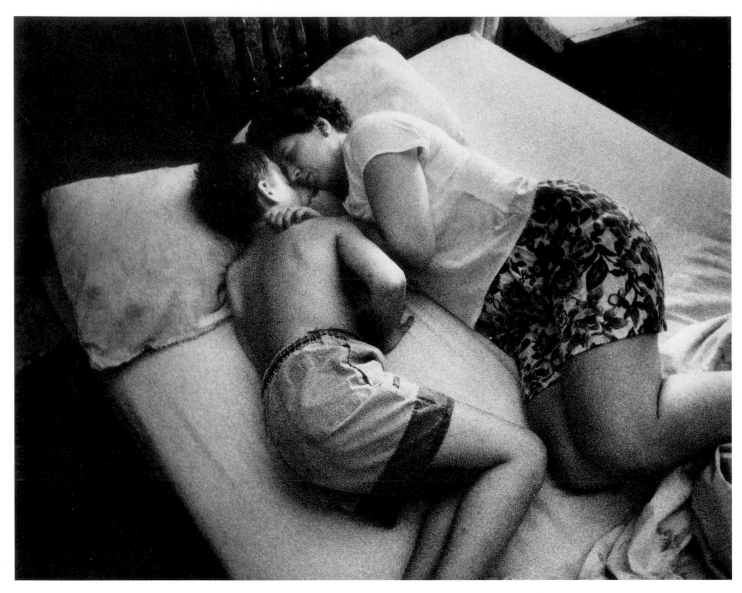

Marlene sleeps with Nicky because he won't go to sleep alone.

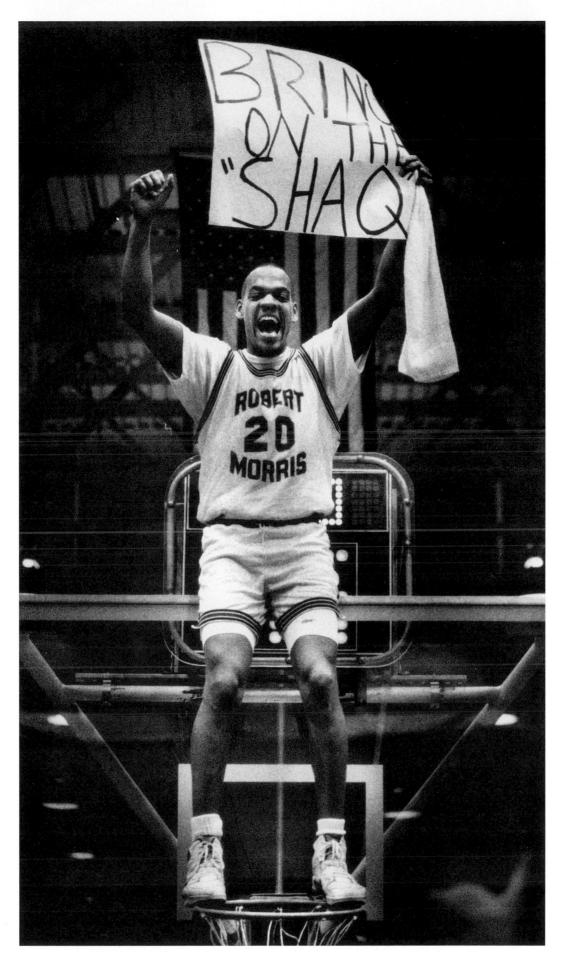

Ricky Cannon, a forward for Robert Morris College near Pittsburgh, celebrates from atop the basket after a Northeast Conference Championship win against Marist College. The win sent them to the NCAA tournament to face Shaquille O'Neill.

The opening credits for "Pet Semetary 2" loom over the concession stand at the Route 40 Drive-in in Brownsville, Pa.

Paul Lowe, Second Place, Network Photographers

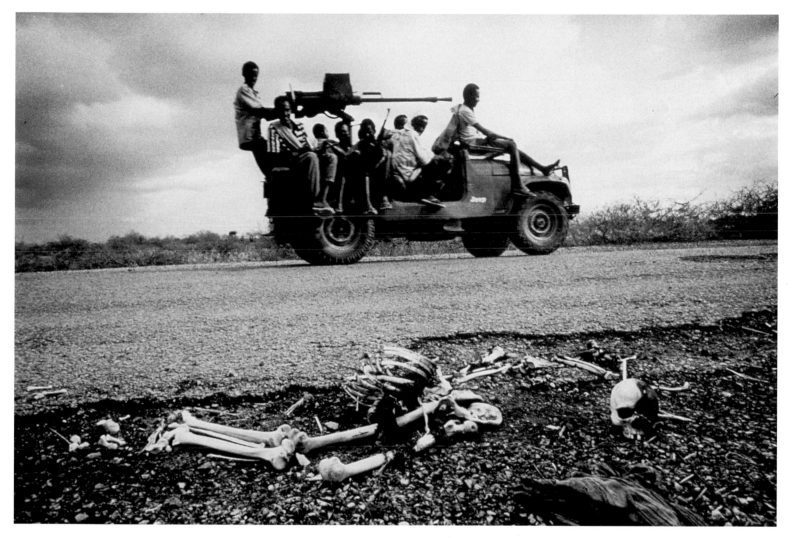

The skeleton of a starvation victim lies untended by a road in Baidoa, Somalia.

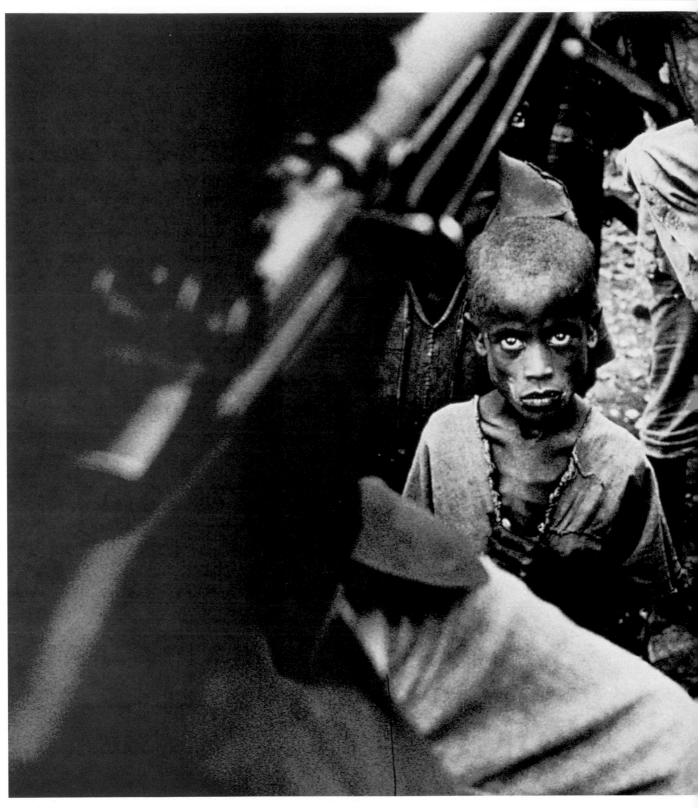

Baidoa, Somalia.

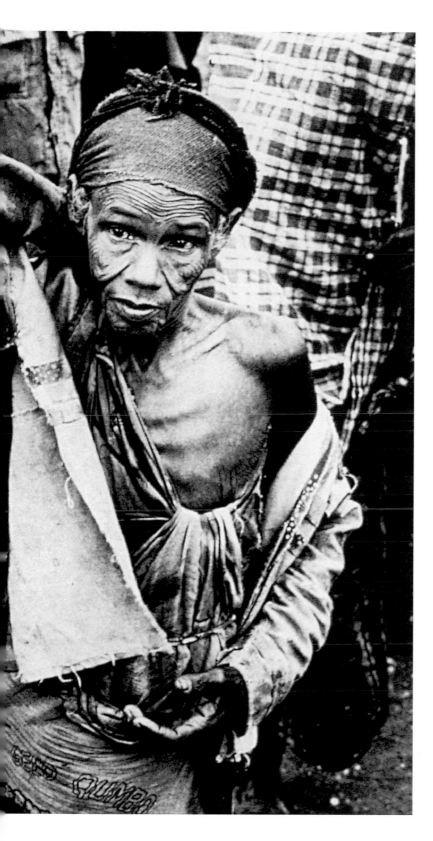

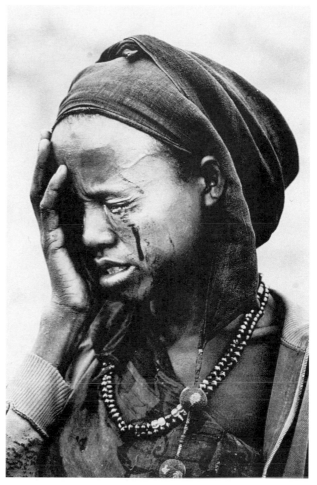

A woman searching for food was beaten.

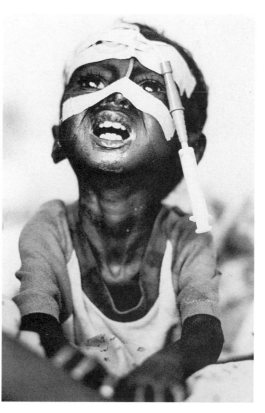

A child is fed in a hospital in Somalia.

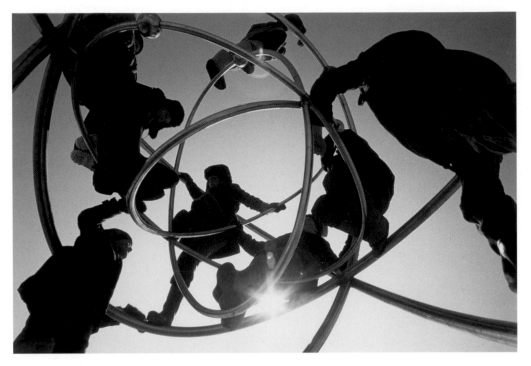

A large model of an atom becomes a plaything for children in Kazakhstan, where the Soviets conducted nuclear testing.

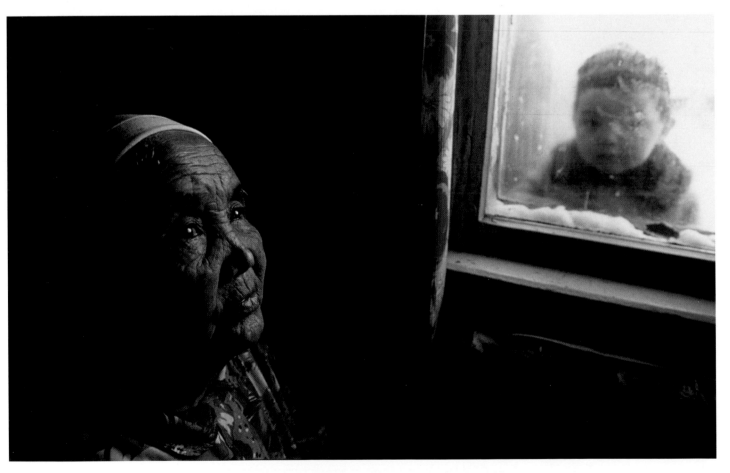

A woman is blind as a result of an earlier atom-bomb test.

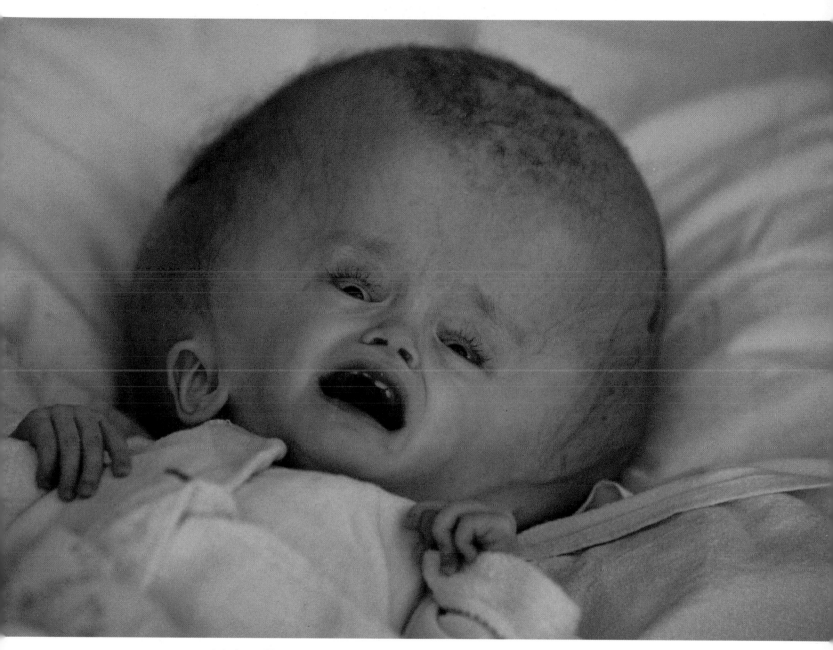

A baby suffers hydrocephalus, a result of radiation poisoning in Kazakhstan.

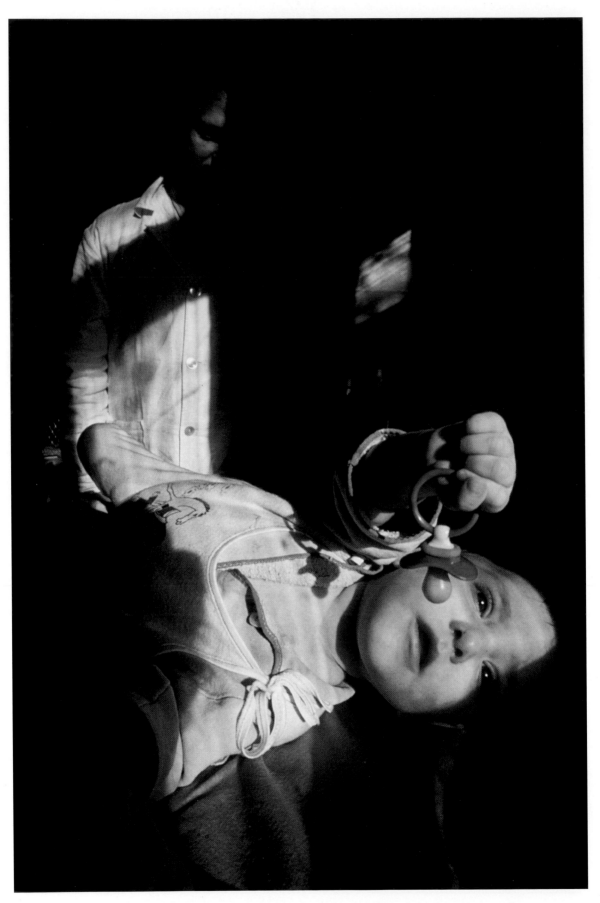

This child's immune system has been weakened by the radiation.

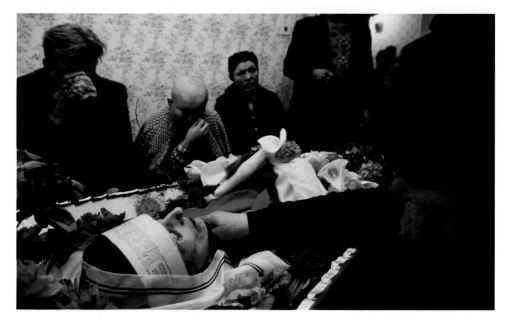

A funeral for a cancer victim. Her son suffers from leukemia.

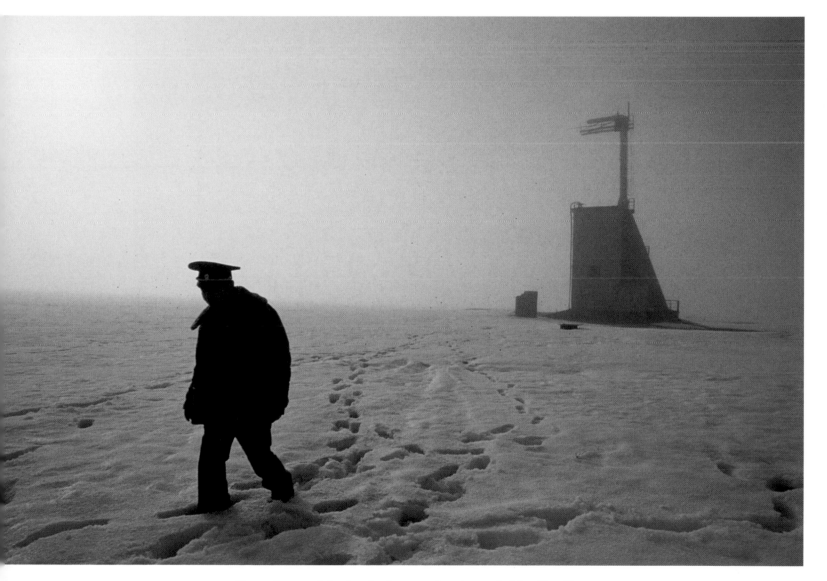

Ground zero of the first Soviet atom-bomb test, held at Kazakhstan.

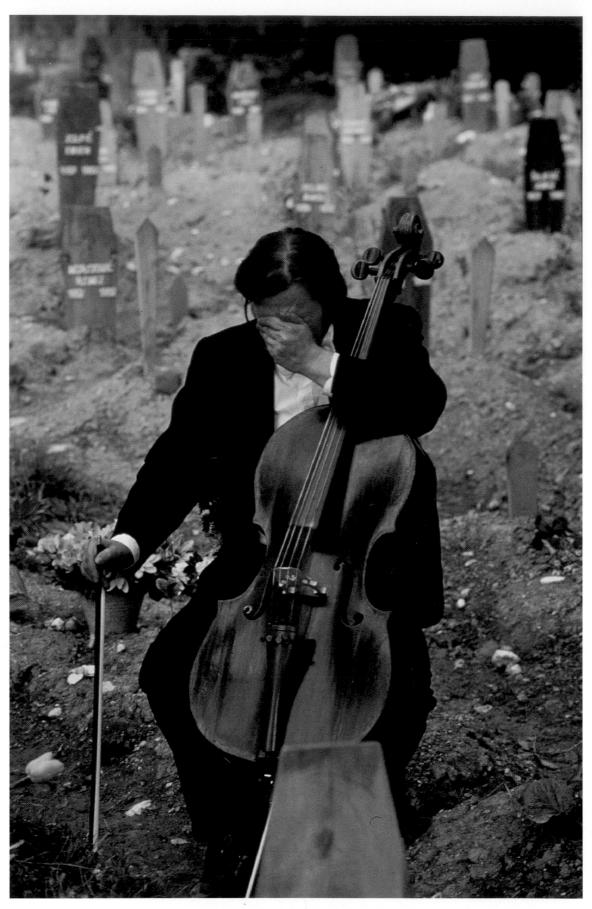

A requiem in Sarajevo, Bosnia-Herzegovina.

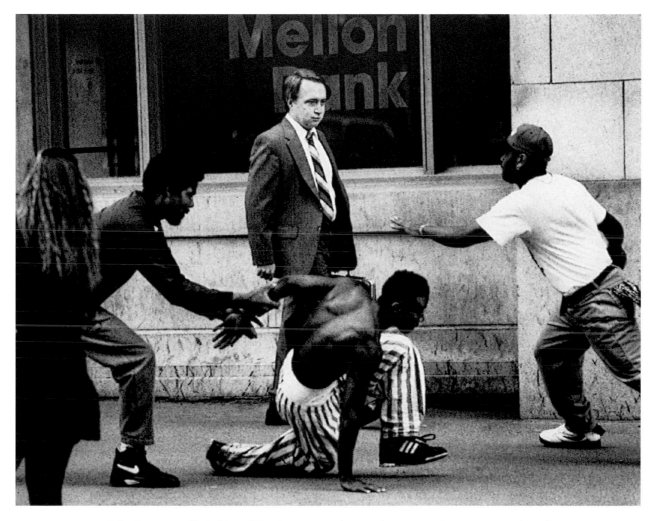

A businessman finds himself in the wrong place at the wrong time as a street brawl
breaks out in downtown Pittsburgh.

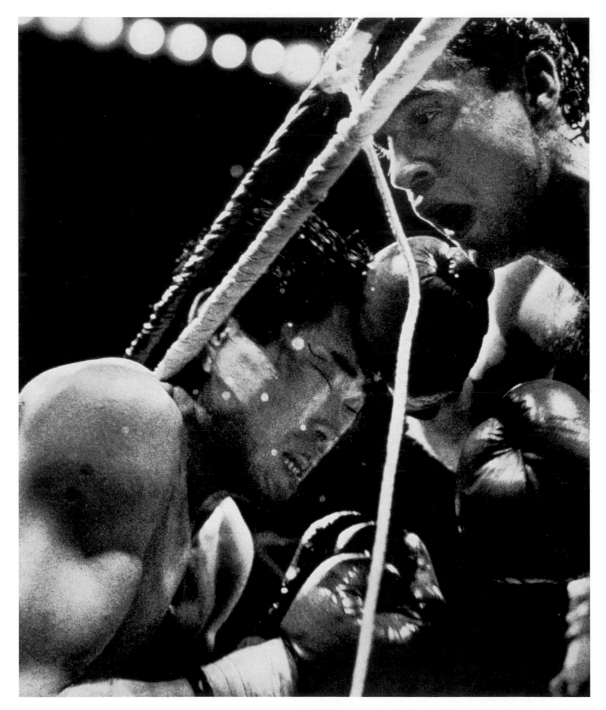

Tony Lopez delivers a 10th round knockout punch to Joey Gamache during a World Boxing Association Lightweight Championship bout.

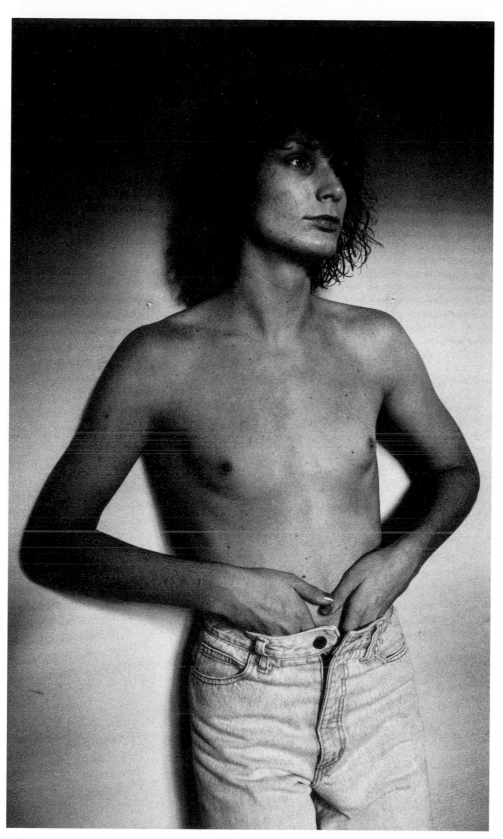

Transexual Paige Whitney Daniels takes female hormones, but still has a man's body.

I'm Not David Anymore

As a youngster in Lewiston, Maine, David Fitch realized he was different from the other boys: David wanted to be a girl. In counseling sessions, David was told he was just going through a phase, but the phase persisted and David began dressing as a girl. At 15, David started taking female hormone pills, which smoothed his face and softened his exterior. After leaving his home, he began a new life as Paige Whitney Daniels, soon turning to prostitution to make a living.

NEWSPAPER PHOTOGRAPHER OF THE YEAR • *Brian Plonka, Third Place, Journal Tribune (Biddeford, ME)*

As a transsexual prostitute, Paige can demand a high price from customers.

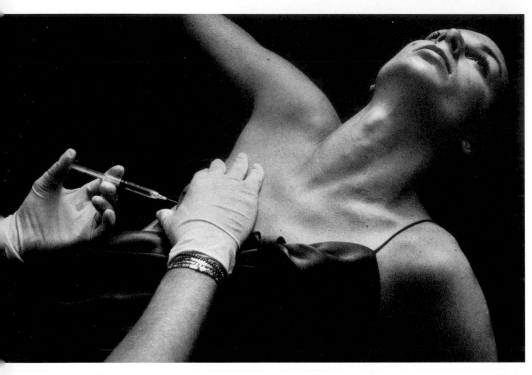

Wanting to look like a woman at any cost, Paige receives silicone injections during an illicit medical procedure.

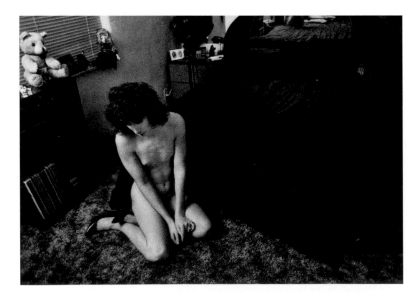

Paige sits depressed at the foot of a bed after turning a trick.

Paige attracts attention at a Florida nightclub while kissing a transexual friend.

Lewis Valentine (right) finds himself outmuscled by a man who doesn't want Lewis hanging out with his sister.
Lewis, 18, has been on his own for years.

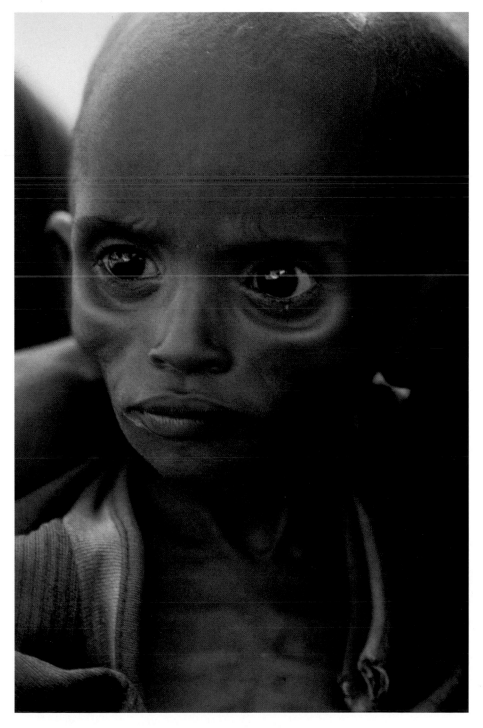

A Somali child in Baidoa.

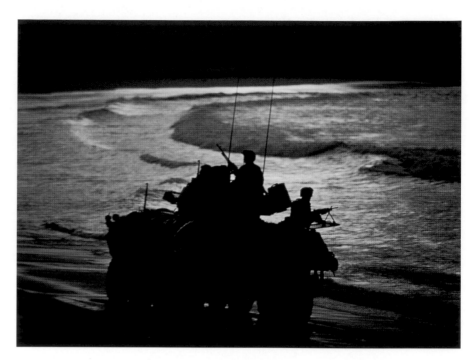

U.S. Marines land on the beach at Mogadishu, Somalia.

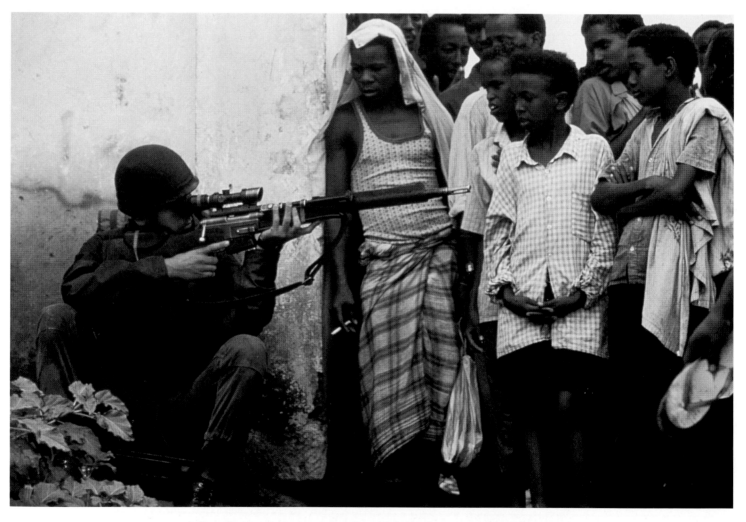

A French paratrooper watches for snipers in downtown Mogadishu.

MAGAZINE PHOTOGRAPHER OF THE YEAR • *Christopher Morris, Third Place, Time Magazine/Black Star*

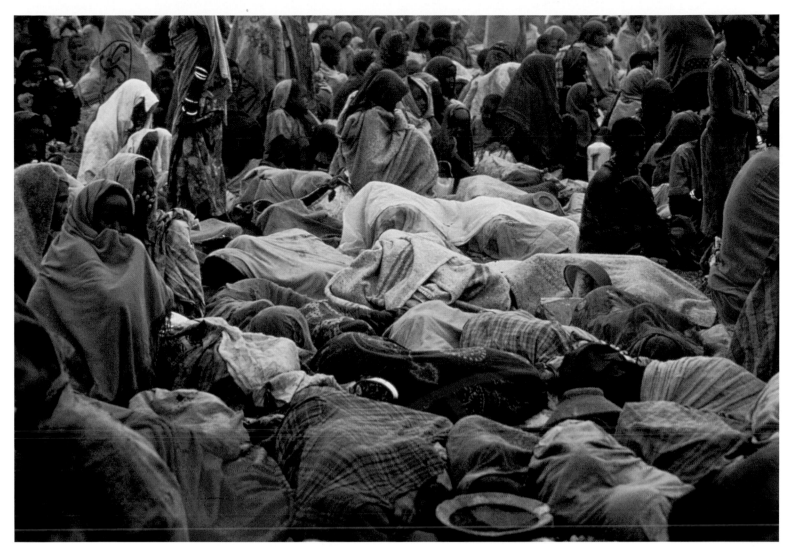

Somalis sleep in Baidoa while waiting for a feeding center to open.

A child licks his bowl clean at a feeding center.

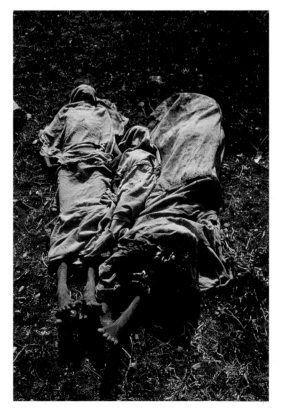

Corpses await burial in Baidoa.

MAGAZINE PHOTOGRAPHER OF THE YEAR • *Christopher Morris, Third Place, Time Magazine/Black Star*

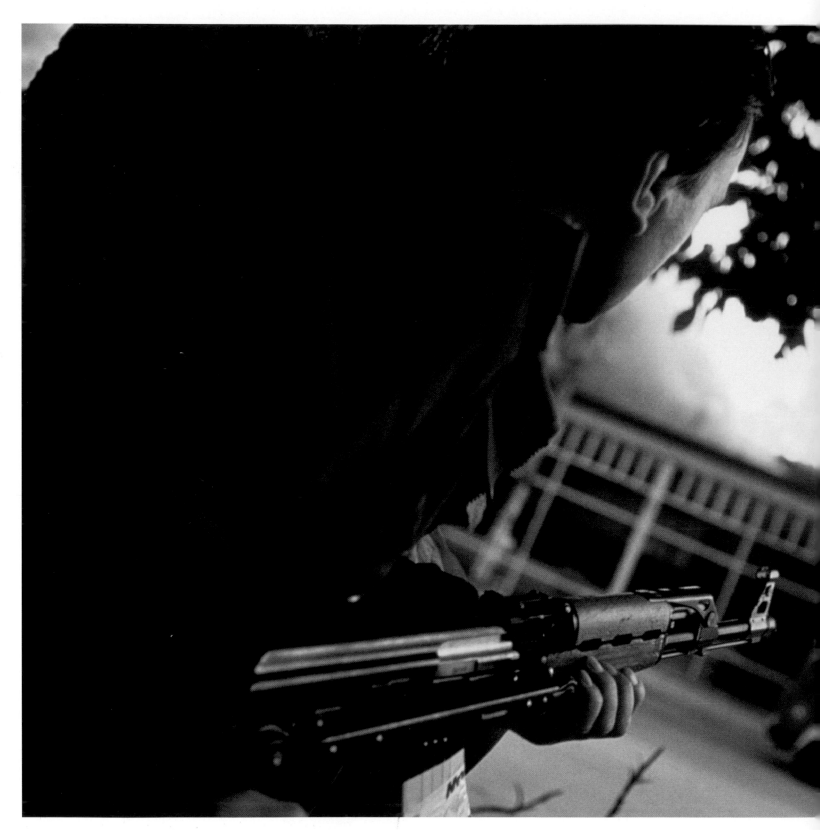

The twin Unis towers of Sarajevo, Bosnia-Herzegovina, burn out of control during heavy shelling.

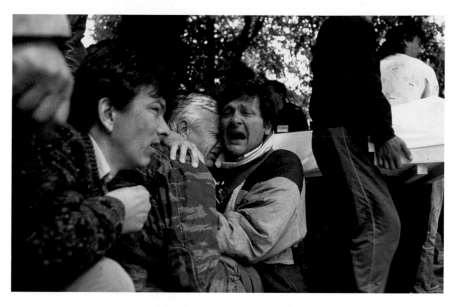

Bosnian Muslims weep at a friend's funeral.

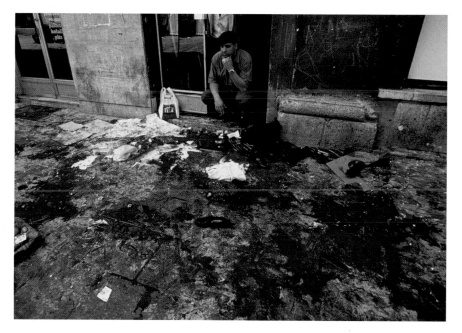

A Bosnian shop owner stares at the blood-soaked sidewalk outside his bread store in Sarajevo.

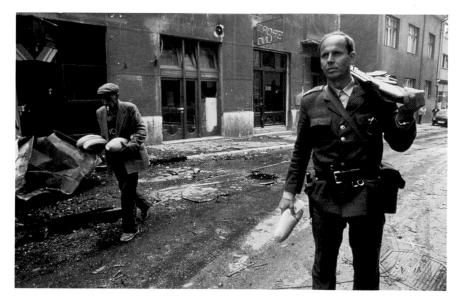

A Bosnian police officer patrols a bombed-out Sarajevo street.

MAGAZINE PHOTOGRAPHER OF THE YEAR • *Christopher Morris, Third Place, Time Magazine/Black Star*

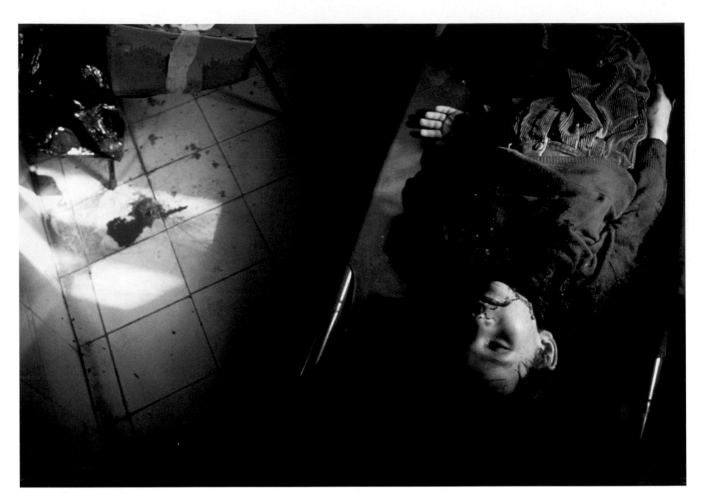

A Bosnian child lies dead in a morgue, another casualty of fighting in Sarajevo.

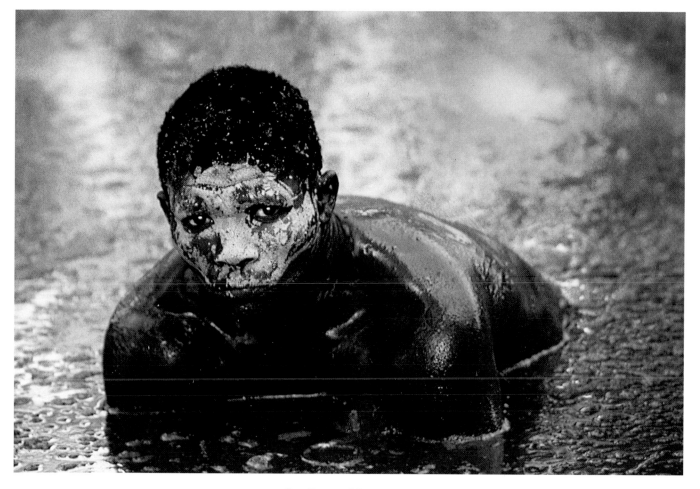

1ST PLACE, NEWSPAPER
Scott Sharpe, The News and Observer (Raleigh, N.C.)
A teenager searches for coins thrown into a sacred mud pit during the Voodoo Festival of Ougou in Haiti.

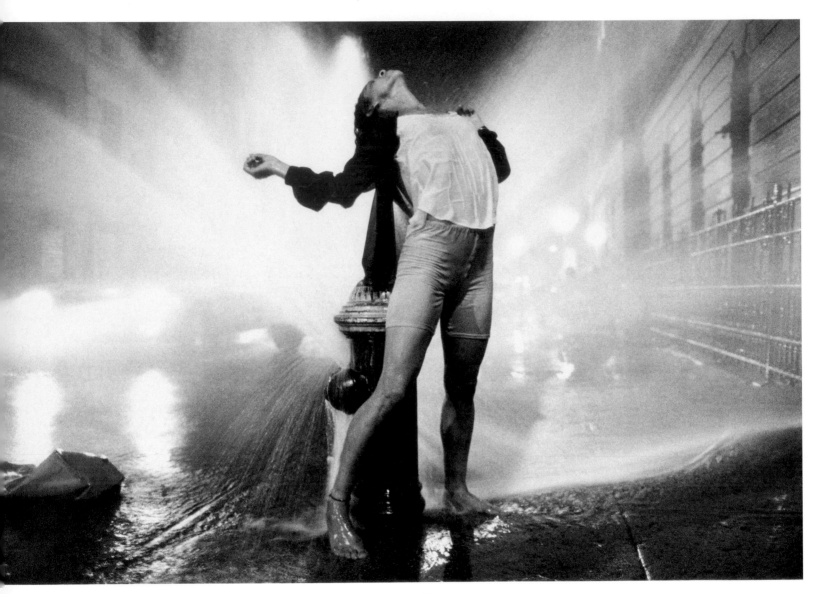

1ST PLACE, MAGAZINE
Scott Thode, Freelance for Outtakes
Venus Williams is an intravenous drug user and AIDS patient who is living on the streets of New York City.

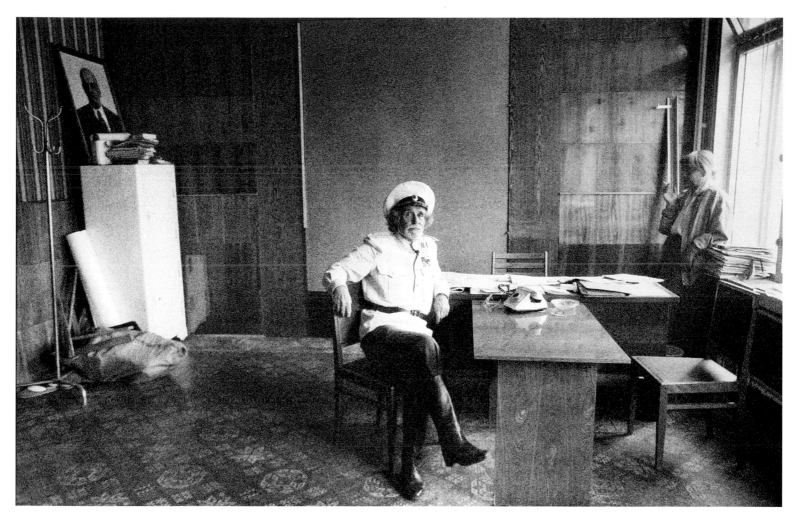

2ND PLACE, MAGAZINE
Antonin Kratocvil, Dot Pictures for the New York Times Magazine
Vladimir Matrosov, a 65-year-old lumberjack in Sakhalin, is rallying the Cossacks to keep the Kuriles Russian.

AWARD OF EXCELLENCE, MAGAZINE
Susie Post, Freelance
Simon Mireego is cared for by his grandmother, who has lost seven of her nine
children to the AIDS epidemic in Uganda.

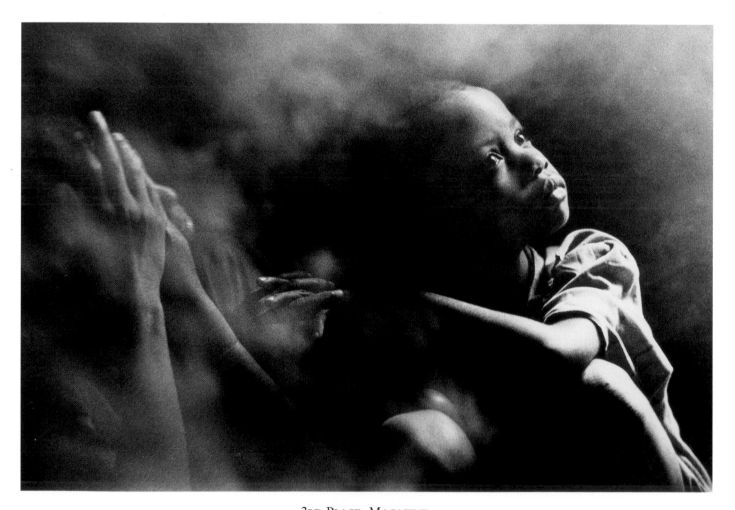

3RD PLACE, MAGAZINE
Susie Post, Freelance
Mutugubya Fred (right) and Kintu Paul sit in a kitchen in Kigenya, Uganda. They are two of nine children who live in the
house without adults because their parents have died from AIDS-related illnesses.

2ND PLACE, NEWSPAPER
Genaro Molina, A Century of Memories
Eugene "Happy" Gragson of Livermore, Calif., has been an entertainer for most of his 101 years. He started in Buffalo Bill's Wild West Show.

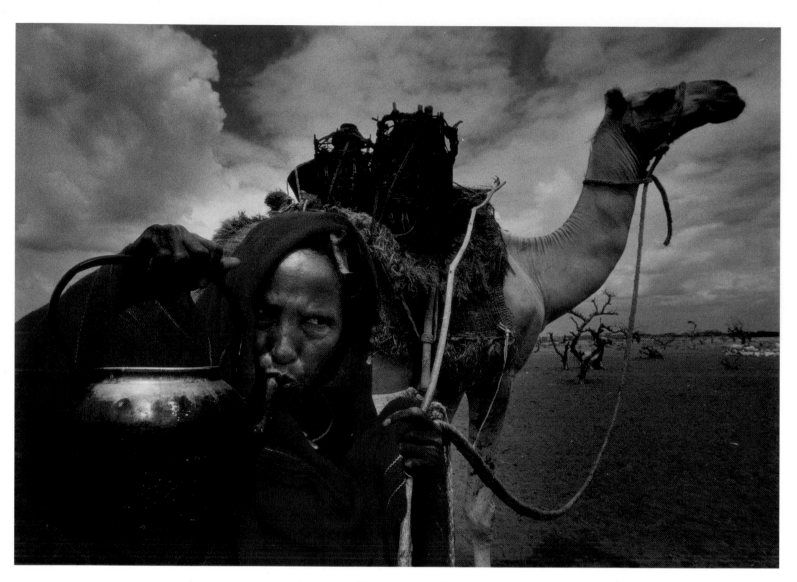

AWARD OF EXCELLENCE, NEWSPAPER
Yunghi Kim, The Boston Globe
A Somali woman drinks from a kettle provided by relief workers at Liboi refugee camp in Kenya.

AWARD OF EXCELLENCE, NEWSPAPER
Tim Zielenbach, Freelance for The Louisville (Ky.) Courier-Journal
In Mogadishu, Somalia, a child holds his mother's hand in a center for Somalis displaced by famine and civil war.

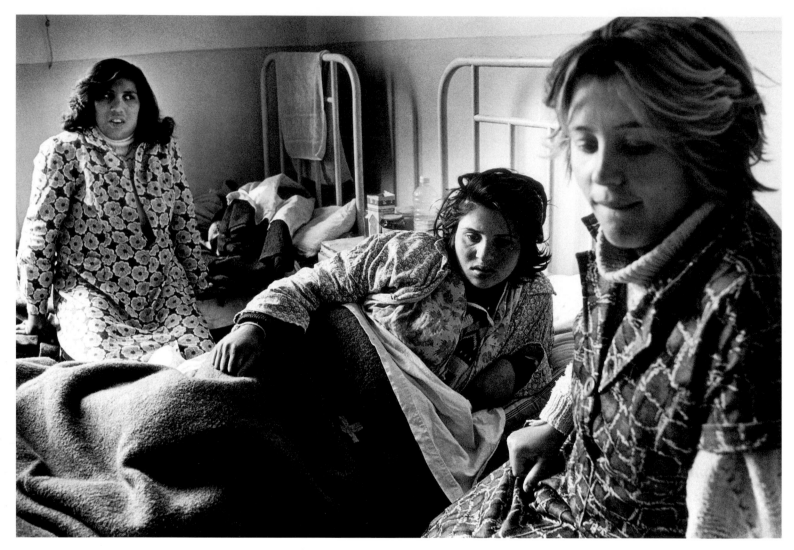

AWARD OF EXCELLENCE, NEWSPAPER
April Saul, The Philadelphia Inquirer
Patients in a maternity ward in Tirana, Albania. Conditions in the hospital are unsanitary; some premature babies share incubators, others go without.

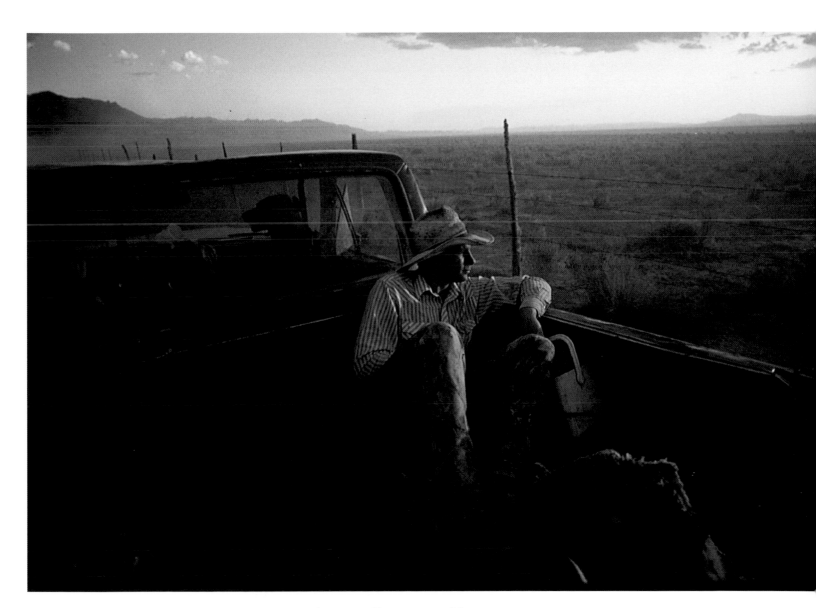

Award of Excellence, Magazine
Chris Johns, National Geographic Magazine
Cowboy Cheth Wallin works 14-hour days in south-central Nevada.

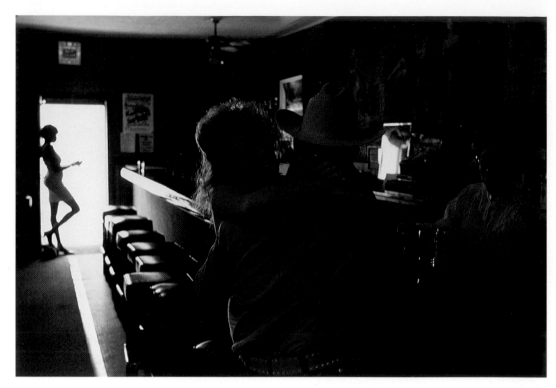

AWARD OF EXCELLENCE, MAGAZINE
Chris Johns, National Geographic Magazine
Inside the Big 4, a legal bordello and bar in Ely, Nev.

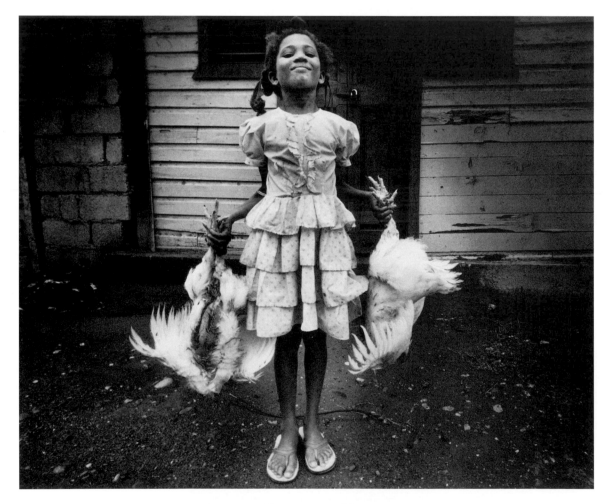

AWARD OF EXCELLENCE, NEWSPAPER
Yunghi Kim, The Boston Globe
A girl proudly displays her family's dinner in Tomayo, the Dominican Republic.

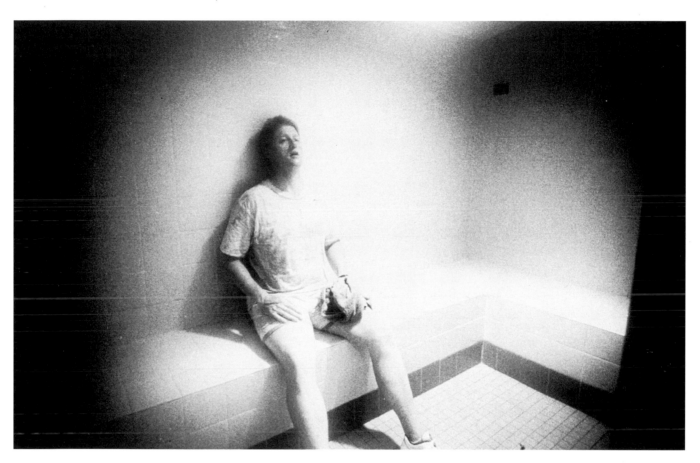

1ST PLACE, MAGAZINE
P. F. Bentley, Time
The afternoon before giving his nomination-acceptance speech,
presidential candidate Bill Clinton rests briefly in a hotel steam room to soothe and moisturize his ragged vocal chords.

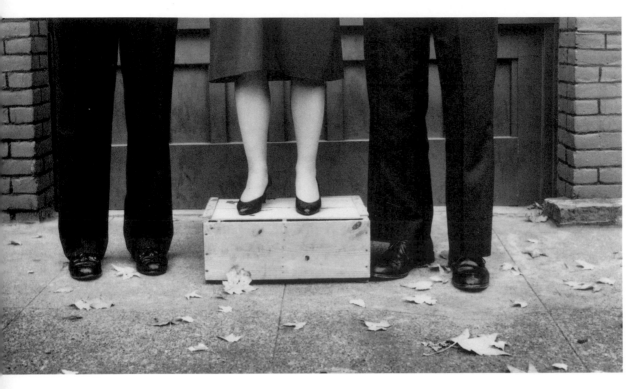

2ND PLACE, NEWSPAPER
Betty Udesen, The Seattle Times
Senatorial candidate Patty Murray campaigns atop a crate, flanked by Seattle Mayor Norm Rice and U.S.
Sen. Bill Bradley, in front of Murray's campaign headquarters. Murray is 4-foot 11-inches tall.

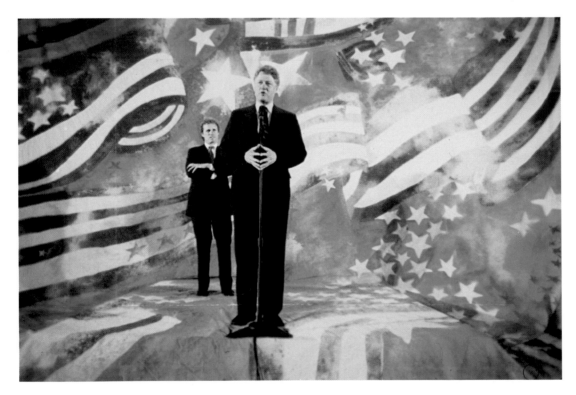

AWARD OF EXCELLENCE, NEWSPAPER
Steven Savoia, The Associated Press
Bill Clinton addresses a group in Boston as U.S. Rep. Joe Kennedy, D-Mass., looks on.

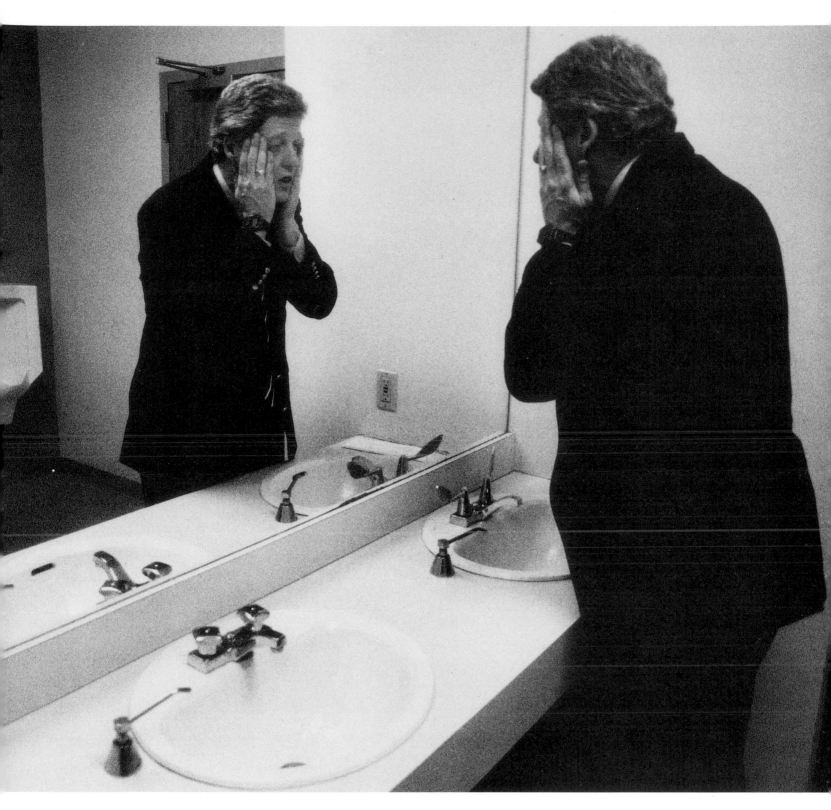

1ST PLACE, NEWSPAPER
Dan Habib, Impact Visuals for the Concord Monitor
A brutal New Hampshire primary campaign catches up with Bill Clinton in a Manchester restroom toward the end of a long day.

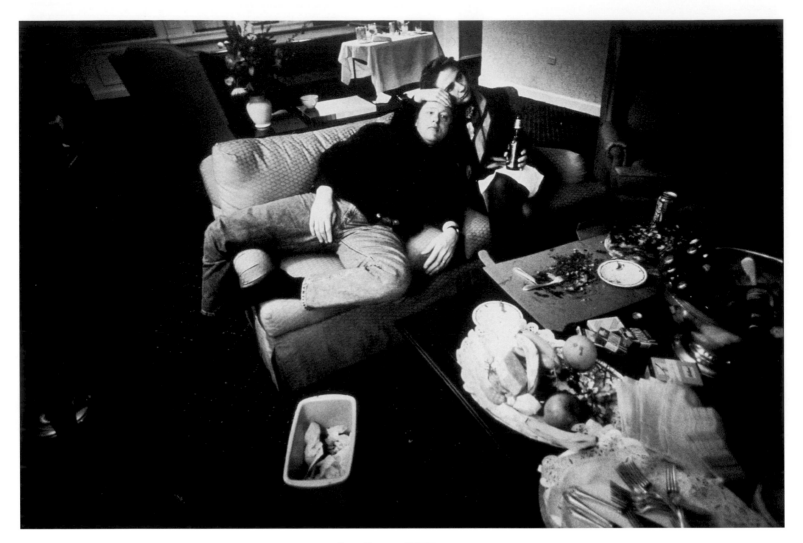

2ND PLACE, MAGAZINE
P. F. Bentley, Time
Bill and Hillary Clinton relax after a late-night pizza party in their hotel suite in Chicago.

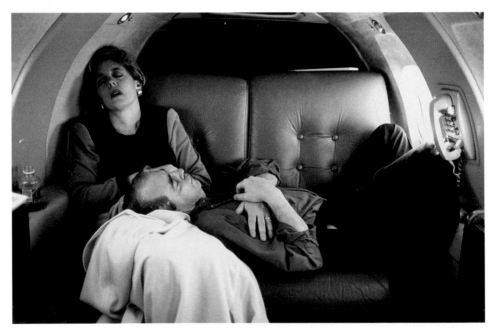

AWARD OF EXCELLENCE, MAGAZINE
Rick Friedman, Black Star
Paul Tsongas and his wife, Niki, sleep after a campaign stop in Georgia.

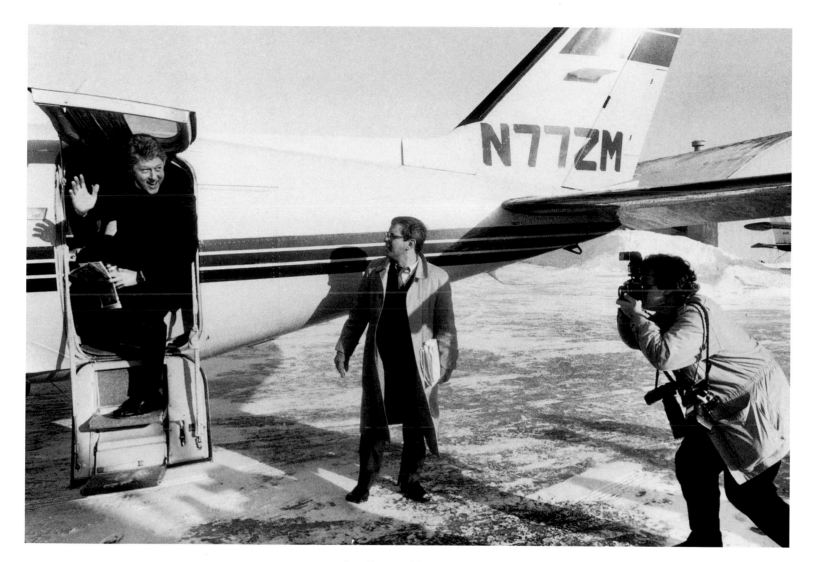

3RD PLACE, NEWSPAPER
Dan Habib, Impact Visuals for the Concord Monitor
At the request of several photographers, Bill Clinton stands at the door of a plane and waves, although only photographers and campaign staffers were in sight.

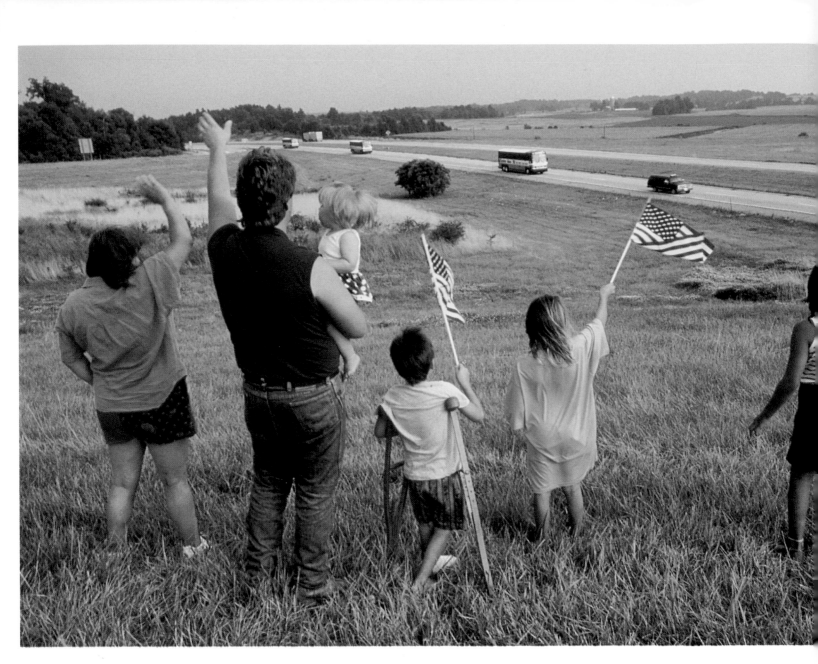

THIRD PLACE, MAGAZINE
Tomas Muscionico, Contact Press Images for Time
Clinton-Gore supporters wave to the campaign bus as it travels to Centralia, Ill., in July 1992.

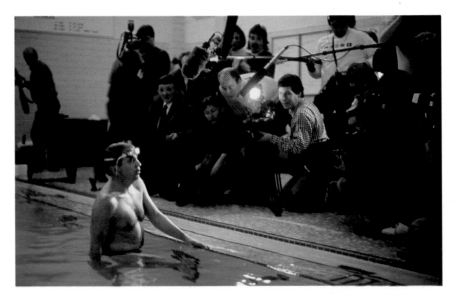

AWARD OF EXCELLENCE, MAGAZINE
David Burnett, Contact Press Images
Presidential candidate Paul Tsongas takes a media dip in February, 1992.

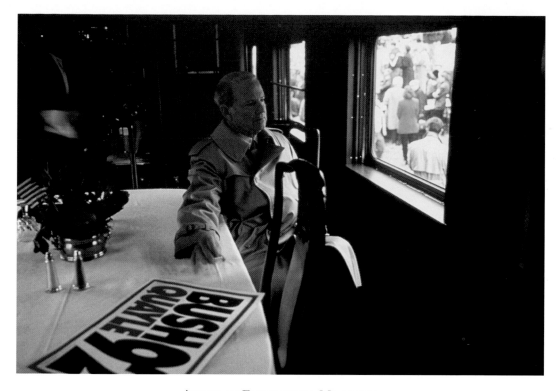

AWARD OF EXCELLENCE, MAGAZINE
Dirck Halstead, Time
James Baker, campaign manager for President Bush, takes a break after reading polls listing his
candidate as trailing three days before the election.

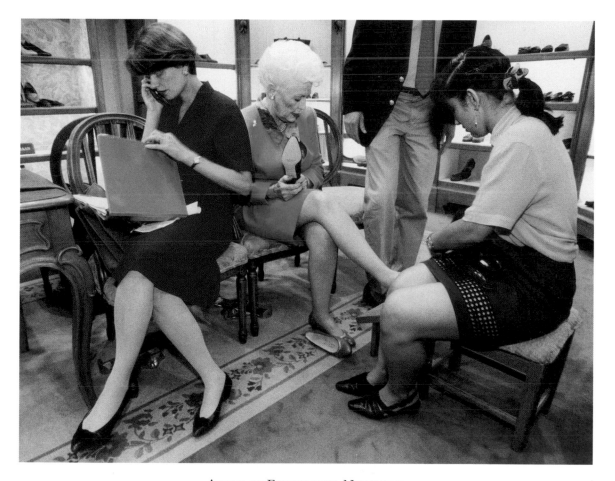

AWARD OF EXCELLENCE, NEWSPAPER
Erich Schlegel, The Dallas Morning News
Texas Gov. Ann Richards, in New York City for the Democratic
National Convention, takes a few minutes to try on shoes with the help of Sandra Casale,
while press aide Margaret Justus makes appointments on a cellular phone.

AWARD OF EXCELLENCE, MAGAZINE
P. F. Bentley, Time
Bill Clinton meets with the Rev. Jesse Jackson in the candidate's
suite overlooking Kansas City, Mo.

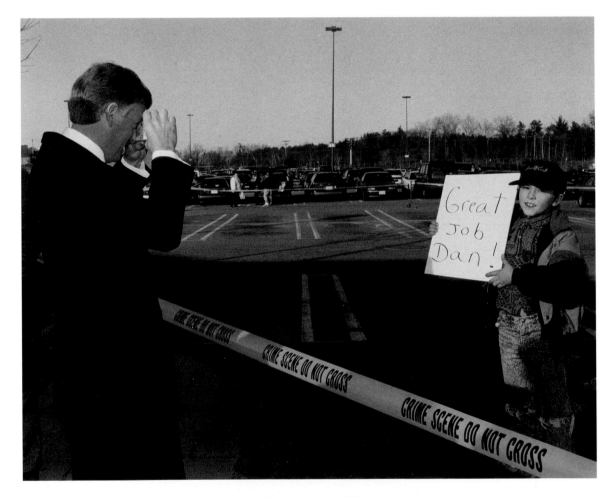

AWARD OF EXCELLENCE, NEWSPAPER
Jim Bourg, Reuters News Pictures
Vice President Dan Quayle snaps a picture of a young fan in Nashua, N.H., in January 1992.

1ST PLACE, MAGAZINE
Linda Troeller, Agence Vu for Spa Finders Magazine
Kimberly Fairbank enjoys a mineral-water spa at Calistoga Hot Springs, Calif.

3RD PLACE, MAGAZINE
Thomas Dallal, Freelance
A Polish artisan ambles home through Krakow Square at the end of his workday.

George Steinmetz, Freelance
Academics in Georgia, a former Soviet republic, make seemingly endless rounds of banquets.

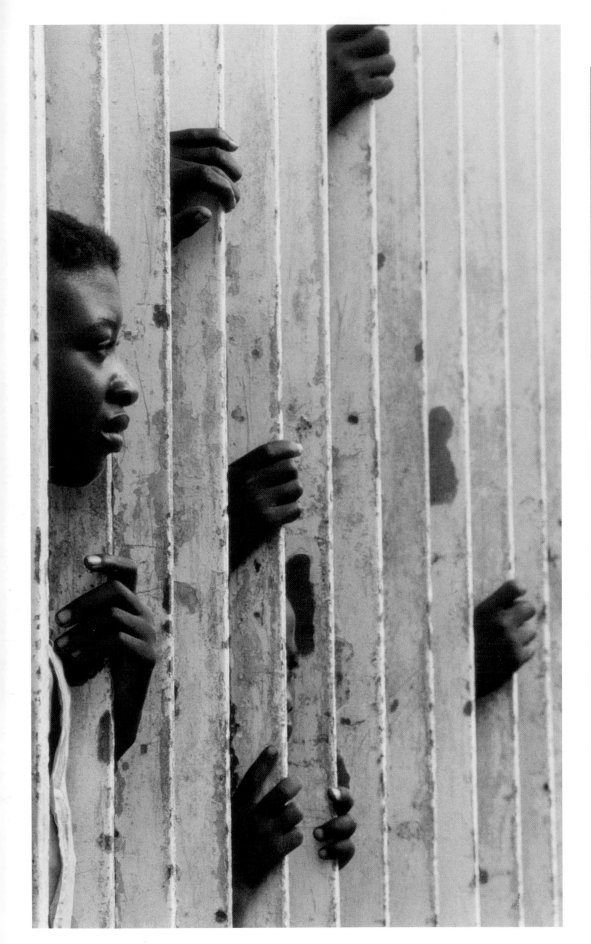

Robert Gauthier, San Diego Union-Tribune
Somalians eager for work peek through a large gate outside the Mogadishu port.

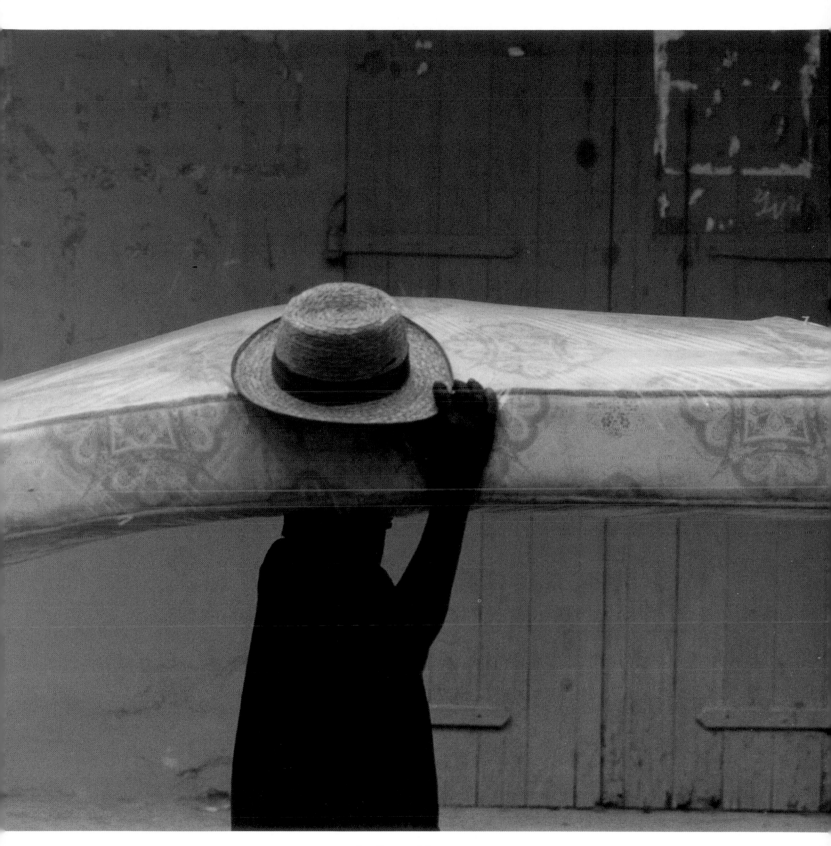

Greg Lovett, The Palm Beach (Fla.) Post
A Haitian man balances a mattress on his head as he walks in Port-de-Paix, Haiti.

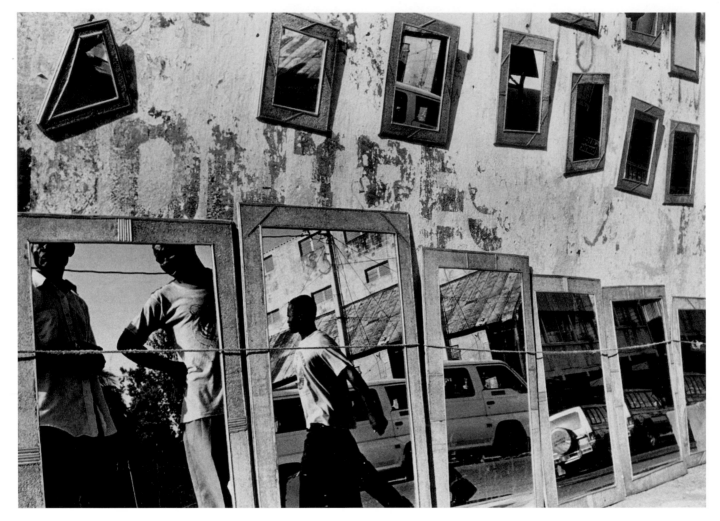

3RD PLACE, NEWSPAPER
Michael S. Wirtz, The Philadelphia Inquirer
A sidewalk vendor's mirrors reflect street life in downtown Port-au-Prince, Haiti.

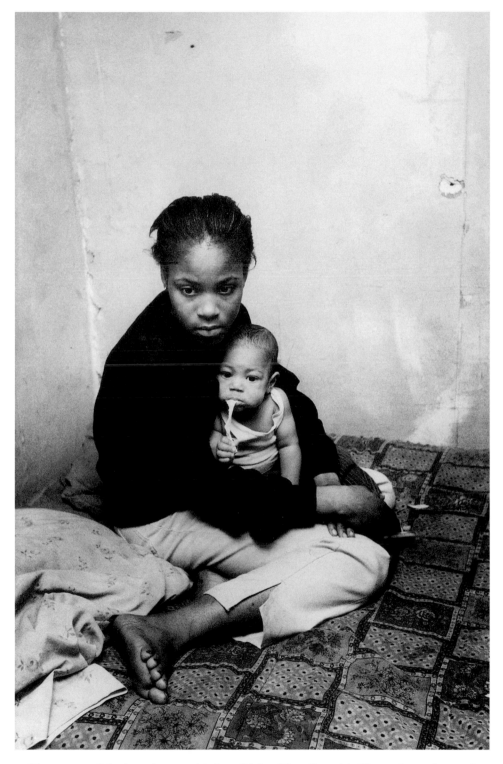

Eleanor was 14 when she gave birth to Livita. They live with Eleanor's mother and siblings in a Chicago tenement. 1985

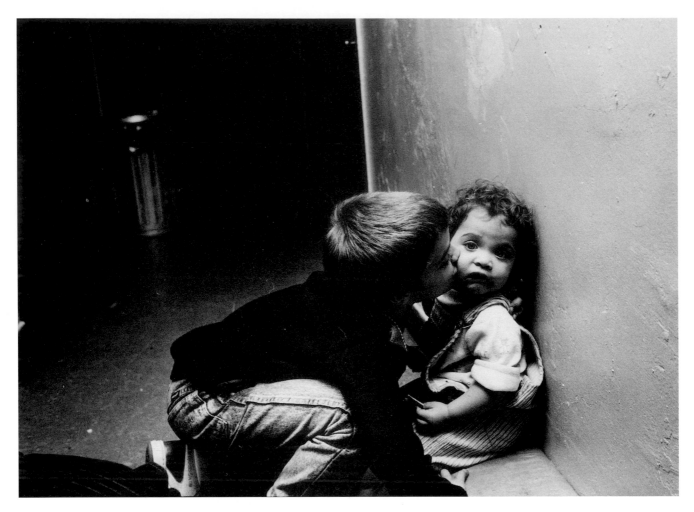

Max kisses his sister, Vanessa, outside their room in the Holland Hotel in New York City. Max, like many poor youngsters, provides child care for his sister. 1987

Outside the American Dream

Photographer Stephen Shames chronicled the lives of young Americans, many living in poverty or otherwise on the fringes of society. Many of his photos appeared in the book *Outside the Dream: Child Poverty in America*, published by Aperture & the Children's Defense Fund.

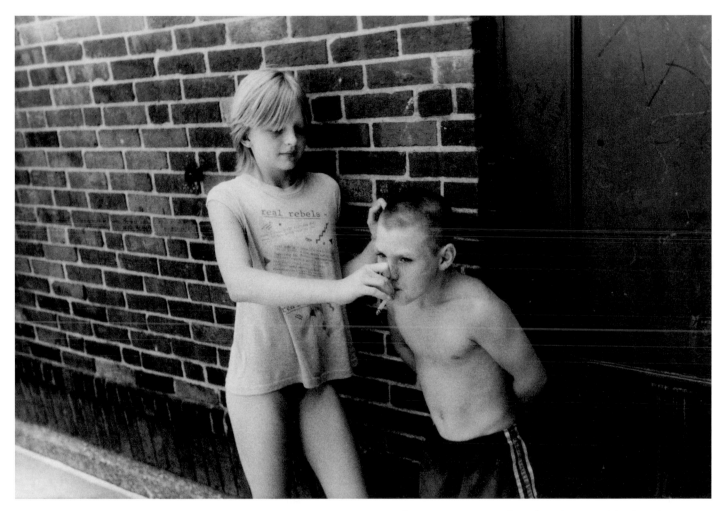

A girl offers a cigarette to a boy at a community swimming pool in Lower Price Hill, a close-knit neighborhood of poor whites in Cincinnati. 1985

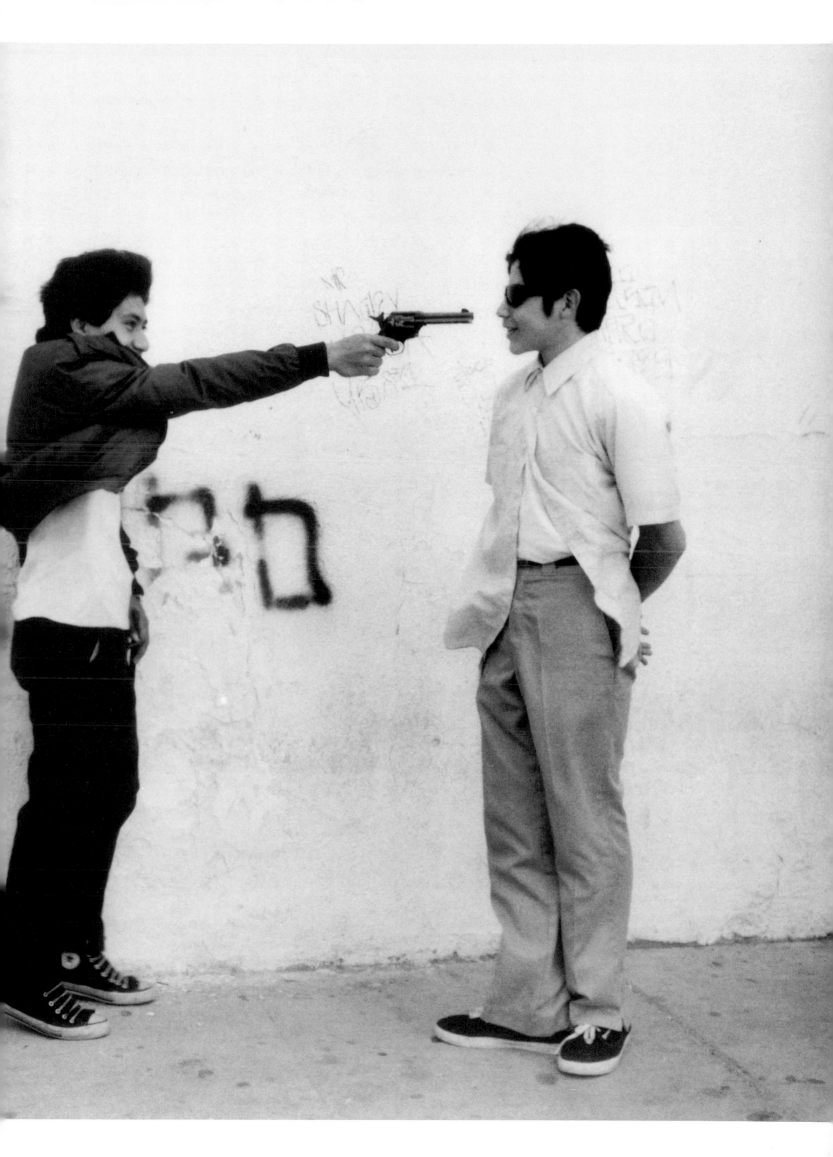

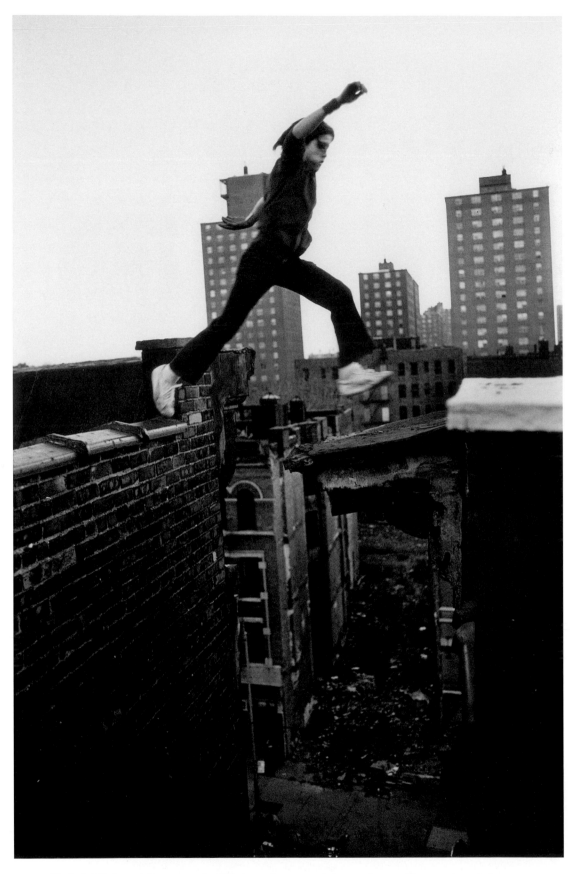

Rafael, 13, jumps from one building to the next, eight stories up. Danger is an inherent part of life in this Bronx ghetto. 1977

Previous page:
A boy in Orange County, Calif., carries
a real, though unloaded, gun to school
every day. 1984

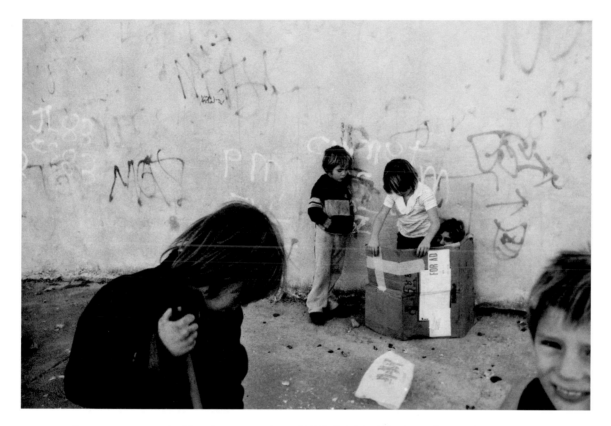

A street scene in the Kensington section of Philadelphia. The loss of manufacturing jobs
devastated this blue-collar community. 1985

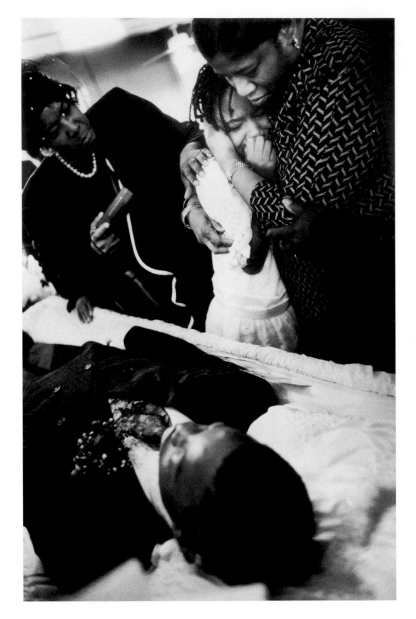

A sister and relatives of 12-year-old Kevin Heath grieve at his funeral in North Philadelphia. Kevin was shot while on a roof with his friends. Says the minister, "Young black males are an endangered species. They ought to be in the National Geographic."

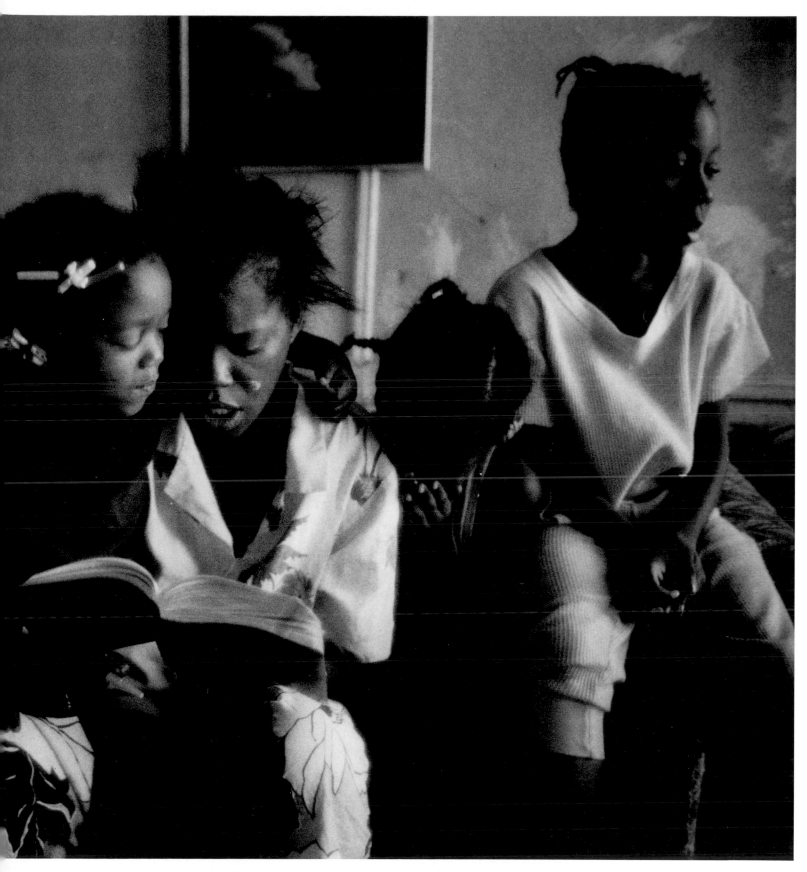

Toni reads the Bible to her children in Brooklyn. She fled an abusive husband with her six children, but it took her a year to find an affordable apartment. 1989

KODAK CRYSTAL EAGLE • *Stephen Shames, Matrix*

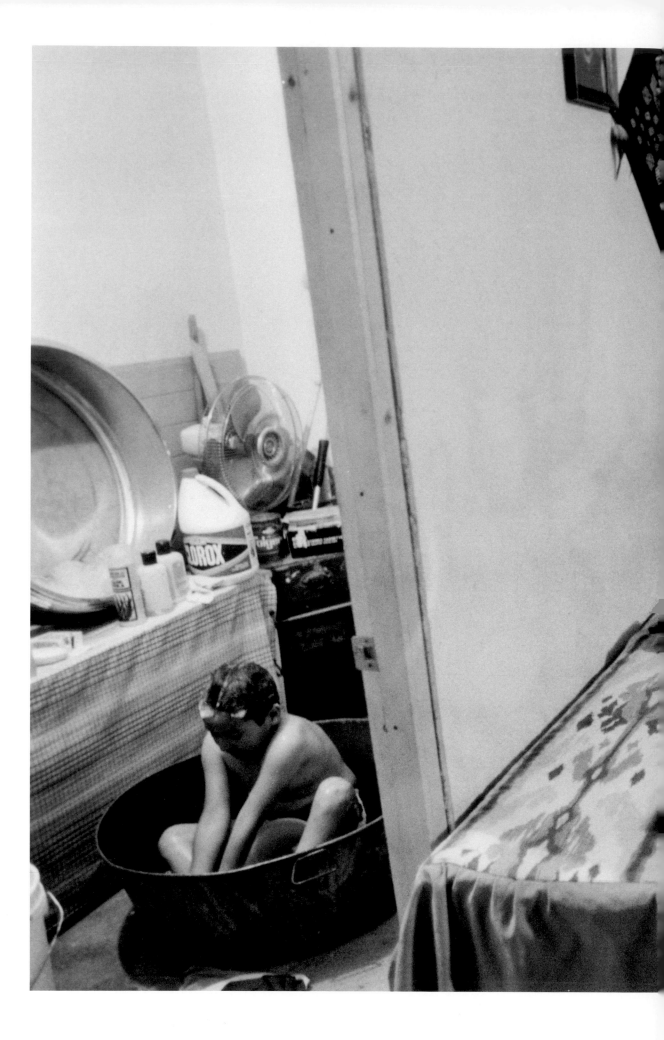

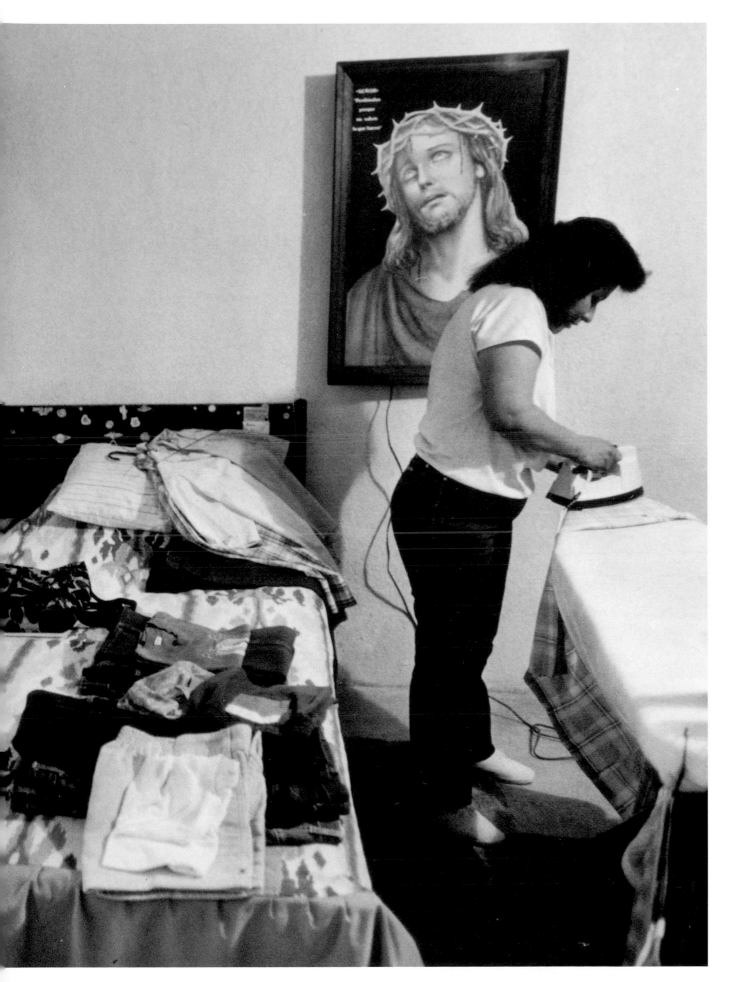

Juan and Sylvia purchased a suburban lot in El Paso, Texas, hoping to escape inner-city violence.
But the developer did not put in promised water and sewage lines, so water must be carried in for baths. 1988

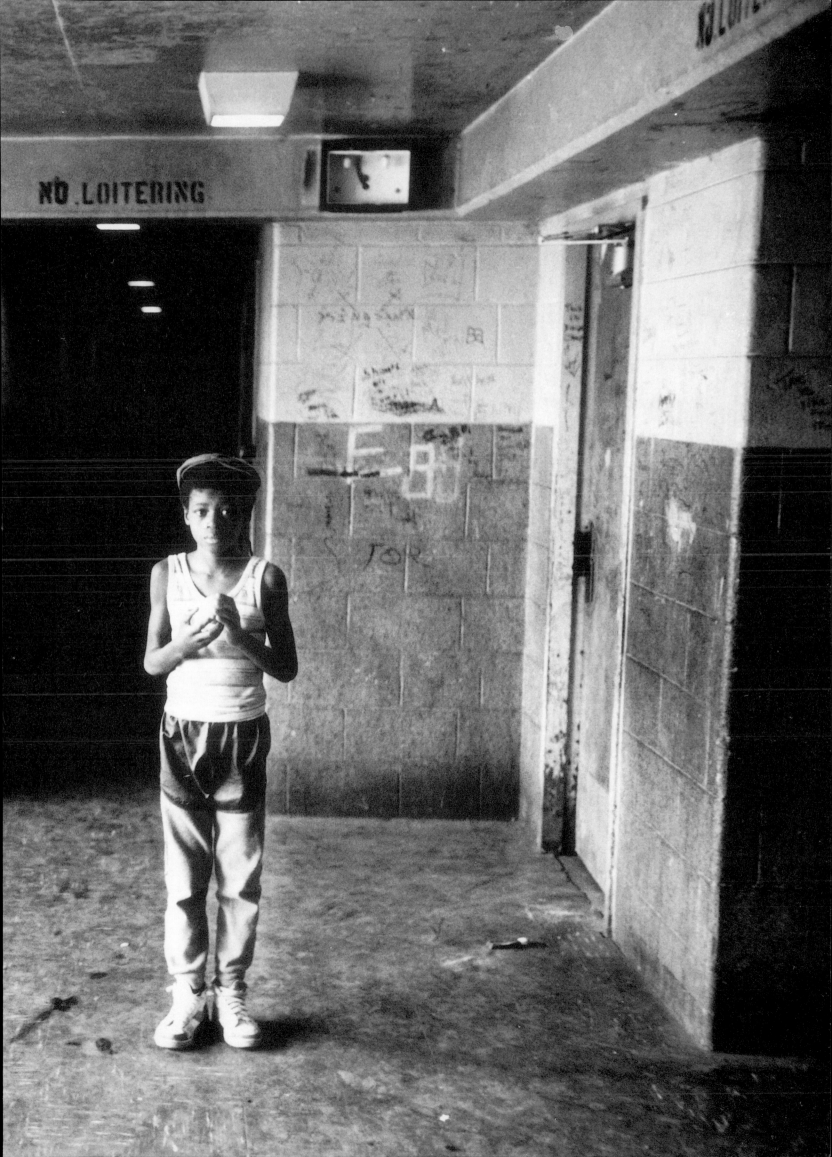

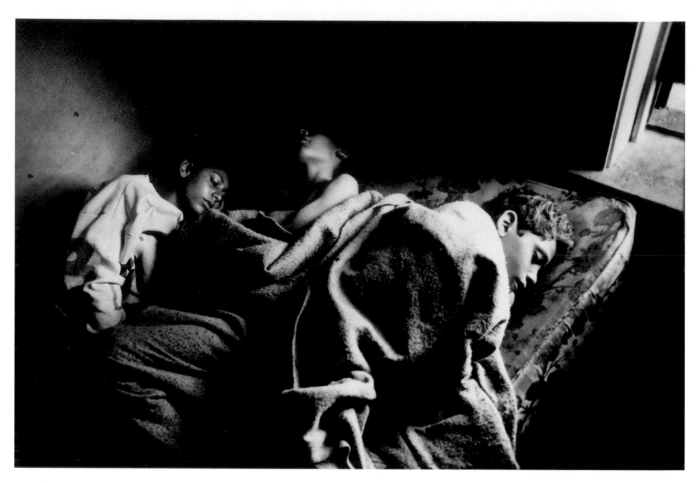

Three of Leopoldo and Iris' nine children sleep together. Leopoldo lost four fingers in an industrial accident. His disability and his inability to speak English make it difficult to find work in Chicago. 1985

Previous page:
Lafayette, 10, witnessed a girl being shot in this
hallway in the Henry Horner Projects. The high-rise
on Chicago's west side is overrun by rival gangs. 1985

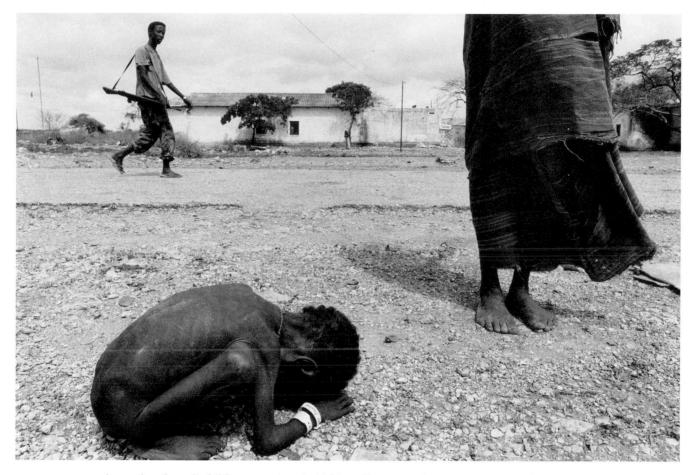

A starving Somali child, too weak to hold himself up, crouches on a street near his mother.

Somalia: War and Famine

Civil war in Somalia destroyed the country's crops and livestock, causing desperate famine. In July 1992, the United Nations voted to send relief supplies to the country, but those efforts were stymied by heavily armed clansmen in Mogadishu. The United States led a multinational military force to disarm the clansmen and ensure delivery of food to relief centers. Despite the effort, Somalis starved to death daily.

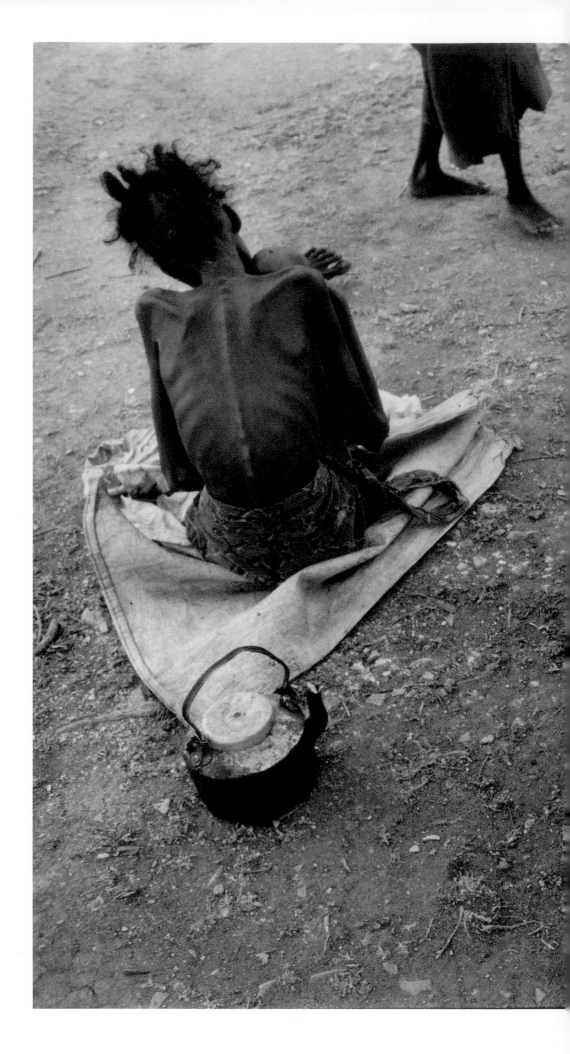

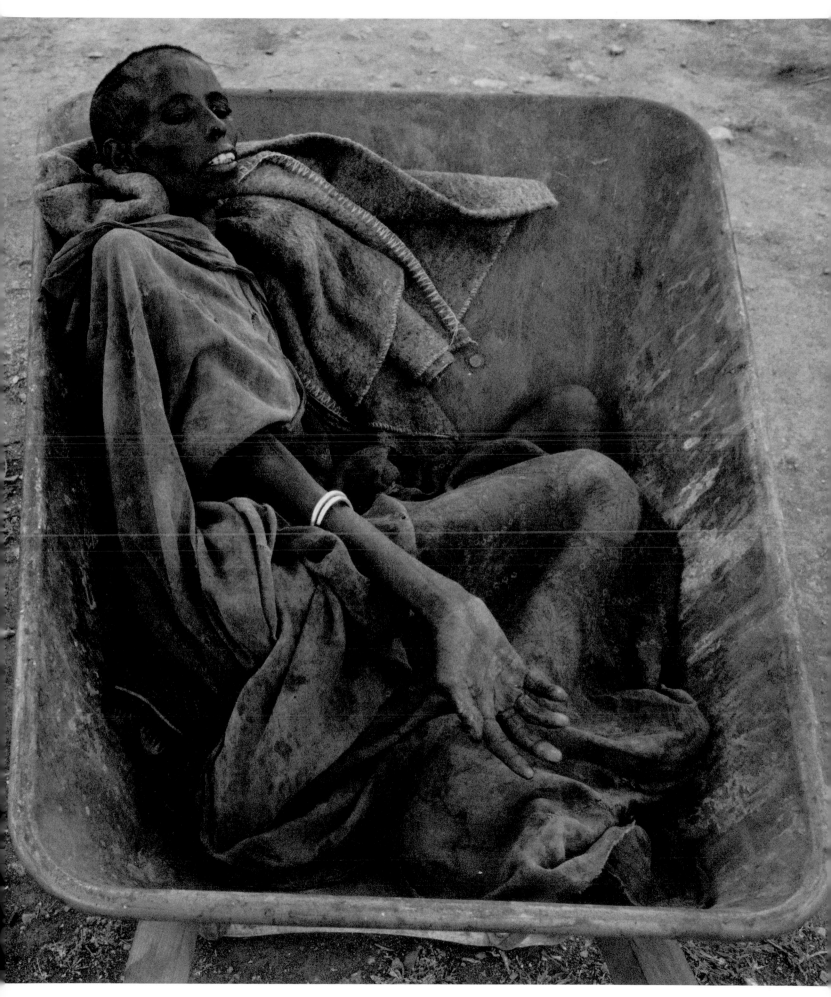

A woman waits for food. She is transported in a wheelbarrow because she is too weak to walk.

CANON PHOTO ESSAY • *James Nachtwey, Magnum*

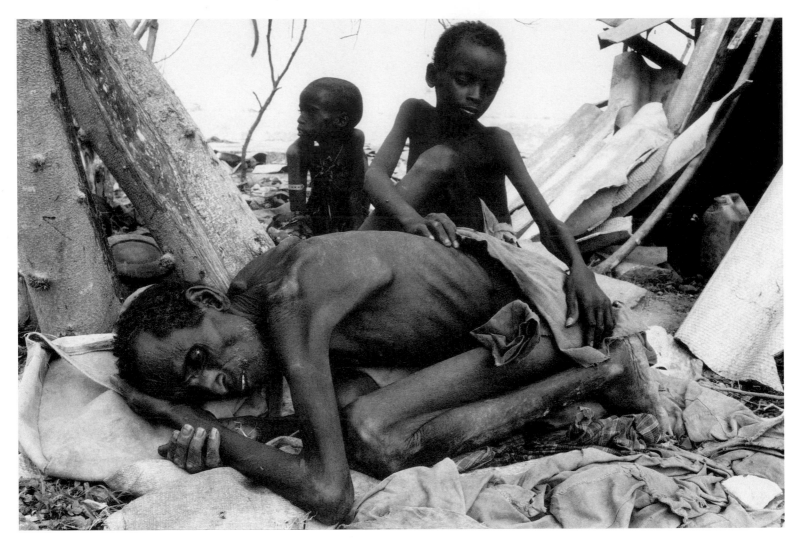

A boy tries to cover his dying father with a scrap of cloth.

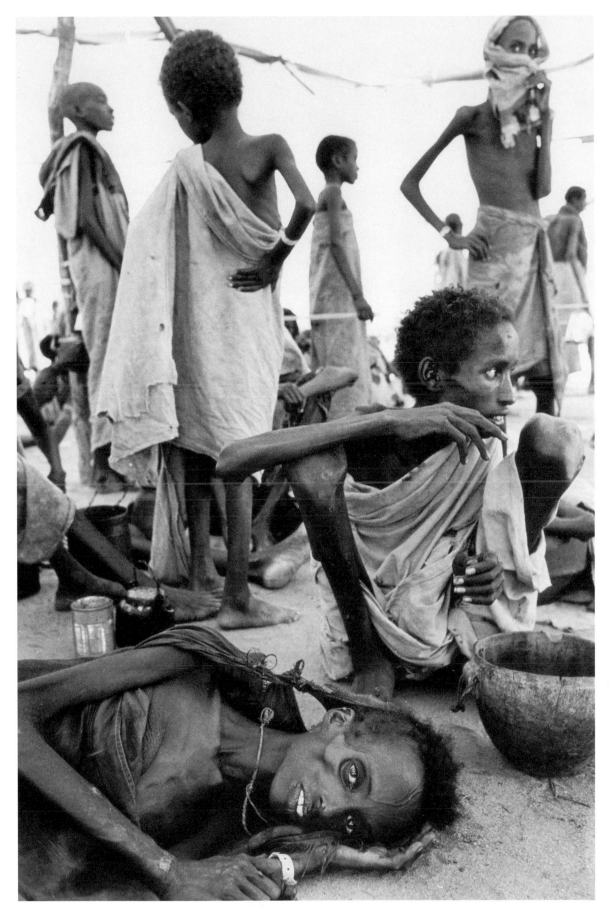

People wait to be fed at a relief center.

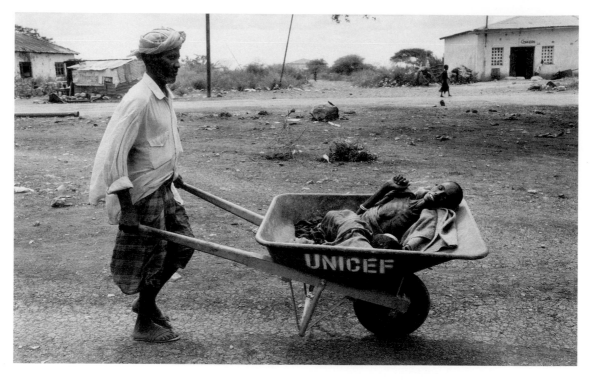

A woman is carried from a hospital back to a feeding center.

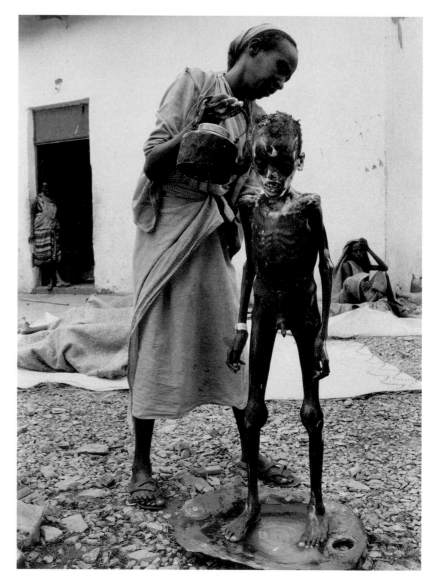

A Somali volunteer washes children at a feeding center.

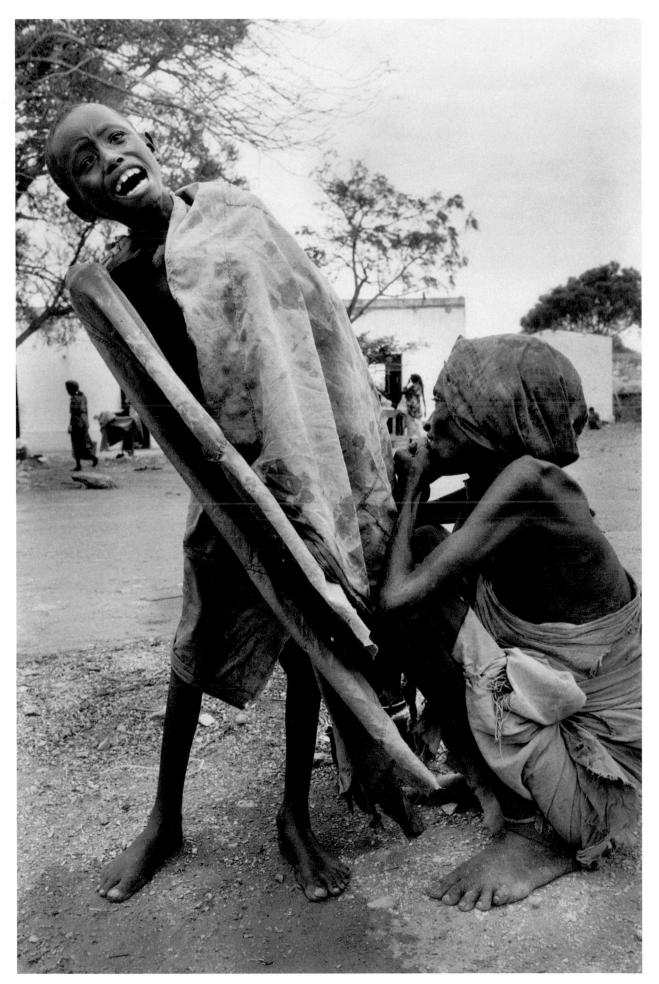

A starving child cries out in pain, as his mother sits helplessly nearby.

CANON PHOTO ESSAY • *James Nachtwey, Magnum*

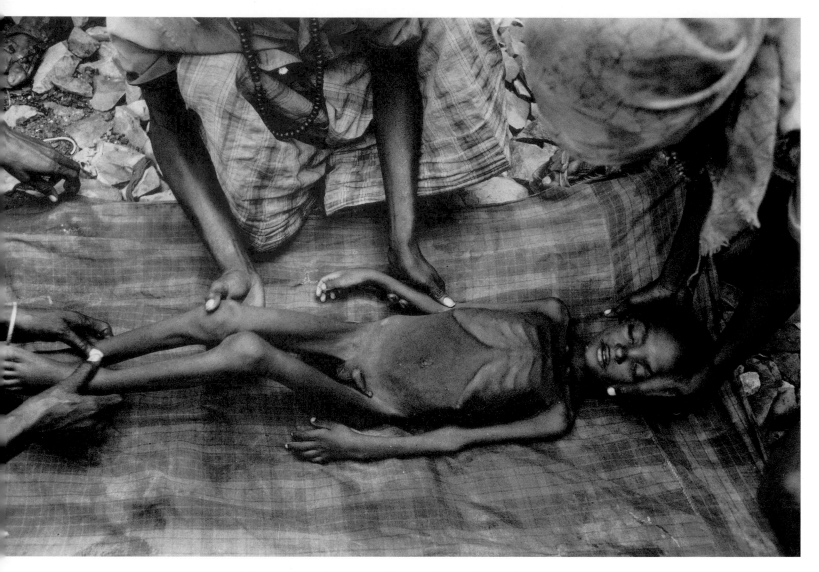

A famine victim is prepared for burial according to Somali custom.

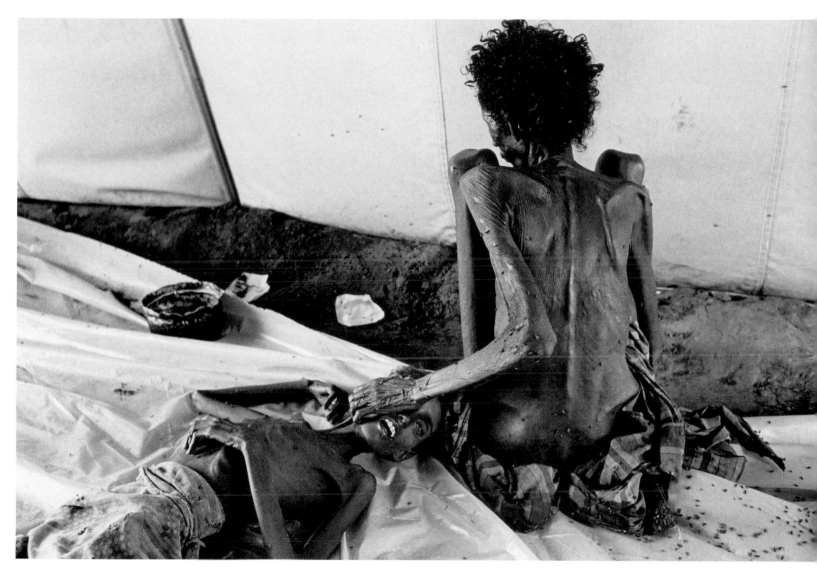

A woman touches the face of a boy who just died.

CANON PHOTO ESSAY • *James Nachtwey, Magnum*

A famine victim is passed on the road by men taking camels to the market.

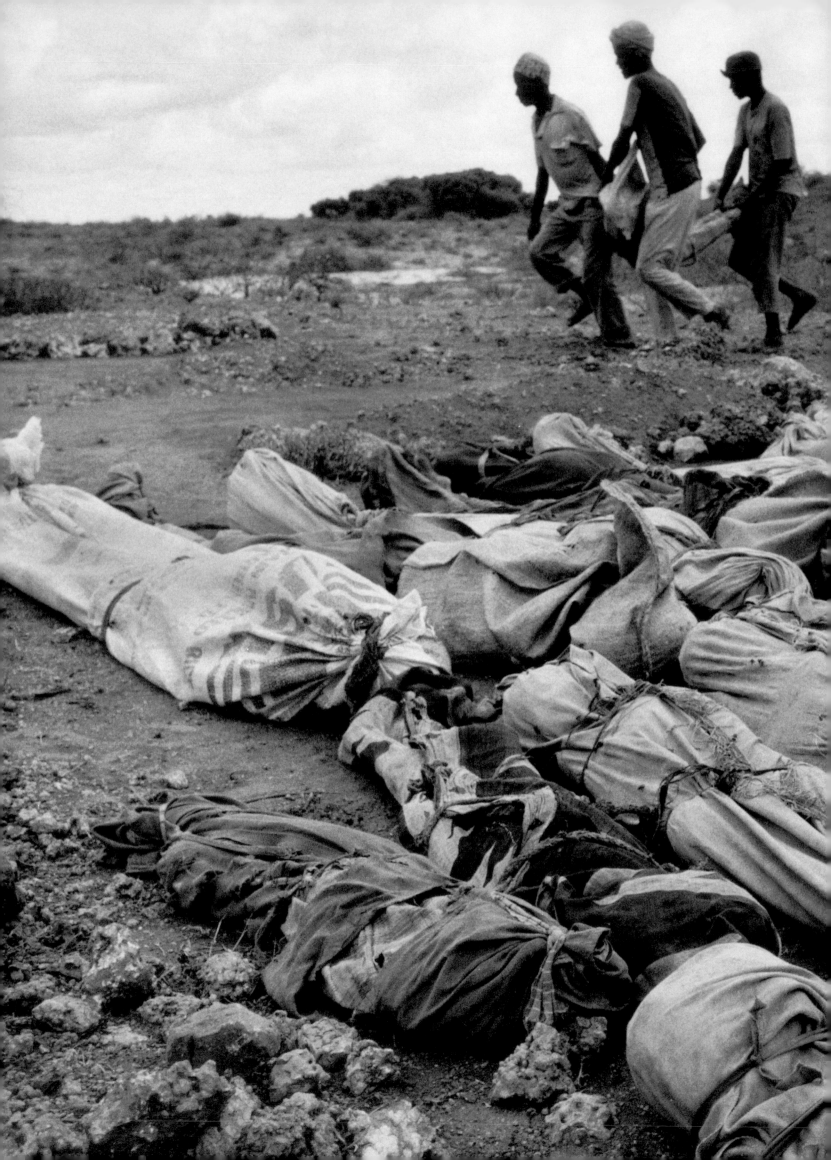

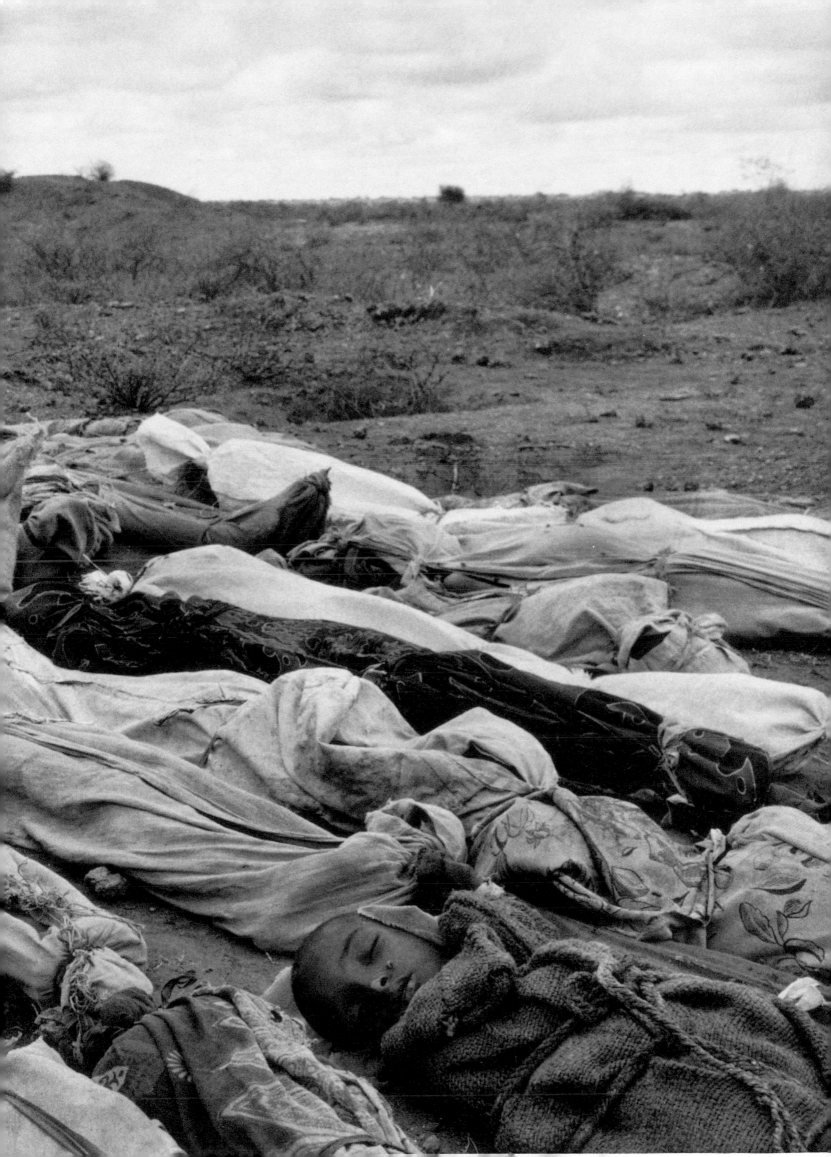

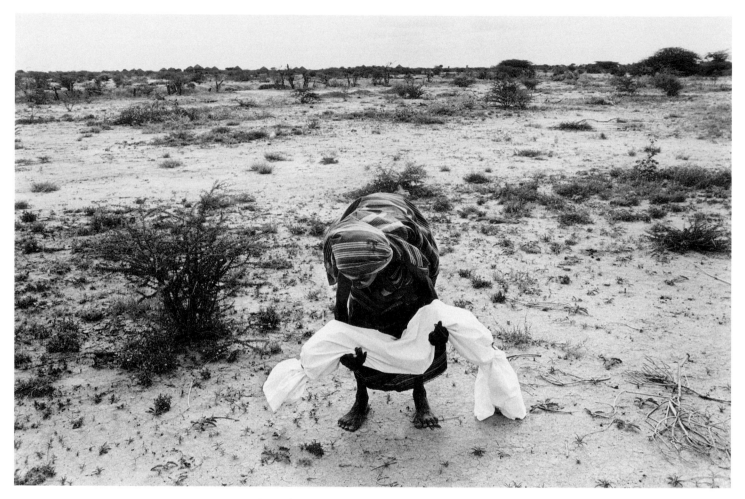

A mother carries her dead child to a grave.

Previous page:
Bodies await burial.

CANON PHOTO ESSAY • *James Nachtwey, Magnum*

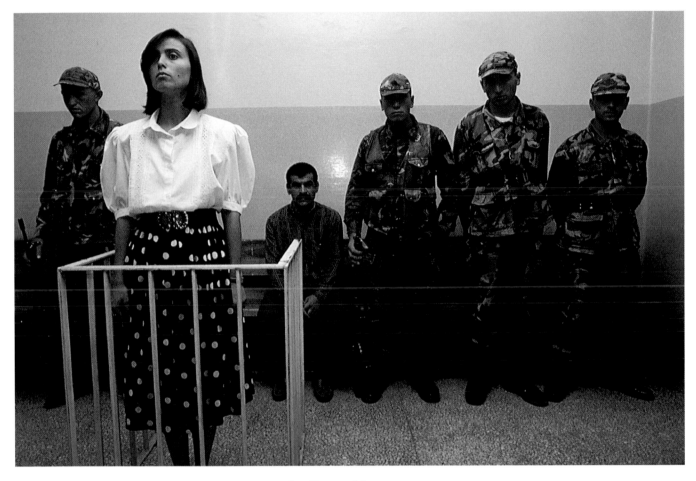

1ST PLACE, MAGAZINE
Ed Kashi, National Geographic Magazine
In a terrorist court in Diyarbakir, Turkey, Yildiz Alpodogan denies charges of belonging to the violently separatist Kurdistan Worker's Party. She was convicted and sentenced to 12 and a half years in prison.

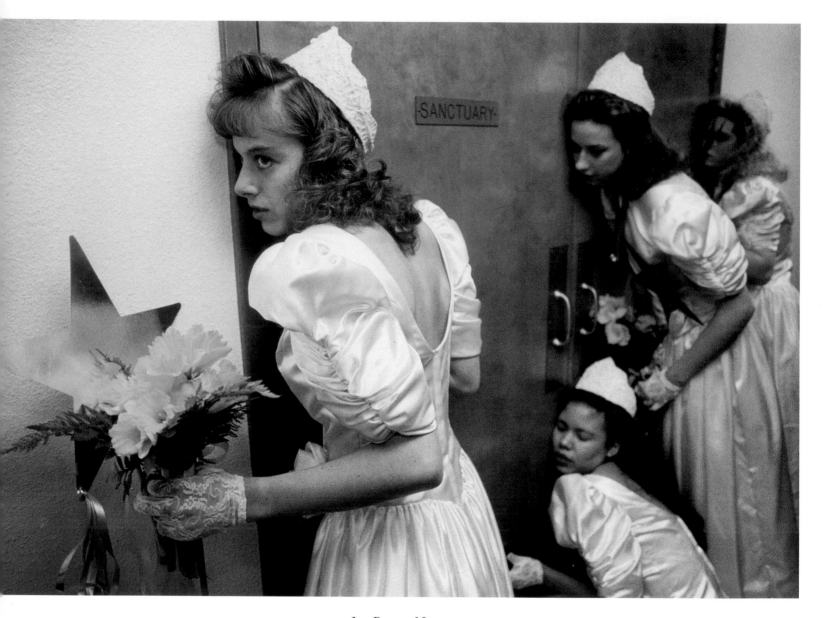

1ST PLACE, NEWSPAPER
Steven G. Smith, Pierce County (Wash.) Herald
Contestants for Daffodil Queen in Tacoma, Wash., eavesdrop as judges interview another competitor behind closed doors. From left are
Janelle Williams, Leigh Gubatayoa, Chelan Van Eaton and Mona Ostle.

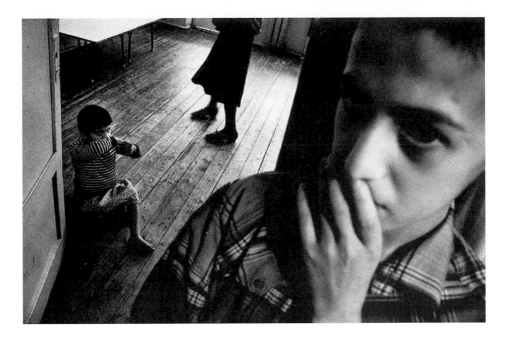

2ND PLACE, MAGAZINE
James Nubile, JB Pictures Ltd.
The Sarai Internat is a home for handicapped children in Sumgait, Azerbaijan. The
children often are abandoned by parents who cannot face caring for them.

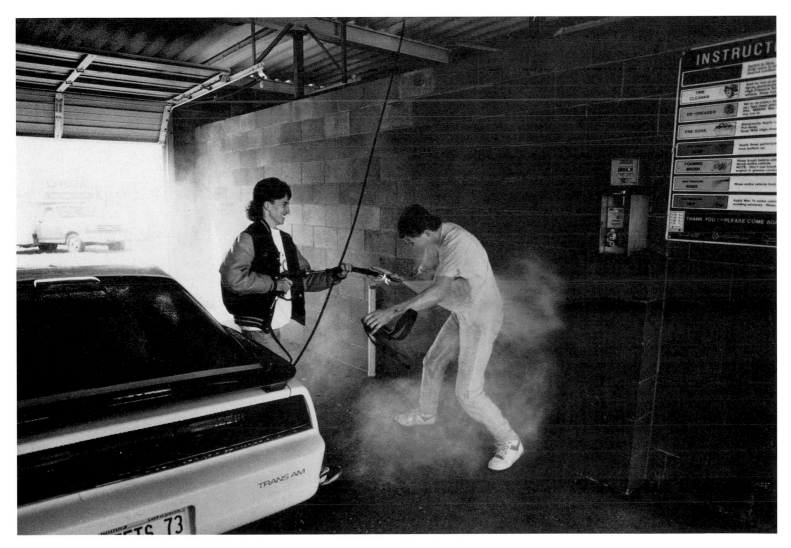

2ND PLACE, NEWSPAPER
Fred Zwicky, Peoria (Ill.) Journal Star
AIDS patient John Keets (left) thwarts a surprise attack from friend Paxton Wefenstette at a car wash, a meeting place in Canton, Ill.

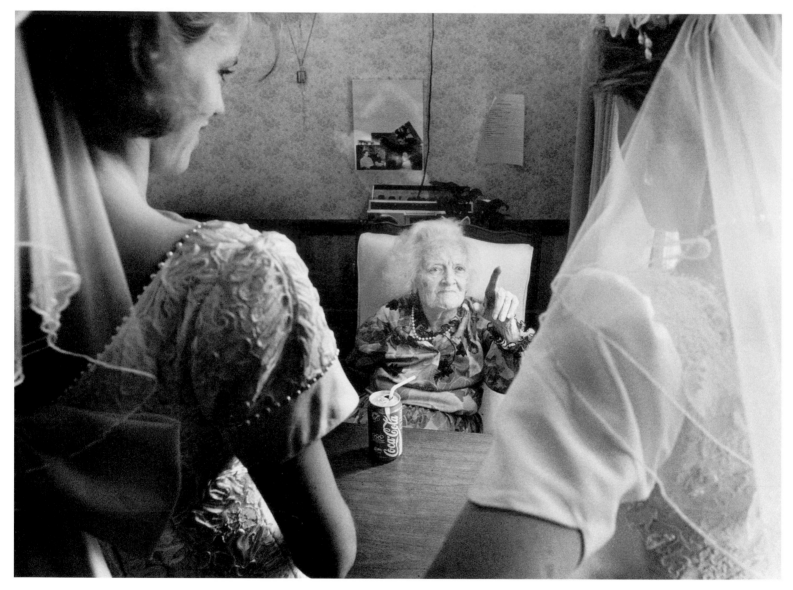

3RD PLACE, NEWSPAPER
Nancy Andrews, The Washington Post
Michelle and Crissie McKeever of Montgomery County, Md., model their wedding gowns for their grandmother, Winifred Bergquist.
The siblings were celebrating a double wedding later in the week, but their grandmother was not well enough to attend.

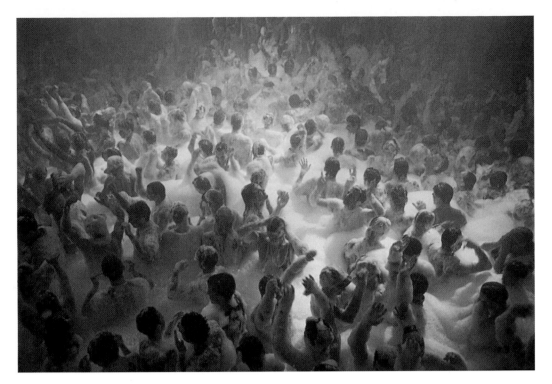

AWARD OF EXCELLENCE, MAGAZINE
David Alan Harvey, National Geographic Magazine
A flood of suds at Amnesia, a popular disco on the island of Ibiza, 80 miles east of Spain.

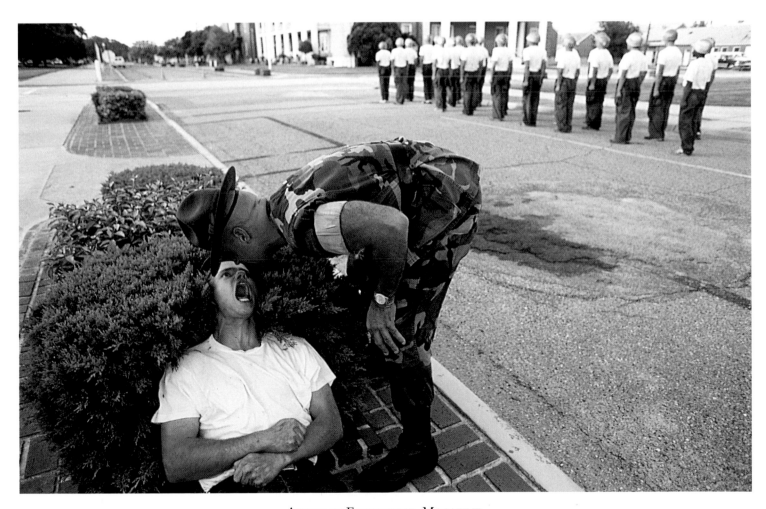

AWARD OF EXCELLENCE, MAGAZINE
Joel Sartore, National Geographic Magazine
After making a mistake during a marching drill, an errant "poopie" responds, "Yes, Sir! Comfortable, Sir!" to his drill instructor's
sarcastic query during basic training at Pensacola Naval Air Station in Florida.

NEWSPAPER/MAGAZINE FEATURE PICTURE

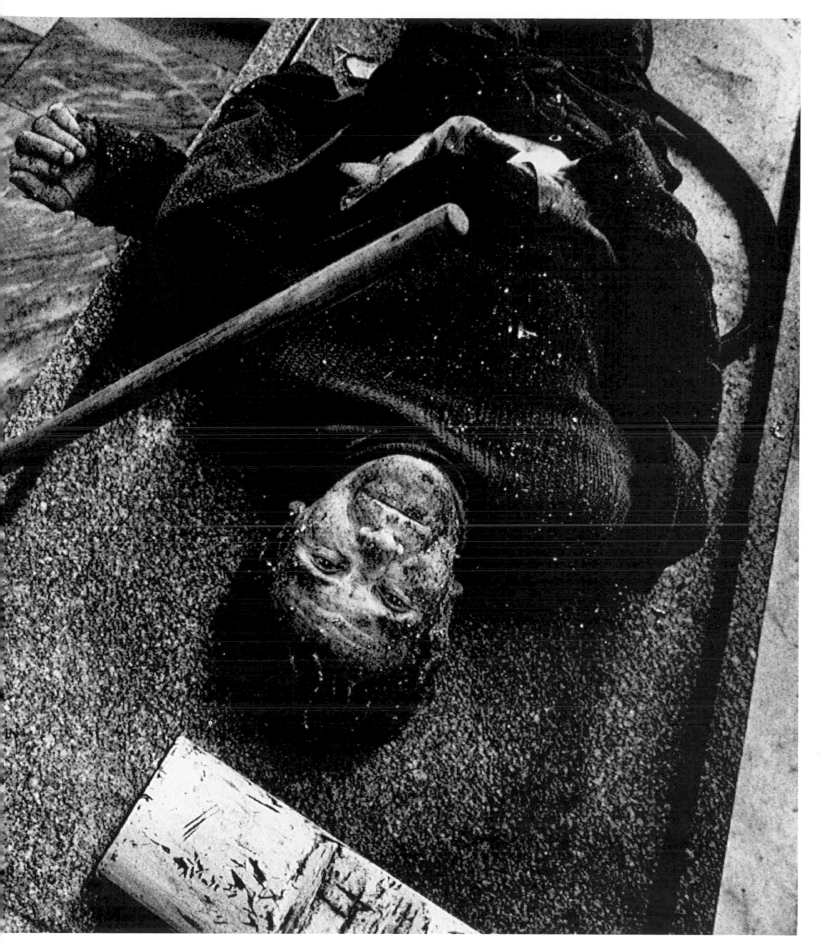

AWARD OF EXCELLENCE, MAGAZINE
James Nubile, JB Pictures
The body of a homeless man who froze to death lies in a Moscow morgue.

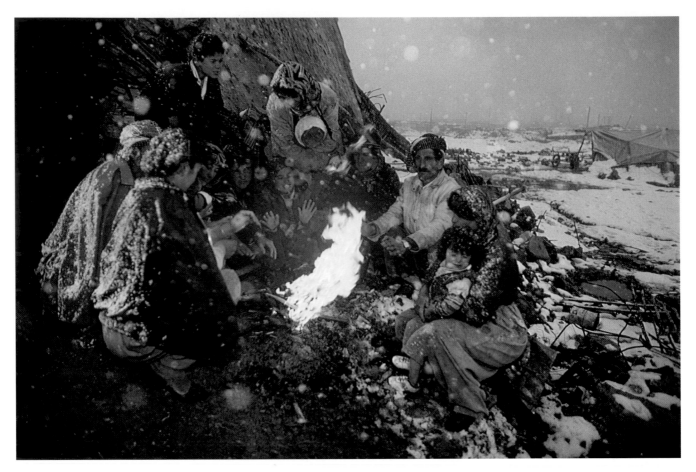

AWARD OF EXCELLENCE, MAGAZINE
Ed Kashi, National Geographic Magazine
After fleeing war-torn Kirkuk, Iraq, a Kurdish family clings to life in the ruins of Panjwin,
a town that was destroyed by Iraqi forces.

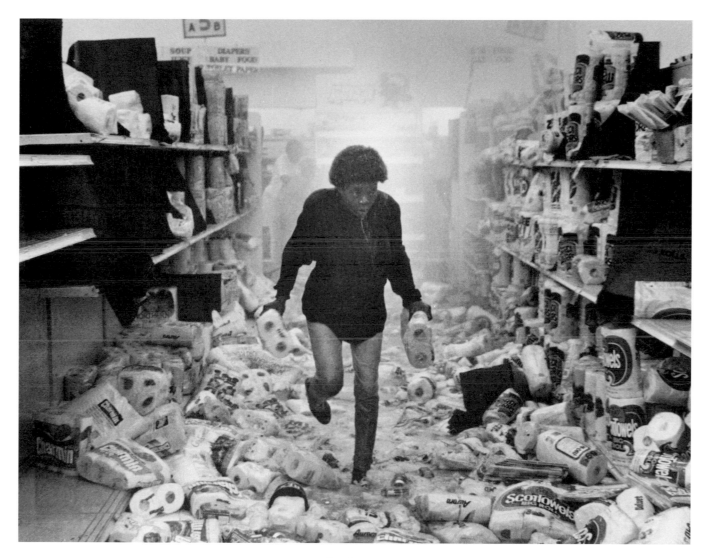

1ST PLACE
Dayna Smith, The Washington Post
Drenched by a store's sprinkler system, a looter makes off with wet toilet paper during a Los Angeles riot.

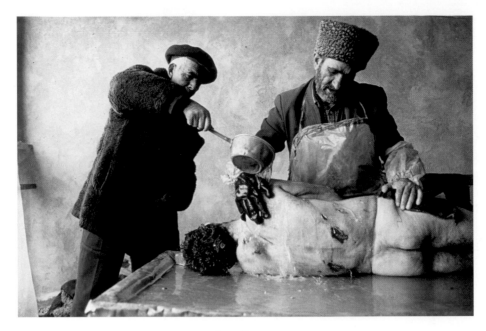

2ND PLACE
David Brauchli for Agence France Presse
Two Azeri men wash the body of a Khojali refugee who was killed while fleeing fighting in Nagorno Karabakh.

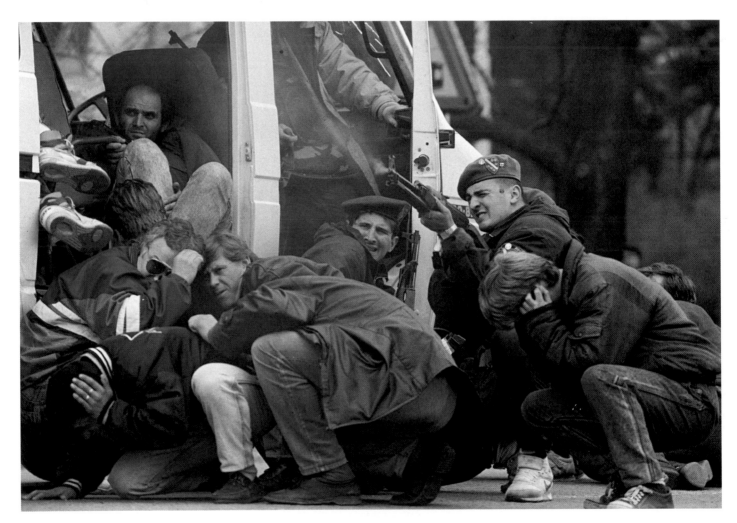

AWARD OF EXCELLENCE
Mike Persson for Agence France Presse
A Bosnian soldier returns fire at Serbian snipers during the first peace demonstration by the people of Sarajevo.

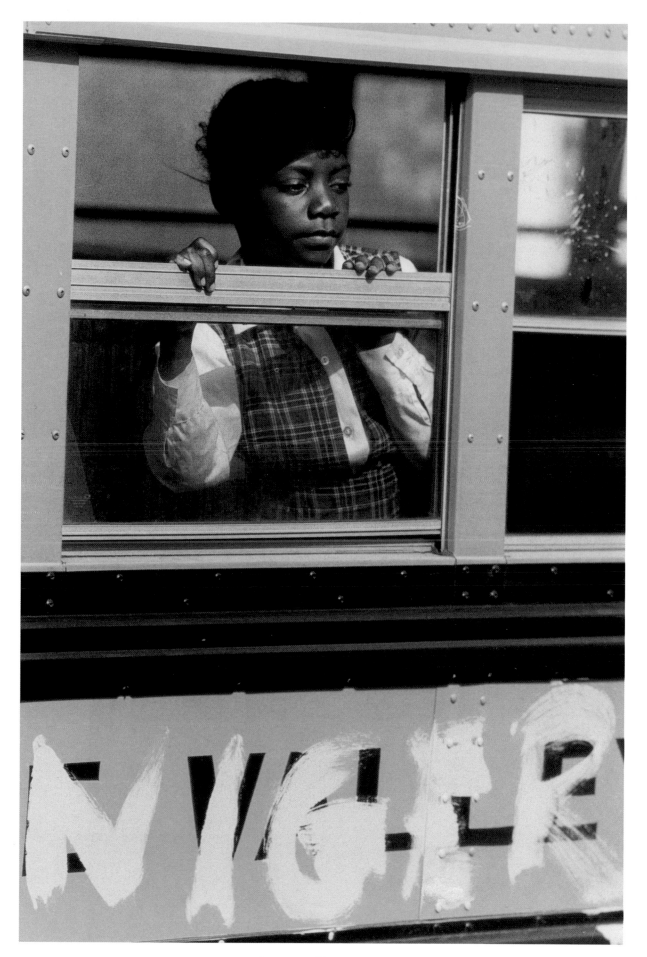

AWARD OF EXCELLENCE
Craig Orosz, The Trentonian (NJ)
Tiera Mason, a first-grader at Incarnation School in Ewing Township, N.J., watches as police officers arrest a
man for painting a racial slur on the bus as it drove through Trenton.

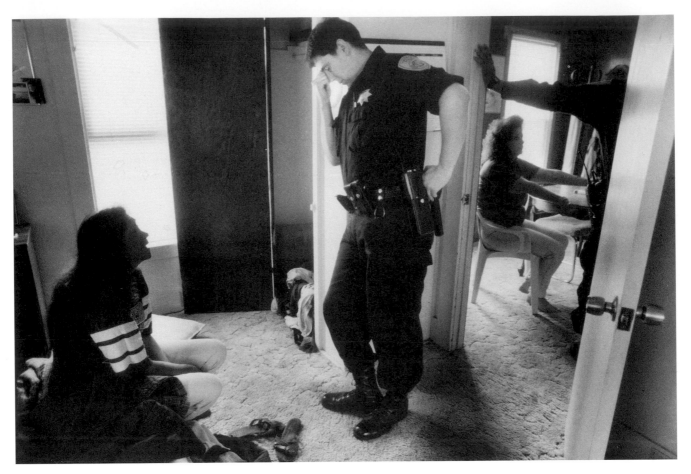

3RD PLACE
Mary F. Calvert, The Oakland (CA) Tribune
Hayward, Calif., police Officer John Lage listens to a drug suspect's story as Officer George Torres checks
for needle tracks on another suspect.

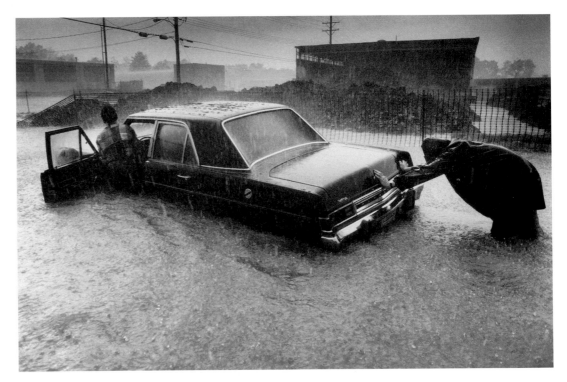

AWARD OF EXCELLENCE
Tom Marks, The Lexington (KY) Herald-Leader
Two men try in vain to push a stalled car from rapidly rising floodwaters in Lexington, Ky.

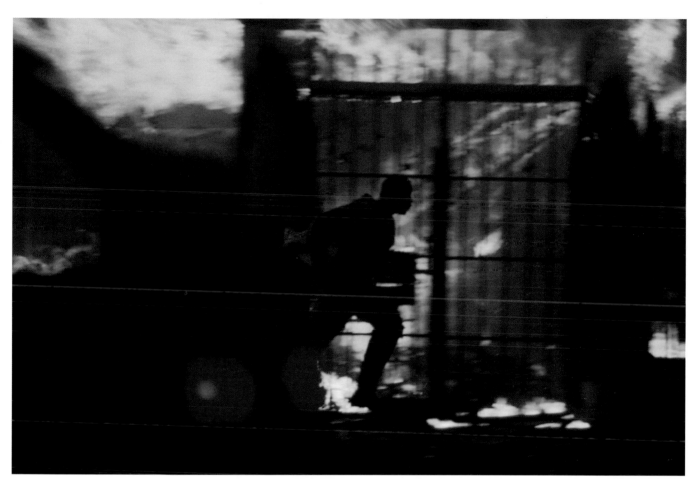

2ND PLACE
Ed Carreon for Life Magazine
In Los Angeles' south-central district, a looter runs from police past a burning liquor store during the first night of riots
spurred by the verdict in the trial of four police officers accused of beating motorist Rodney King.

(The 1ST PLACE winner in this category
can be seen on page 103)

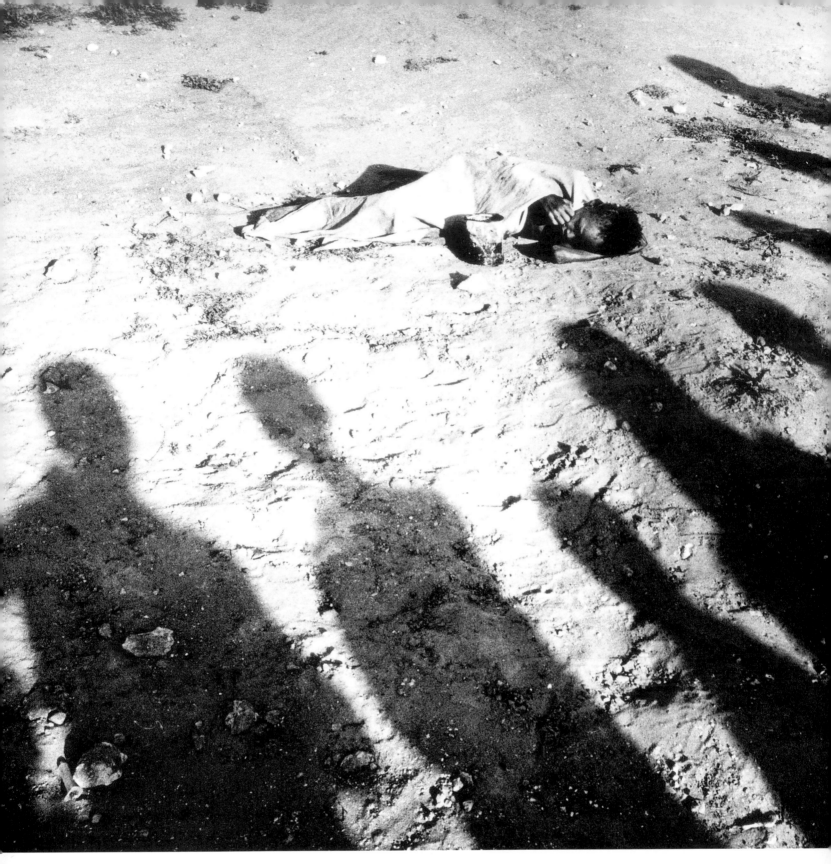

AWARD OF EXCELLENCE
Paul Lowe, Network Photographers
Watching a child die in Baidoa, Somalia.

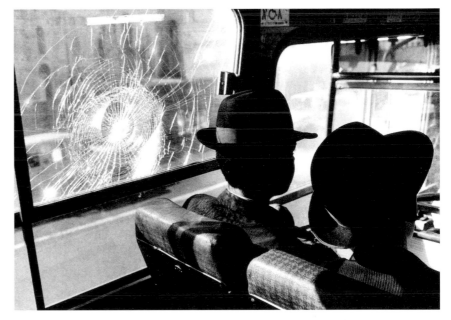

David H. Wells, Philadelphia Inquirer Sunday Magazine
Two Orthodox Jewish men ride on a bus in Jerusalem, sitting near a window
that had been shattered by a stone. This photo is from an essay on the
relationship between Arabs and Jews in Israel.

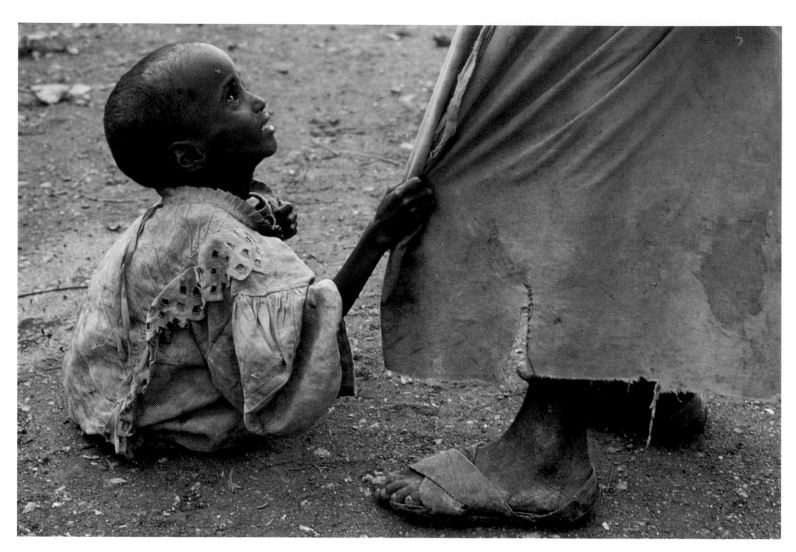

AWARD OF EXCELLENCE
Andrew Holbrooke, Black Star
A starving girl tugs at her brother's robe at a feeding station in Baidoa, Somalia.

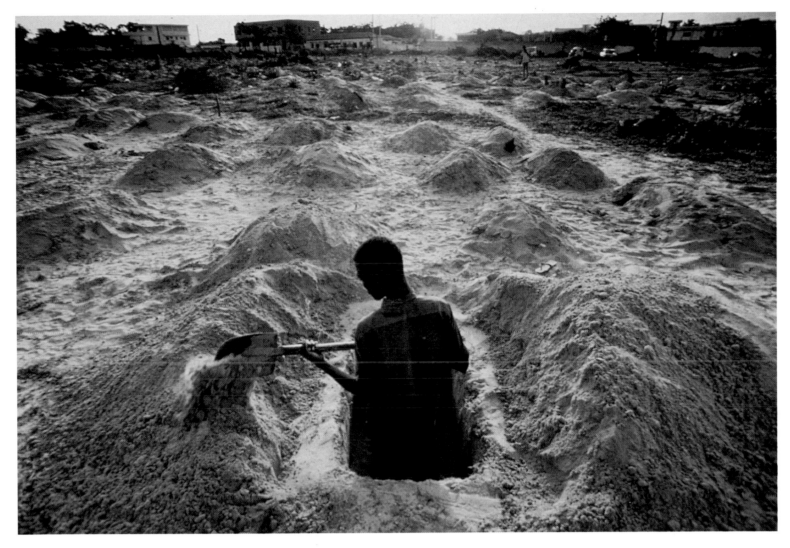

1ST PLACE
Howard Castleberry, The Houston Chronicle
Hussein Fiiffiddo digs a grave for his daughter in what once was a Mogadishu botanical garden.

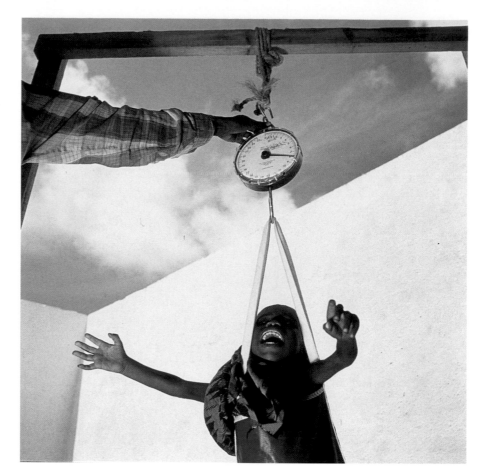

AWARD OF EXCELLENCE
John Trotter, The Sacramento Bee
Sokoiey, a 3-year-old Somali refugee, cries as she hangs from a scale in a feeding center in Medina run by the Irish relief group, Concern. Her weight will determine whether she is put on an intensive feeding program.

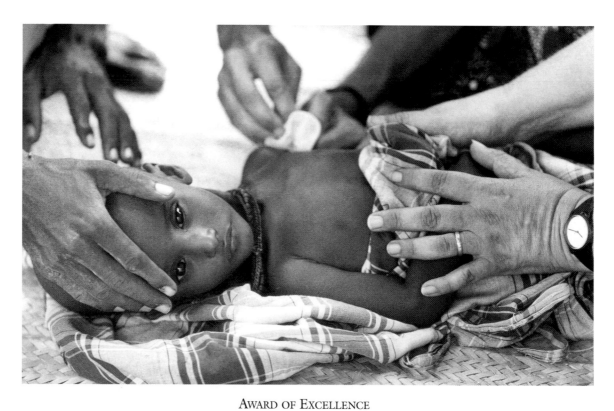

AWARD OF EXCELLENCE
Benjamin Brink, The Oregonian
Members of the Northwest Medical Team from Portland, Ore., prepare to put a feeding tube into Mahamud Issac, a severely dehydrated child in Wajir, Kenya. The boy is a refugee from Somalia.

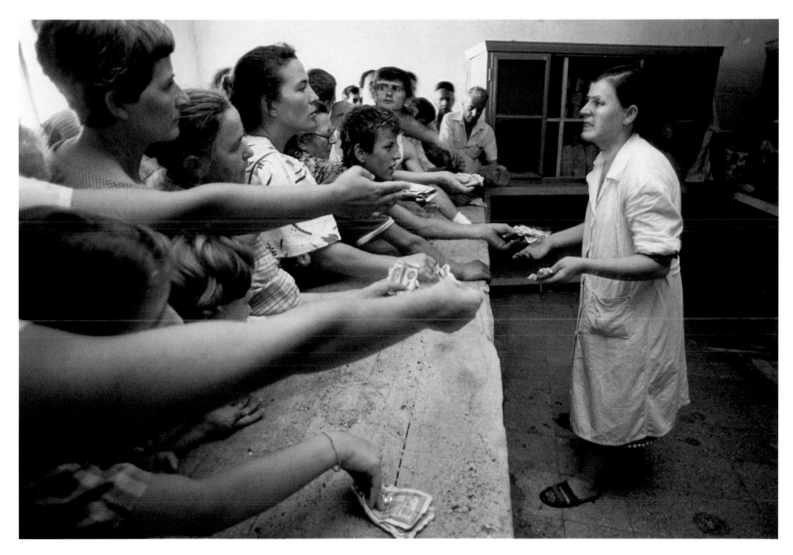

2ND PLACE
Bruce Strong, The Orange County (CA) Register
A woman is overwhelmed by the number of people trying to buy bread in an Albanian store.

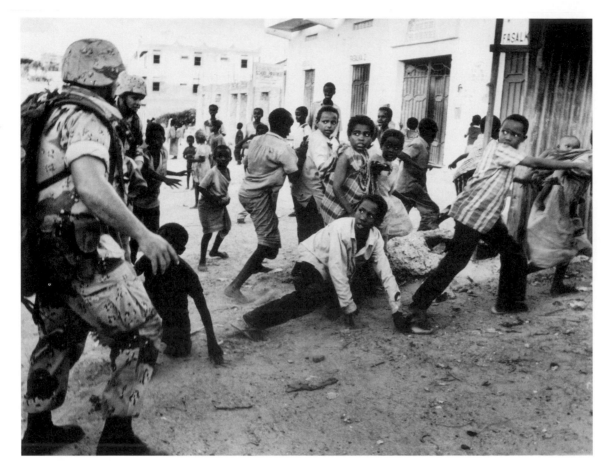

3RD PLACE
Dayna Smith, The Washington Post
U.S. Marines in Somalia must get along with residents who sing their praises one minute, only
to steal from their packs the next.

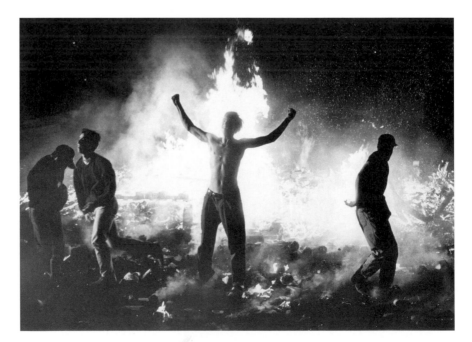

AWARD OF EXCELLENCE
David Yee, Oakland (CA) Tribune
Students from the University of California at Berkeley cheer after adding fuel to
a bonfire. The rally was held on the eve of the college's annual football game
against rival Stanford University.

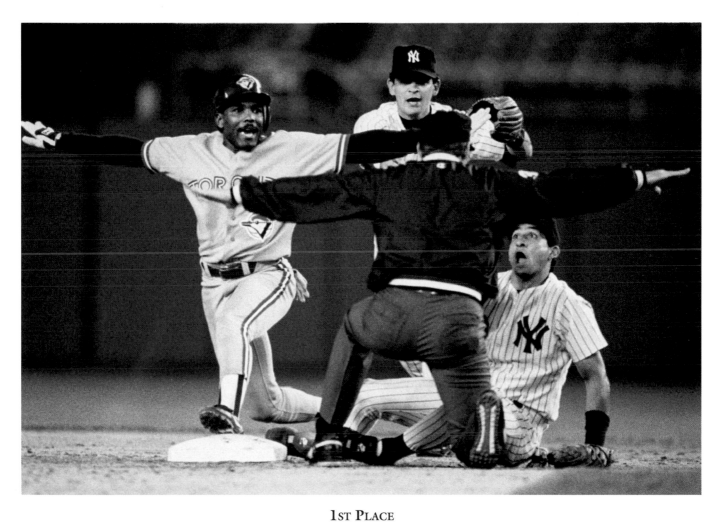

1ST PLACE
Mark D. Phillips, Agence France Presse
Manny Lee of the Toronto Blue Jays mimics the umpire's signal of "safe" after breaking up a double play. Andy Stankiewicz
(right) and Mike Gallego of the New York Yankees react to the decision.

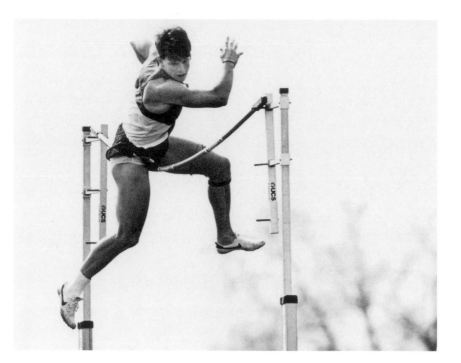

Todd Anderson, Indiana University
An Indiana University pole-vaulter misses an attempt to clear the bar
during a Big 10 triangular track meet in Indianapolis.

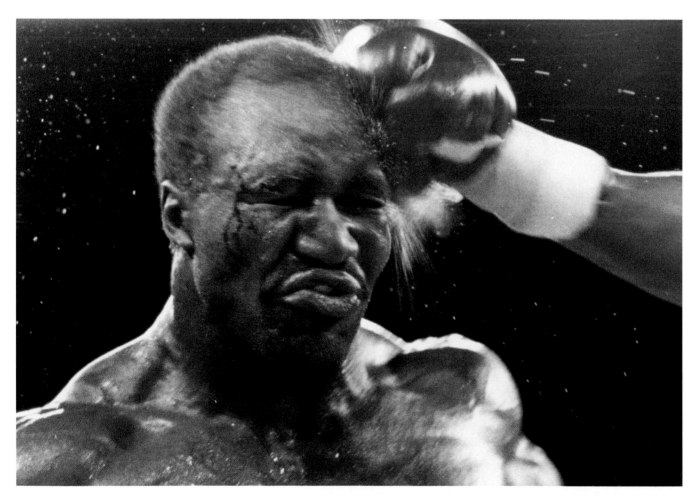

Robert Hanashiro, USA Today
Heavyweight champion Evander Holyfield receives a crushing blow from Larry Holmes during the 7th Round of their
title fight at Caesar's Palace in Las Vegas. The 42-year-old Holmes went the distance but lost by a unanimous decision.

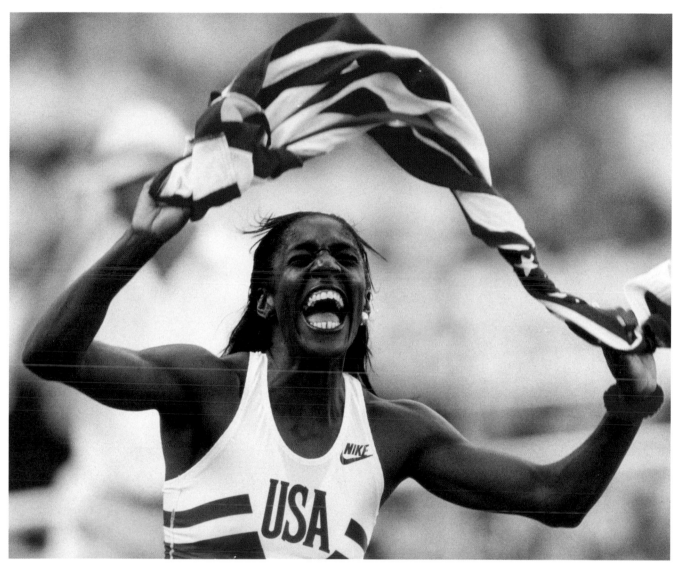

3RD PLACE
Jean-Loup Gautreau, Agence France Presse
U.S. sprinter Gwen Torrence is jubilant after winning an Olympic gold medal in the 200-meter dash in Barcelona, Spain.

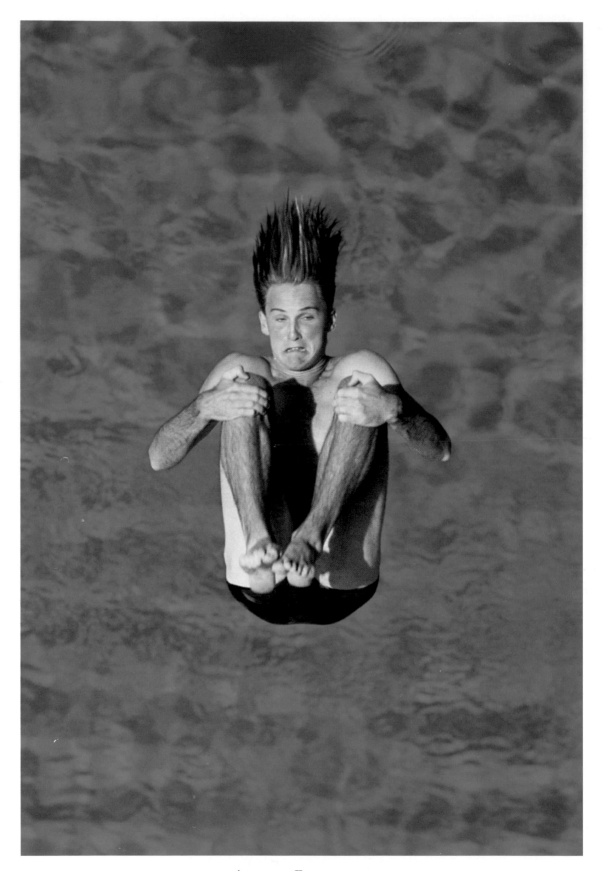

AWARD OF EXCELLENCE
Mark Henle, The Phoenix Gazette
David Bradshaw of Mountain View High School takes a dive during preliminary competition for the
Arizona 5A class swimming and diving championships at Arizona State University.

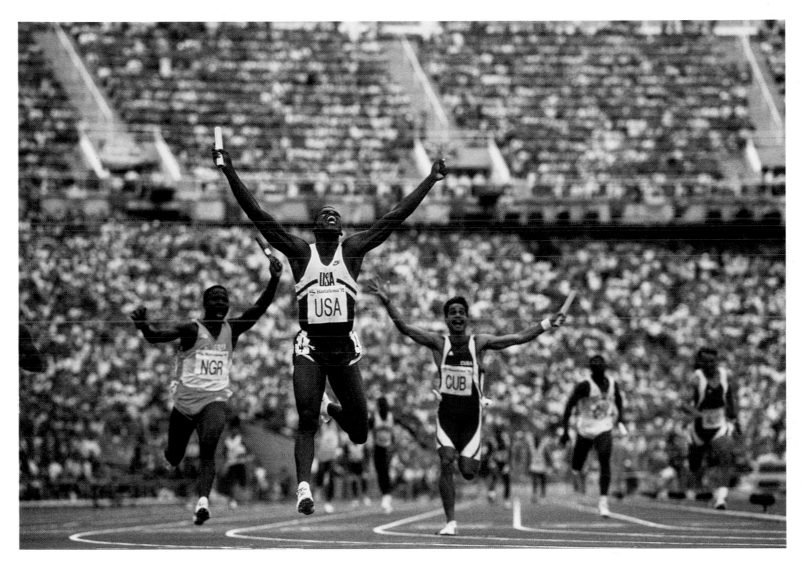

1ST PLACE
Bill Frakes, Sports Illustrated
Carl Lewis celebrates as he crosses the 100-meter finish line with the fastest time ever recorded.

AWARD OF EXCELLENCE
Mike Powell, Allsport USA
Yves Mankel and Thomas Rudolph of Germany compete in the Luge doubles event during the Winter Olympics.

MAGAZINE SPORTS PICTURE

2ND PLACE
Jose Azel, Aurora
Romanian gymnast Nicolae Bejenaru
competes during the Summer
Olympics in Barcelona.

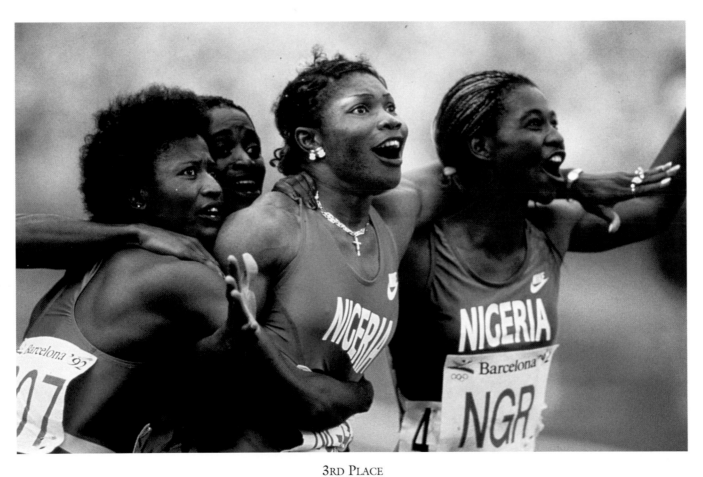

3RD PLACE
Bill Frakes, Sports Illustrated
Nigerian runners exult in their third-place finish in the 100-meter relay at the Summer Olympics in Barcelona, Spain.

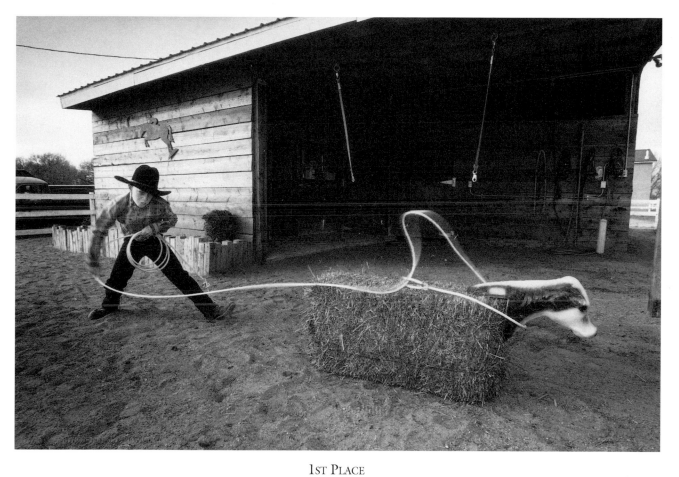

1ST PLACE
Kristy MacDonald, Albuquerque Tribune
Eleven-year-old cowboy Terry Klein Jr. competes against – and beats – adult men on the rodeo circuit. "I practice four hours every night," he says, "then I do my homework."

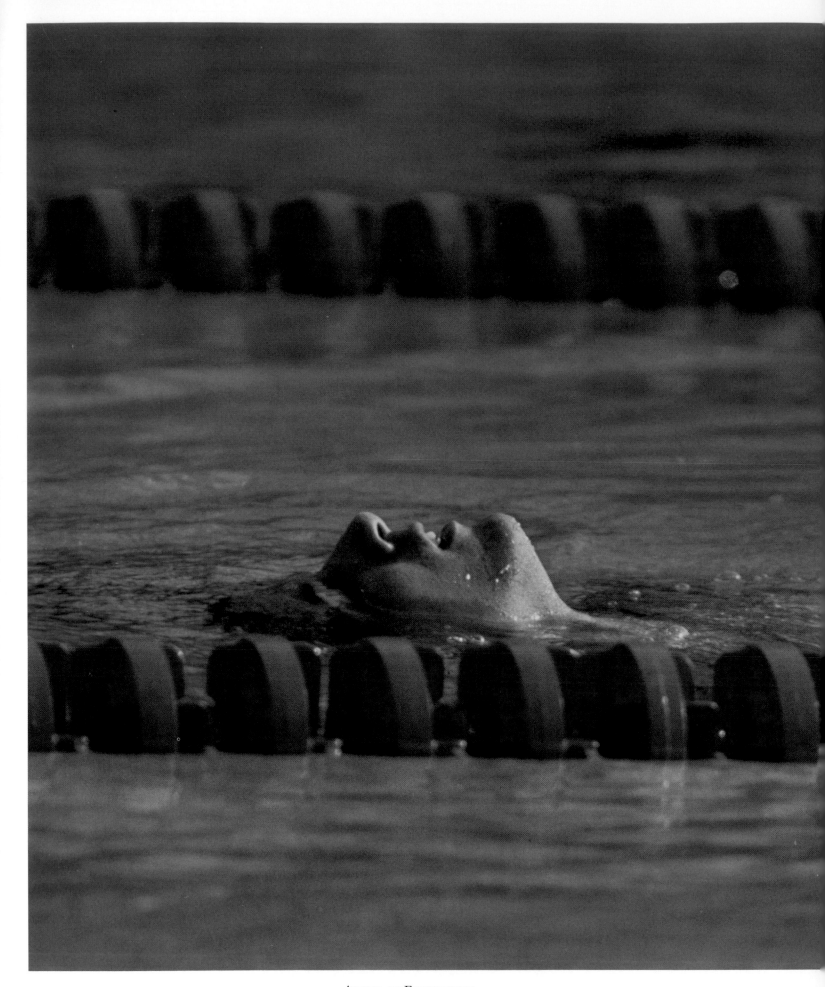

Daniel A. Anderson, The Orange County Register
Pablo Morales, at 27 the oldest member of the U.S. Olympic swim team, rests after capping a comeback from a three-year layoff by winning the gold medal in the 100-meter butterfly.

NEWSPAPER SPORTS FEATURE

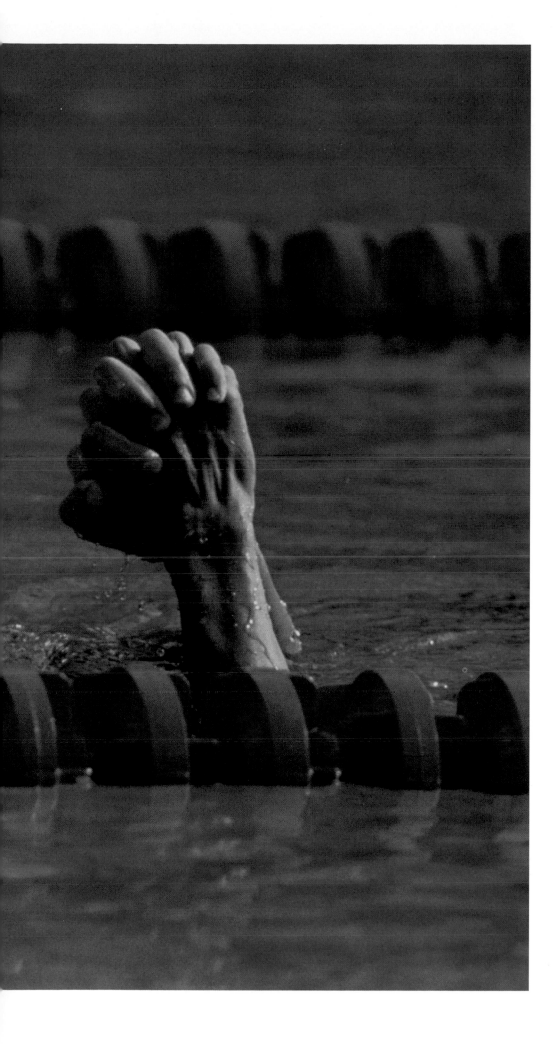

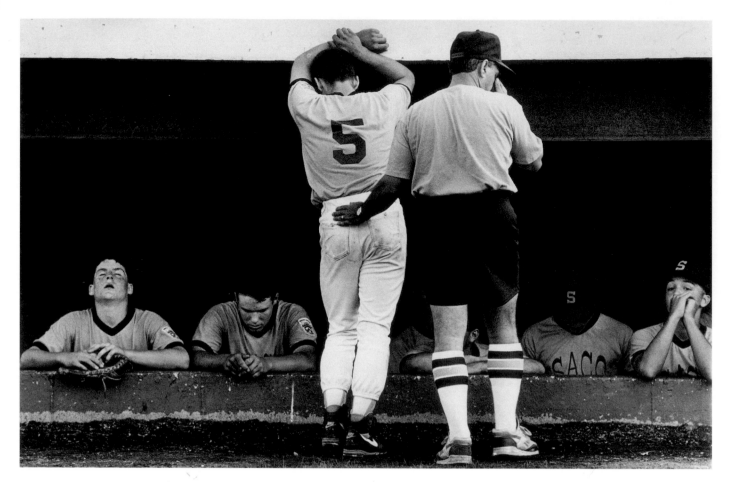

3RD PLACE
Teresa Hurteau, Biddeford (Maine) Journal Tribune
Saco, Maine, Senior League baseball coach Don Lauzier gives his son, Ben, a comforting pat after the team's loss to
Biddeford during District 4 finals.

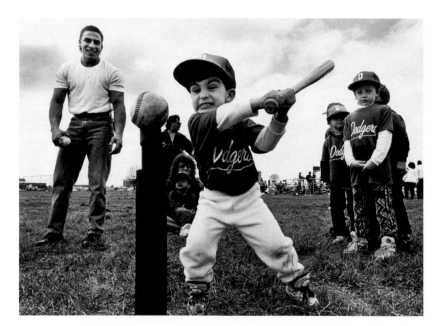

2ND PLACE
April Saul, The Philadelphia Inquirer
Richard Lana swings away at his first T-ball practice in South
Philadelphia.

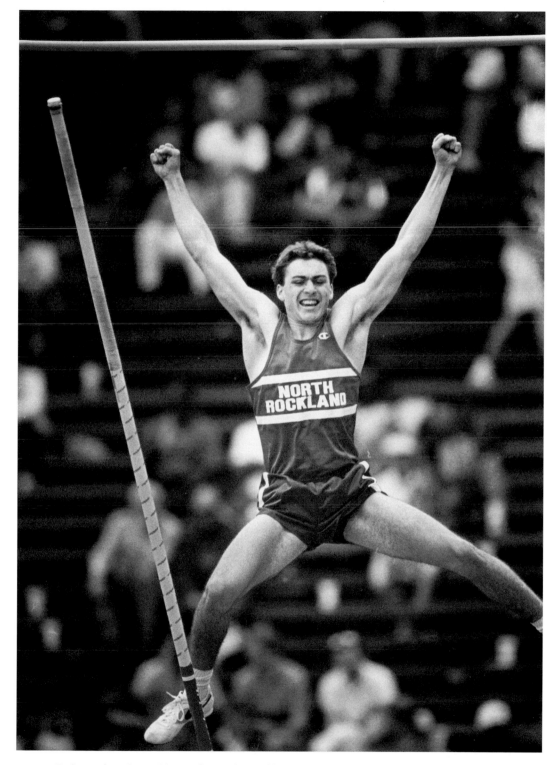

Pole-vaulter Scott Biggs of North Rockland celebrates after clearing the bar on his
third try at the Penn Relays.

Diamonds in the Rough

Summertime, and the playing is easy. In Philadelphia, community softball leagues are a popular pastime, and any scraggly patch of ground can sport a softball diamond.

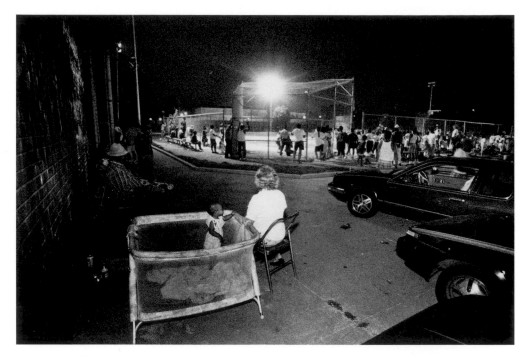

As a neighbor watches over a player's child, two women's softball teams play under the lights in North Philadelphia.

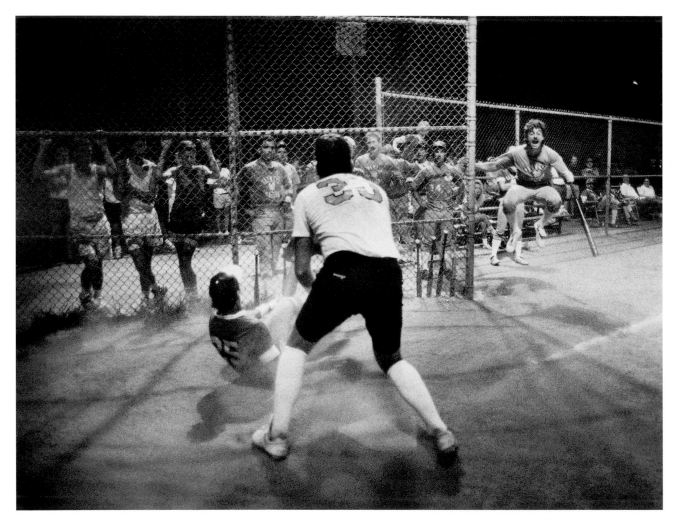

A Carney Tavern player is called out at home plate in a playoff game against McCullough Too.

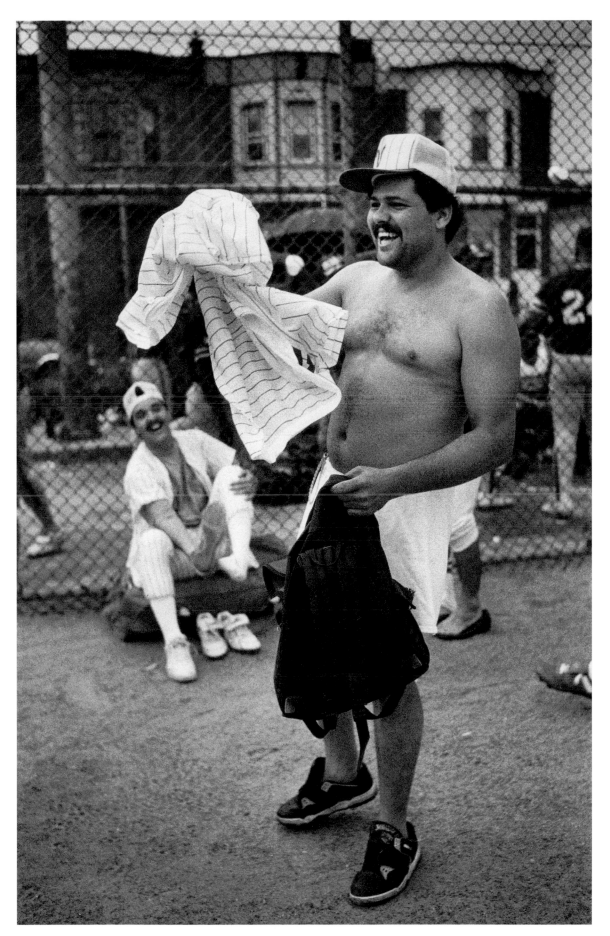

A player changes from work clothes to play clothes.

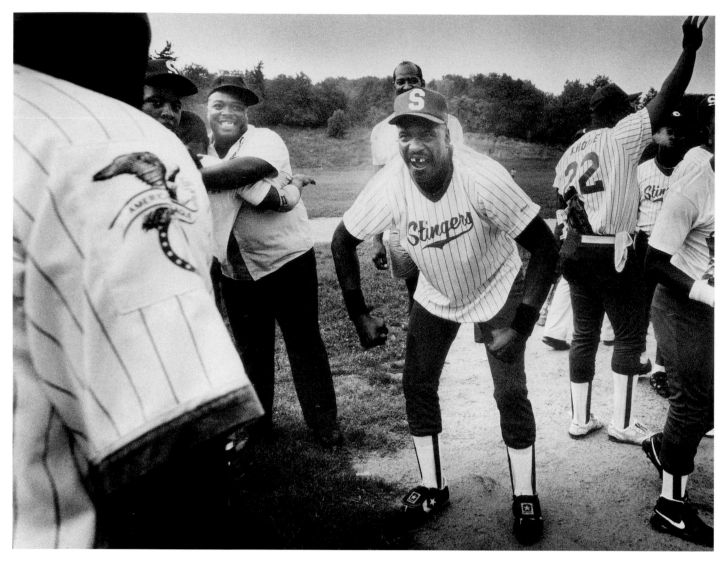

Stingers pitcher Tom DeVoe celebrates his team's championship victory in the Leroy Kelly league.

Players relax after a game.

NEWSPAPER SPORTS PORTFOLIO • *Ronald Cortes, First Place, The Philadelphia Inquirer*

Golden State Warrior coach Don Nelson is booed by a crowd for keeping favorite
player Chris Mullin out of an NBA game in San Jose, Calif.

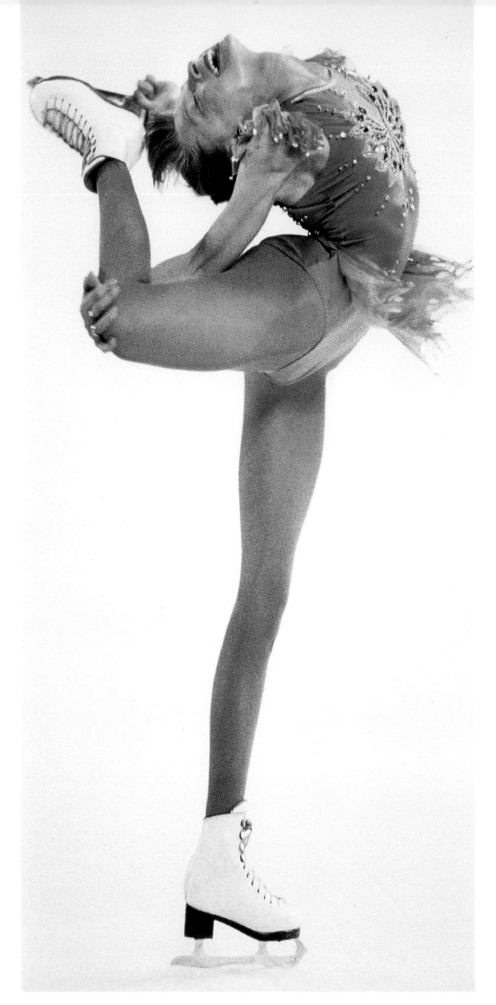

Swiss skater Nathalie Krieg performs during World Figure Skating
Championships in Oakland, Calif.

British golfer Nick Faldo searches for a lost ball during the U.S. Open at Pebble Beach, Calif. He never found the ball.

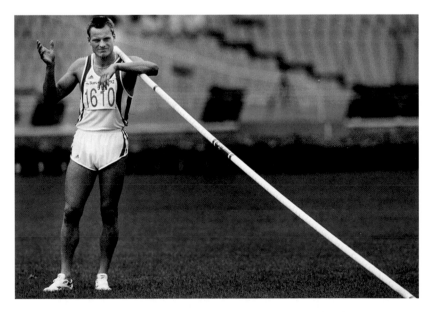

Decathlete Robert Zmalik of Czechoslovakia indicates that he is ready to
make his vault during the Summer Olympics in Barcelona.

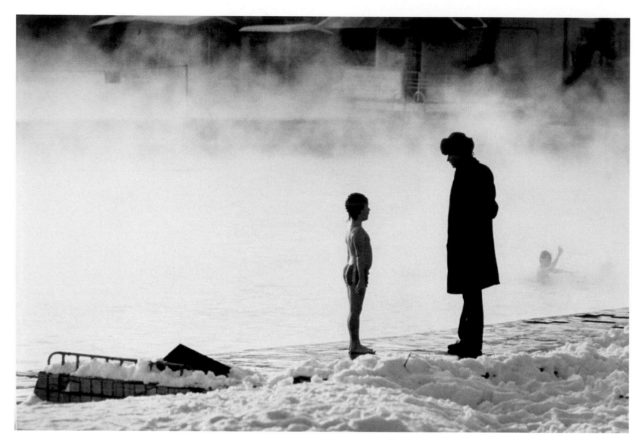

A Russian coach gives a promising young athlete a stern lecture during swim practice at Basin Moskva, Moscow. Children who are destined to be athletes practice even in below-freezing weather.

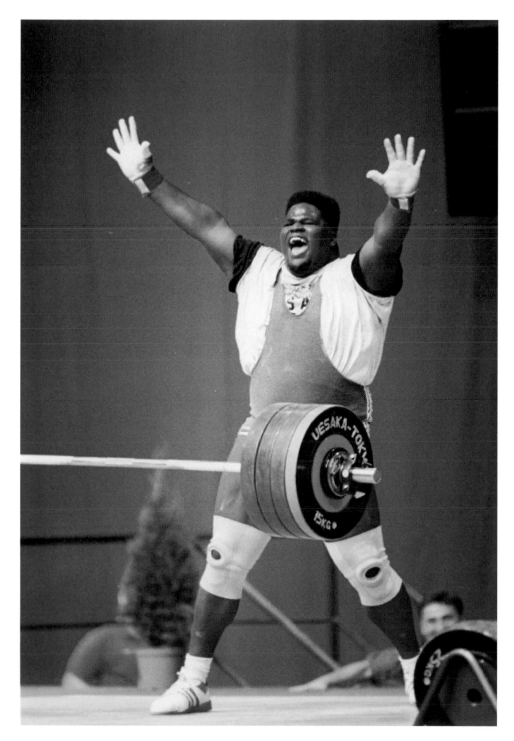

Mark Henry reacts to setting his personal best of 468 pounds in the clean-and-jerk lift
in the super heavyweights during the Summer Olympics.

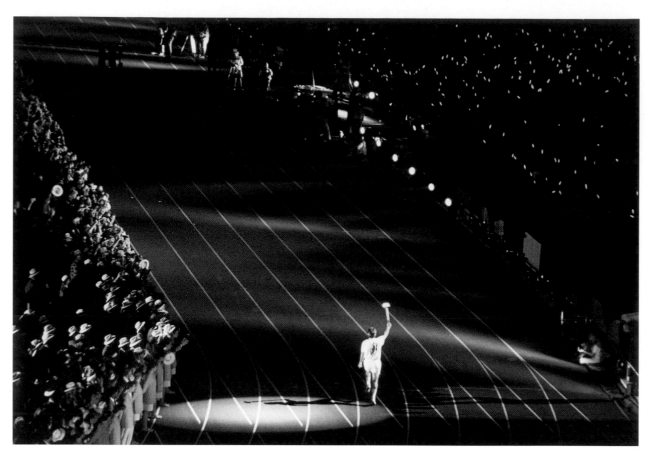

During opening ceremonies for the Summer Olympics in Barcelona, the torch bearer circles the track.

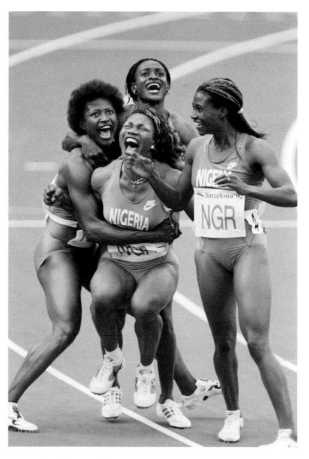

Members of the Nigerian 4x100 relay team celebrate as the scoreboard indicates a bronze-medal performance.

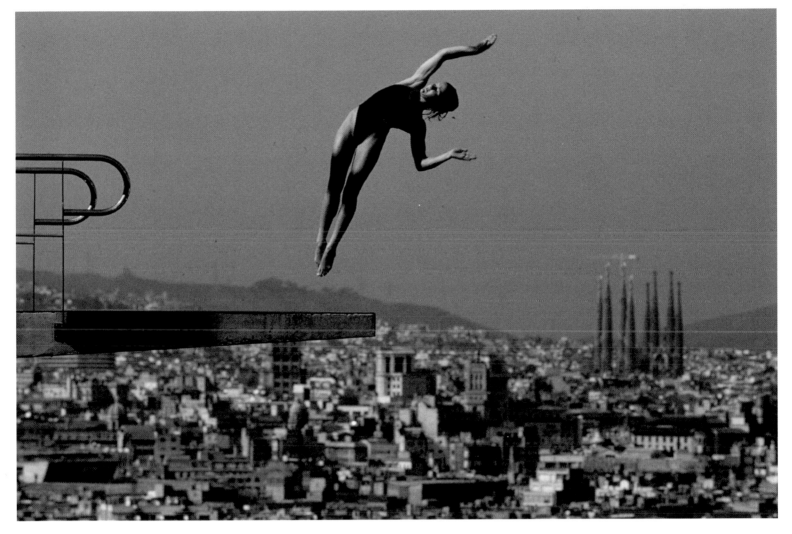

The city of Barcelona makes a panoramic background for an Olympic contender in the 10-meter diving.

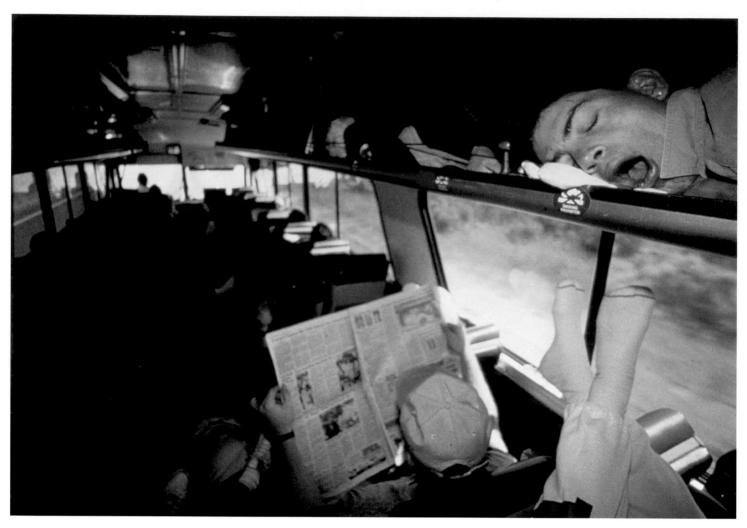

On an overcrowded bus, a player manages to find a place to catch some sleep.

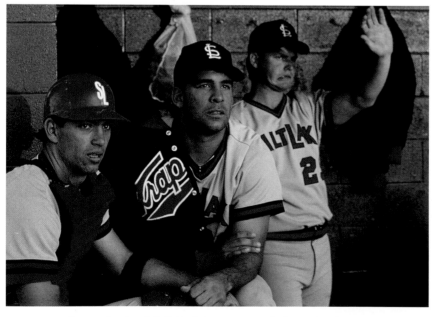

Players for the Salt Lake Trappers watch from the dugout.

Chasing a Dream

Baseball's minor leagues: no million-dollar contracts, no commercial endorsements, no fame. Just cheap hotels, endless bus trips, brown-bag lunches, and the often elusive dream of playing in the major leagues. And the joy of playing the game.

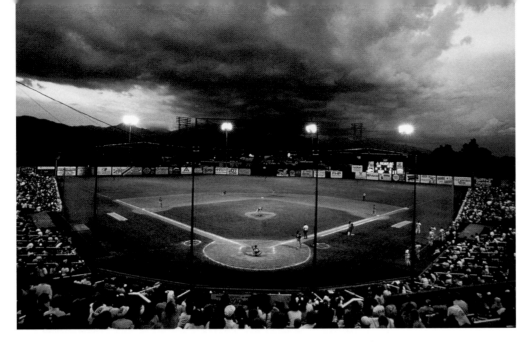

A game in Salt Lake City draws a crowd.

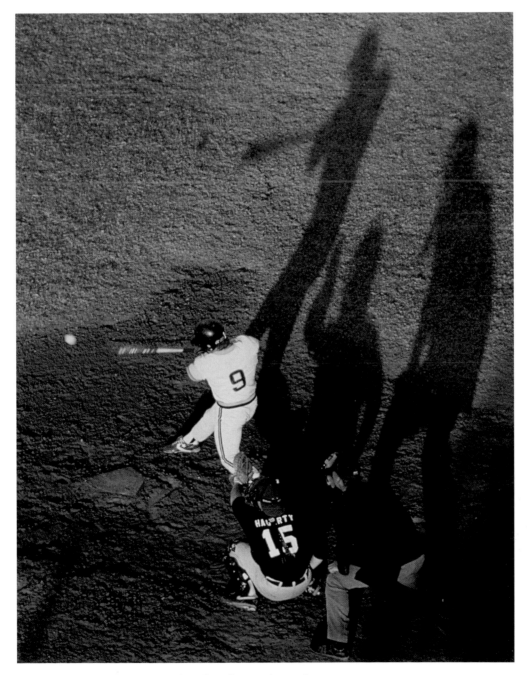

Another diamond, another game.

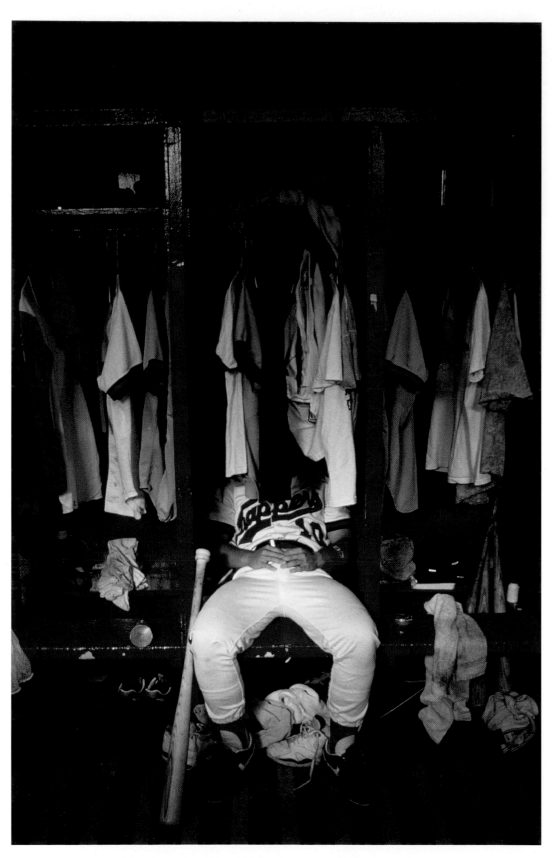

A player hides behind clothing for a moment of solitude before a game.

Bill Frakes, Second Place, Sports Ilustrated

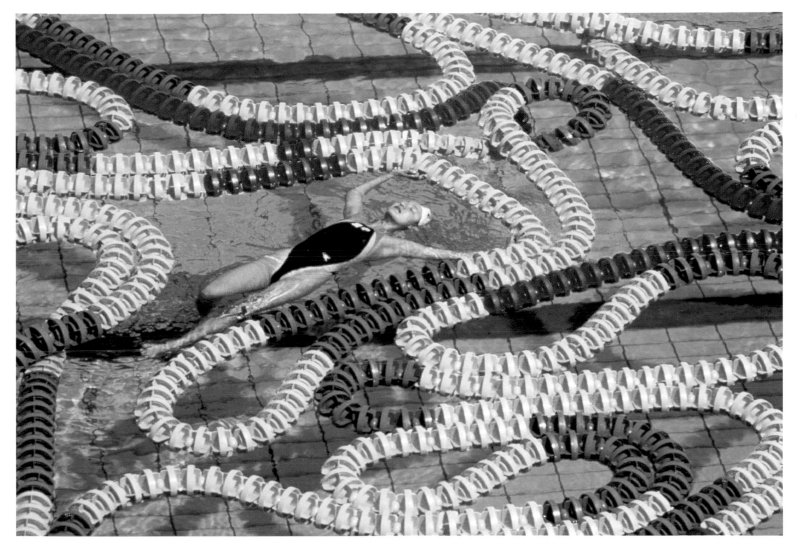

Chinese diving champion Xi relaxes during a break in the XXV Summer Olympics.

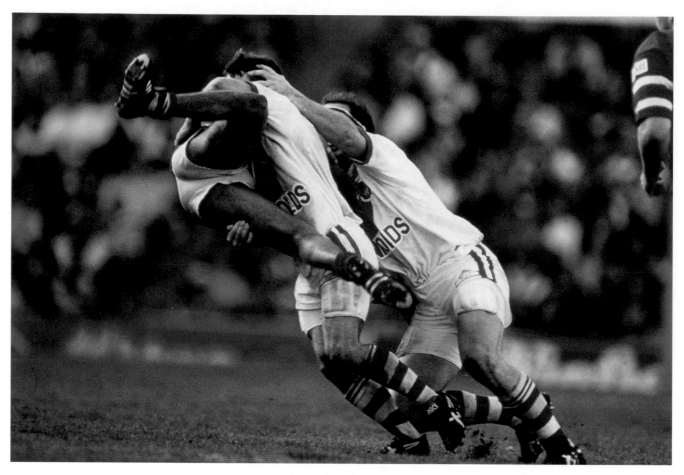

An Australian rugby rover is slammed to the ground as he tries to score in Grand Final.

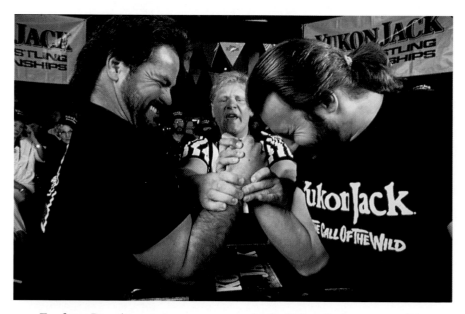

Far from Barcelona, two men compete in the Yukon Jack arm-wrestling championship in Hartford, Conn.

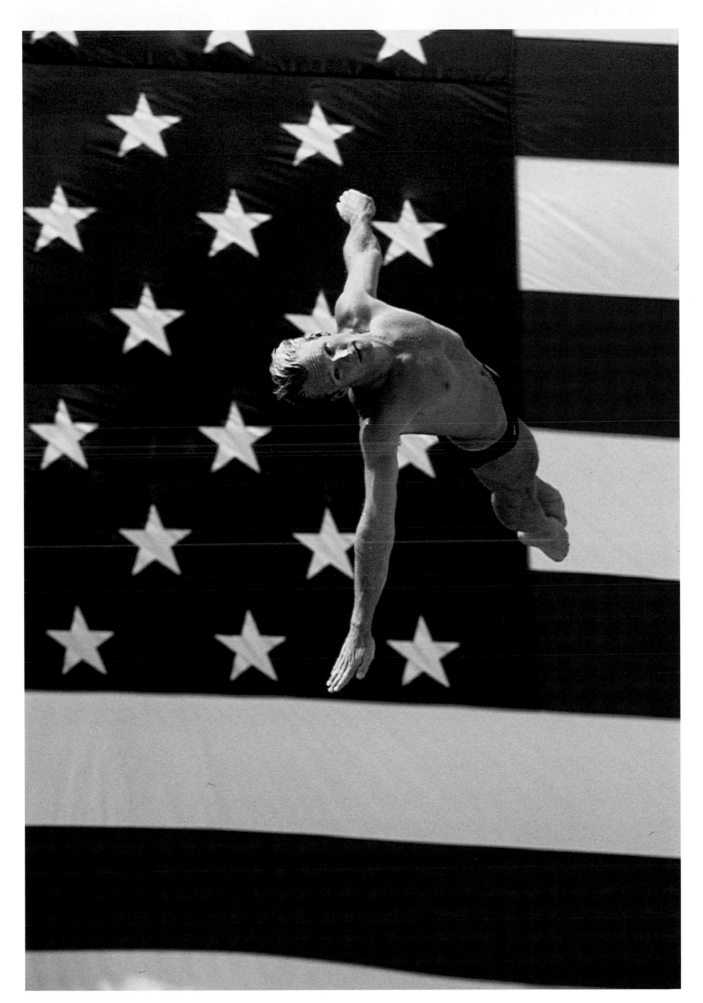

With his country's flag as a backdrop, Olympic diver Kent Ferguson practices at a pool in Fort Lauderdale, Fla.

MAGAZINE SPORTS PORTFOLIO • *Bill Frakes, Second Place, Sports Illustrated*

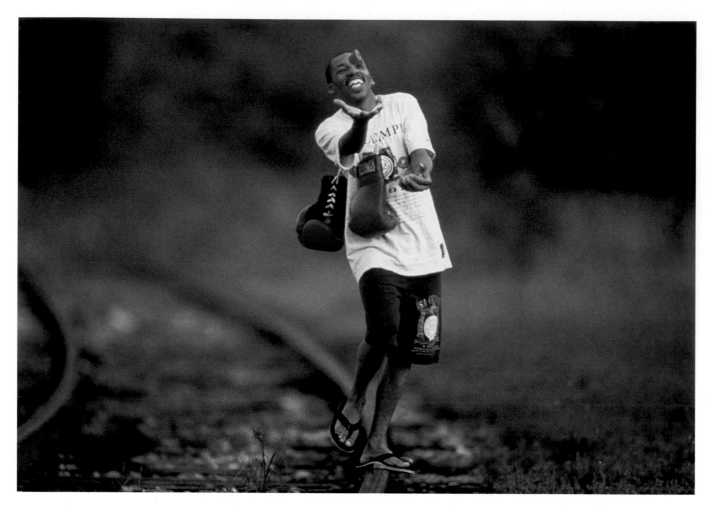

Olympic boxer Eric Griffin juggles while balancing on a railroad track in Tennessee as he returns home from a workout.

Basketball superstar Magic Johnson is surrounded by other athletes during the opening ceremonies of the Summer Olympics.

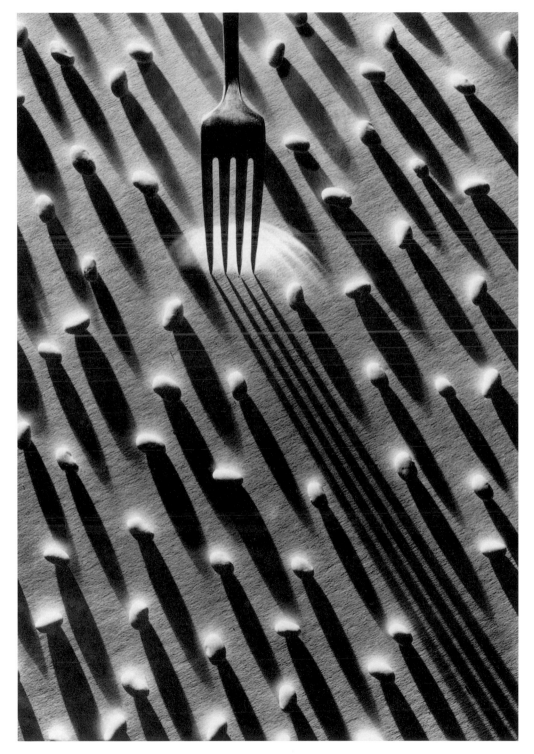

1ST PLACE
Patrick Tehan, The Pittsburgh Press
Beans

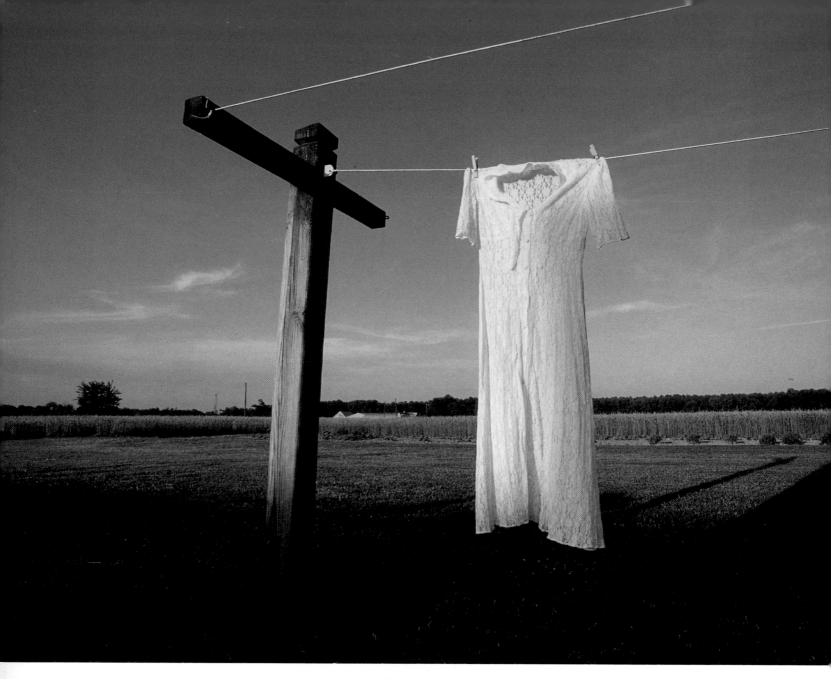

2ND PLACE
William Tiernan, The Virginian-Pilot
White lace

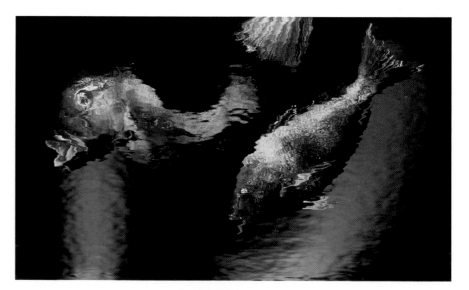

AWARD OF EXCELLENCE
Jay Koelzer, The Rocky Mountain News
Swimmin' with the fish

NEWSPAPER PRODUCT ILLUSTRATION

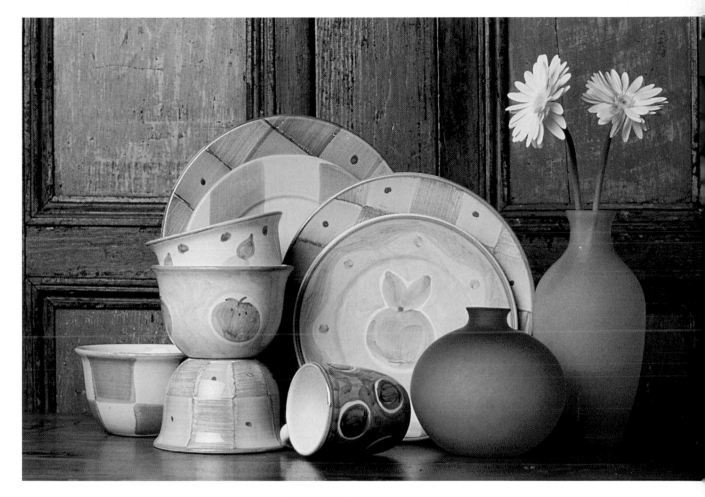

Award of Excellence
Melanie Stetson Freeman, The Christian Science Monitor
Sunnyside dinnerware

3RD PLACE
Mark B. Sluder, The Charlotte Observer
Landscape architecture

1ST PLACE
Jay Koelzer, The Rocky Mountain News
Neverending deadlines

2ND PLACE
Tom Reese, The Seattle Times
State of the Economy

AWARD OF EXCELLENCE
Jay Koelzer, The Rocky Mountain News
Buffalo Spring

3RD PLACE
Beth Bergman, The Virginian-Pilot
Guardian angel

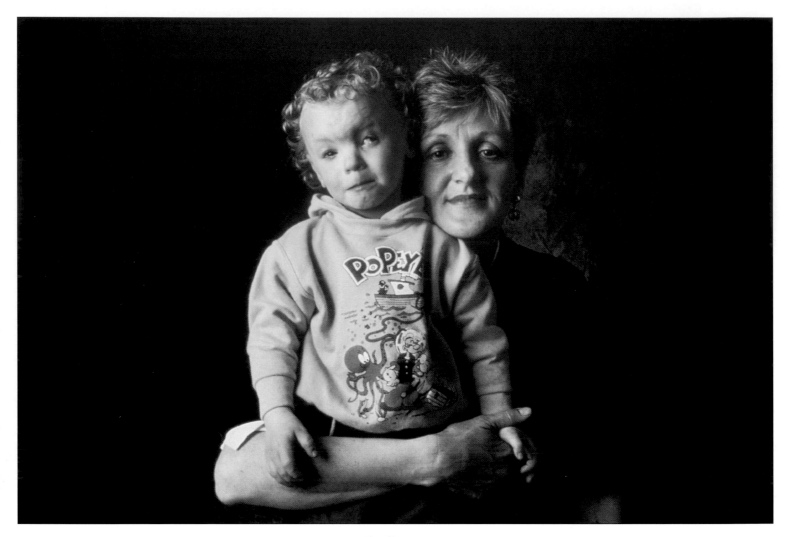

1st Place
George Steinmetz, Freelance
A mother and her 4-year-old son, who has Fetal Alcohol Syndrome.

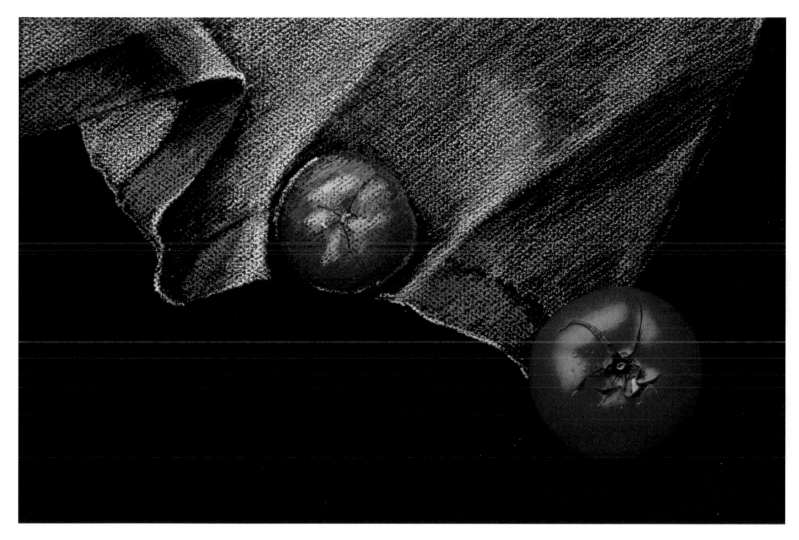

1ST PLACE
Carmen Troesser, University of Missouri
Tomato on drawing

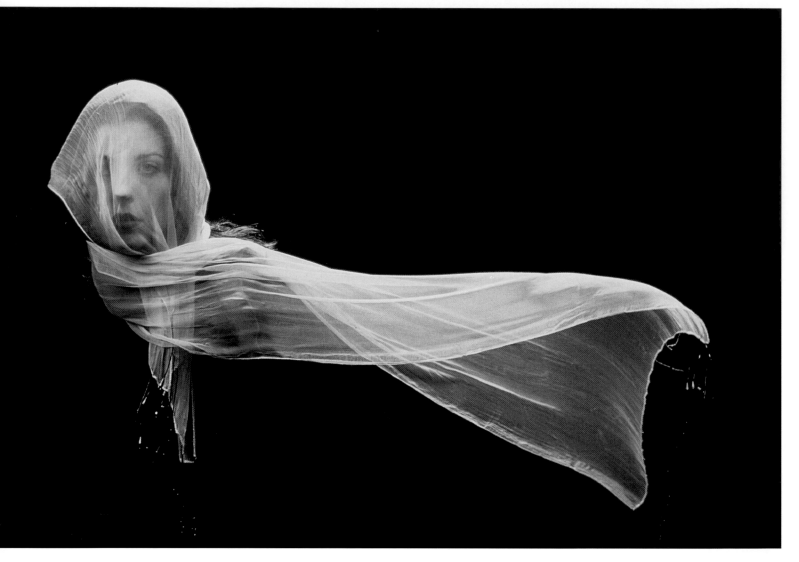

2ND PLACE
John Samora, The Arizona Republic
Scarves

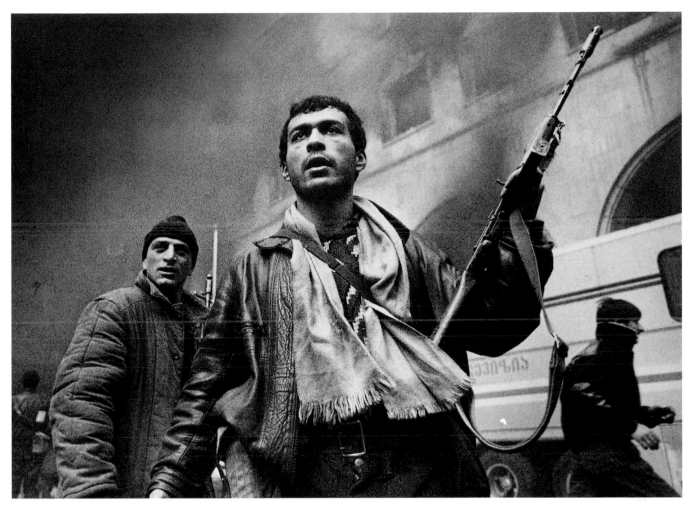

Rebel forces take to the street in their bid to oust Georgian President Zviad Gamsakhurdia.

Tbilisi

Zviad Gamsakhurdia, a former dissident in Soviet Georgia, had been elected president of the new state with an overwhelming majority. Within eight months, rival armed bands were playing out a civil war in Tbilisi, Georgia's capital, and Gamsakhurdia was hiding in an underground bunker in the Parliament building. Although his supporters rallied in the streets, opposition forces intensified their fighting, eventually burning the Parliament building and forcing Gamsakhurdia to flee to western Georgia. Much of Tbilisi was left in ruins as Georgian was pitted against Georgian.

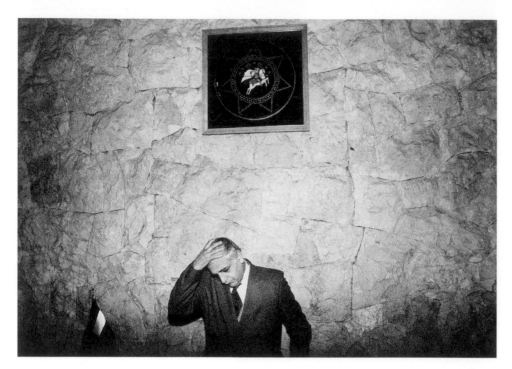

Georgian President Zviad Gamsakhurdia hides in an underground bunker in Tbilisi's Parliament building as fighting rages outside.

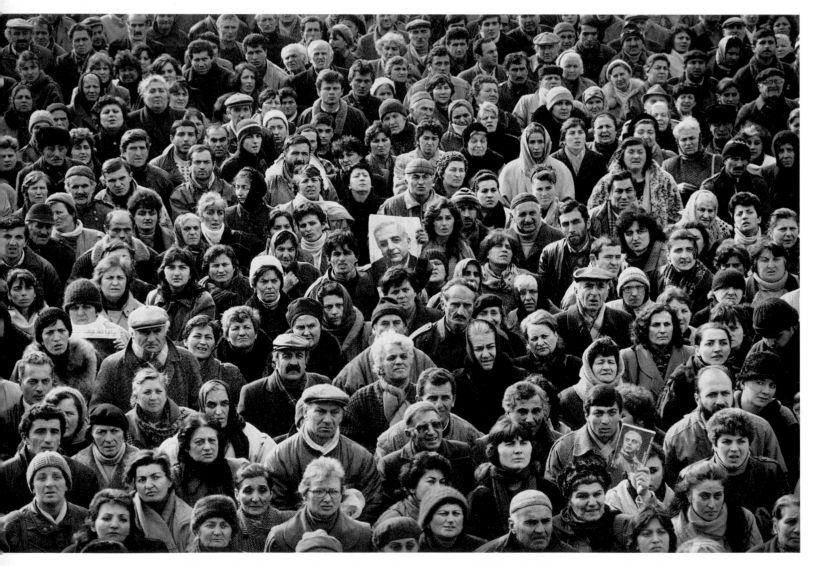

Supporters of Gamsakhurdia stage a demonstration in downtown Tbilisi as fighting rages elsewhere downtown.

NEWSPAPER NEWS PICTURE STORY • *Carol Guzy, First Place, The Washington Post*

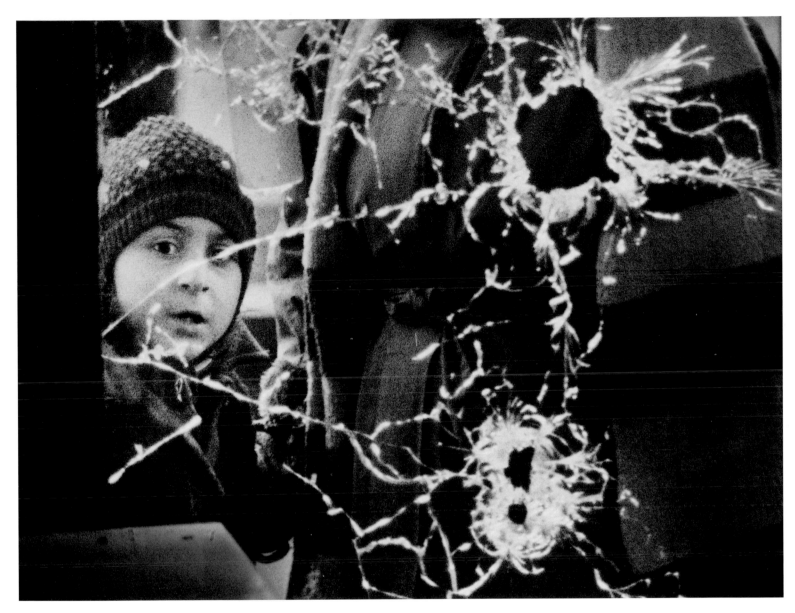

A young Tbilisi resident looks in a shop window shattered by bullet holes on Rustaveli Prospect.

NEWSPAPER NEWS PICTURE STORY • *Carol Guzy, First Place, The Washington Post*

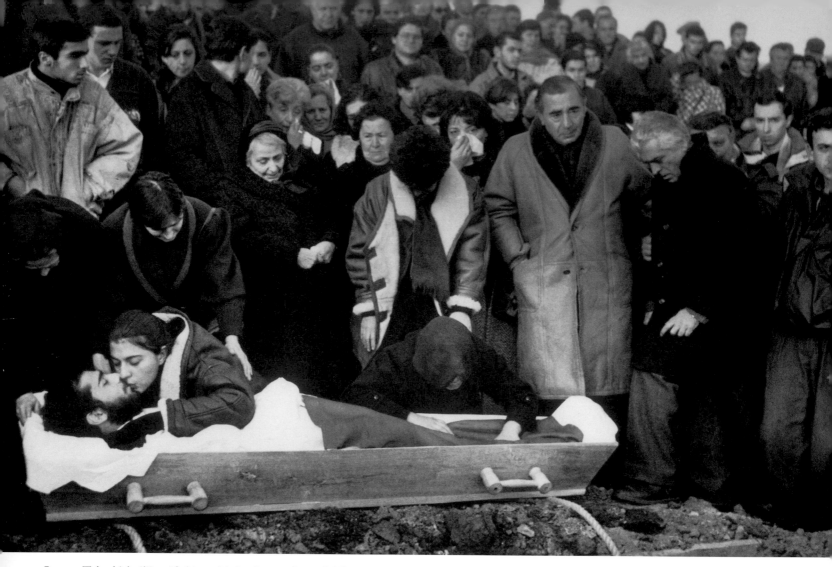

Levon Taktakishvili's wife kisses his body at a funeral. The 21-year-old was shot by militiamen during a rally in support of Gamsakhurdia.

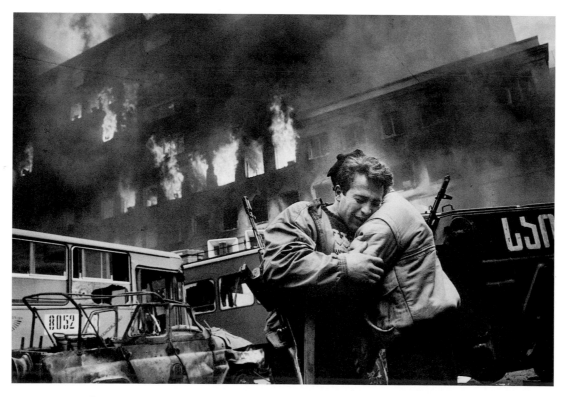

Opposition fighters hug in celebration as the Parliament building burns.

NEWSPAPER NEWS PICTURE STORY • *Carol Guzy, First Place, The Washington Post*

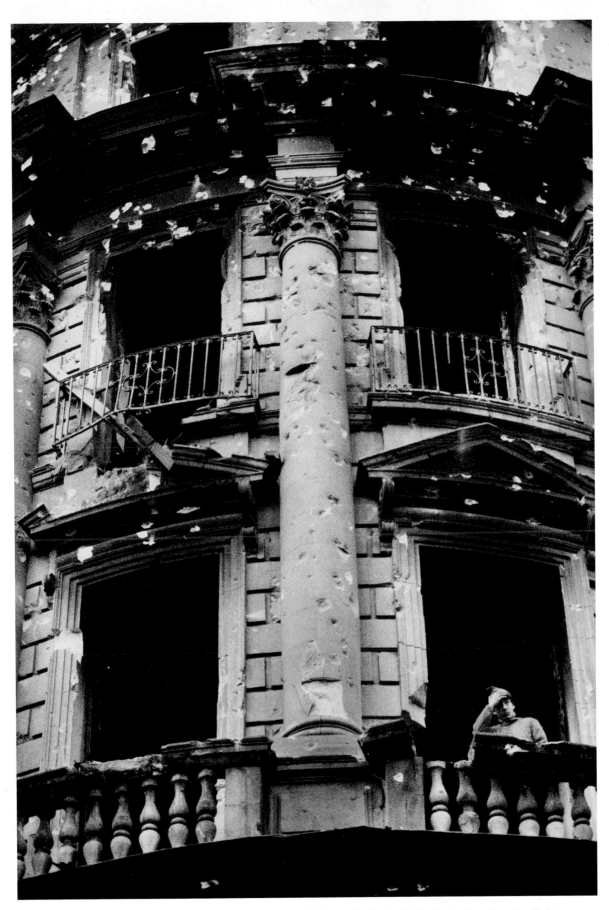

An old hotel on Rustaveli Prospect in downtown Tbilisi is riddled with bullet holes after the fighting.

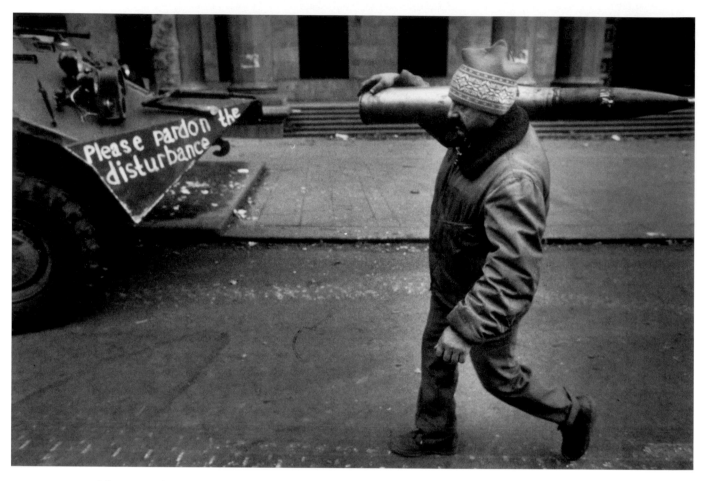

After Gamsakhurdia fled Tbilisi, the cleanup of the city began. "Please pardon the disturbance" appears on the side of a tank on Rustaveli Prospect.

Dan Habib, Second Place, Impact Visuals

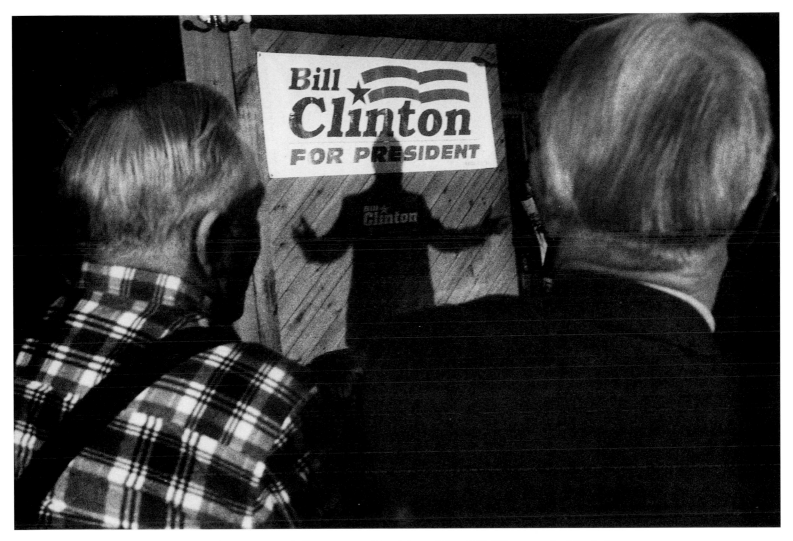

Roland Thibeault and Jay Doussault listen to presidential candidate Bill Clinton make his pitch at a restaurant in Berlin, New Hampshire.

Clinton Survives a Primary

Now that Bill Clinton has become president, it's hard to remember that in New Hampshire he faced controversy so severe that few thought his campaign would survive. Gennifer Flowers, the "draft-dodging" letter and skeptical, economically devastated voters wore Clinton down. But in retrospect, the campaign for the New Hampshire primary demonstrated both the endurance of "Robo-Candidate" Clinton and the toll a presidential campaign inflicts on a candidate.

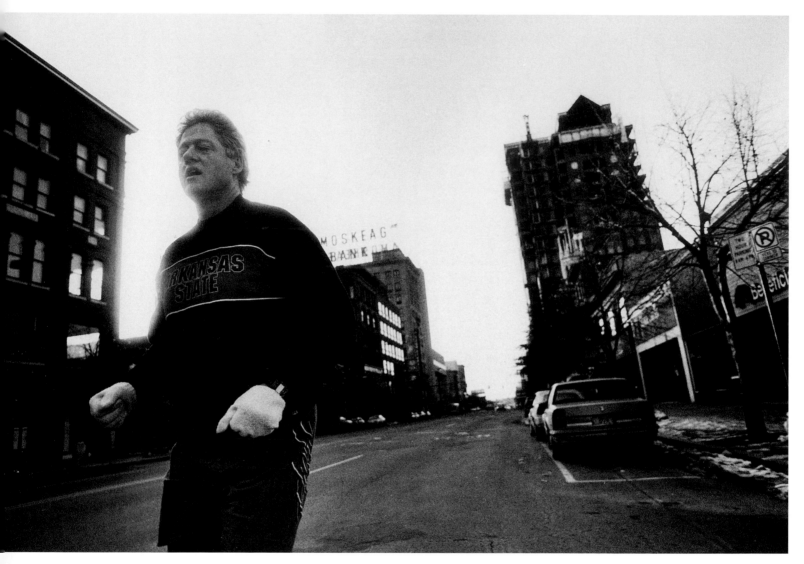

After a red-eye flight from Little Rock, Ark., Clinton tries to revive himself with a quick 8 a.m. jog through frigid temperatures in Manchester, N.H.

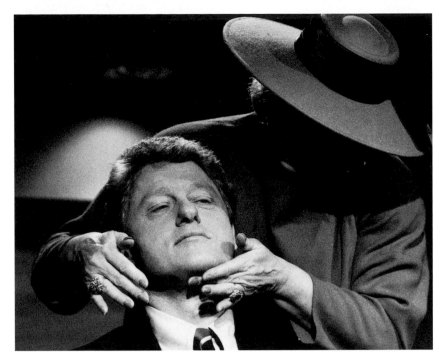

Clinton gets make-up from Phyllis Berg of Manchester before a series of
television interviews at WMUR-TV.

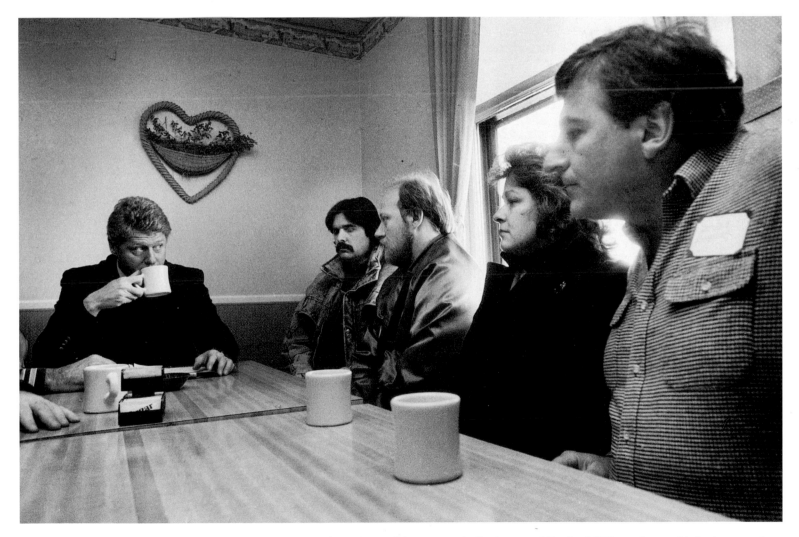

Workers from the James River Paper Mill, which employs most of the economically depressed Berlin, N.H., region and is in danger of
closing, share their fears with Clinton over coffee at a diner near the mill.

NEWSPAPER NEWS PICTURE STORY • *Dan Habib, Second Place, Impact Visuals*

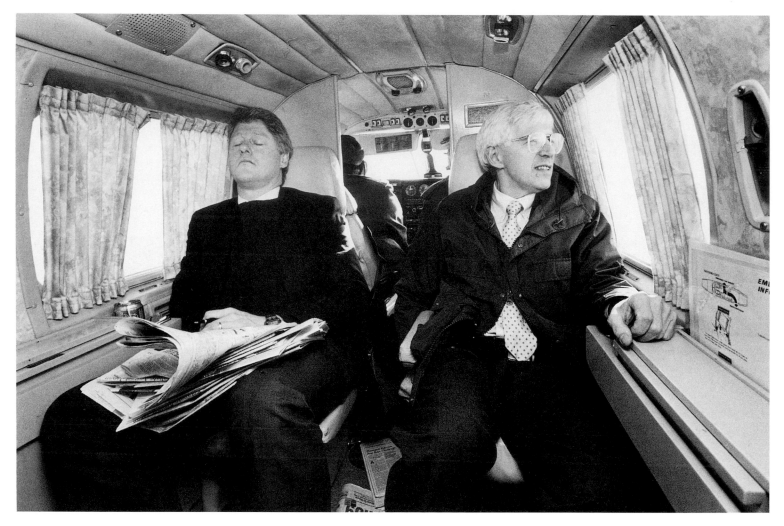

Clinton dozes off on his campaign plane in the midst of a hectic day as New Hampshire Democratic activist
George Bruno peers out at the White Mountains.

Ron Tarver, Third Place, The Philadelphia Inquirer

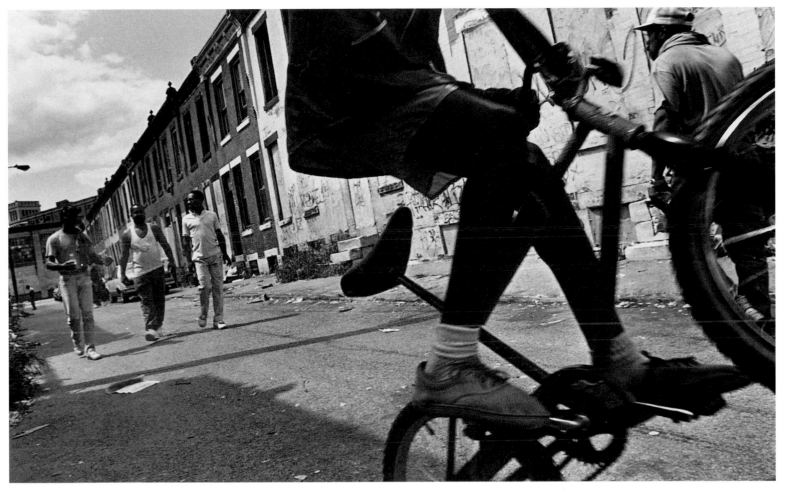

Although the Carter children were not allowed outside unsupervised, the street was their only playground. The constant parade of people wandering back and forth from the shooting galleries was a constant reminder of the dangers down the street.

On the Street Where Heroin Lived

Mark Carter wanted the best for his family when he bought an abandoned house from the city of Philadelphia for a dollar. His vision was to fix up the run-down property on Stella Street and persuade other families to do the same to the 40 or more abandoned homes on the block. His vision was in vain, though, because heroin addicts by the dozens moved in instead and turned most of the houses into shooting galleries, making life on the street a nightmare. Eventually, the shooting galleries were raided, the addicts arrested and most of the homes on the block destroyed through a collaborative effort on the part of law enforcement and the city. Five homes were spared, including the Carters'.

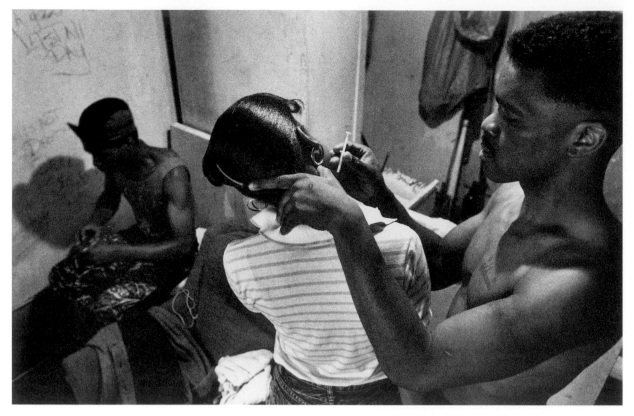

Inside one of the shooting galleries (above), Seville, a junkie who ran the gallery, injects an addict in the neck as another injects himself. Sweeping used syringes away from his home was an everyday occurence for Mark Carter (below).

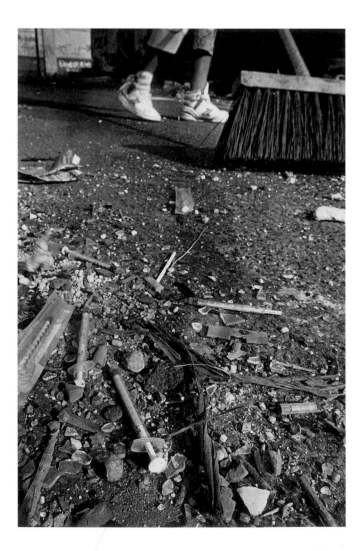

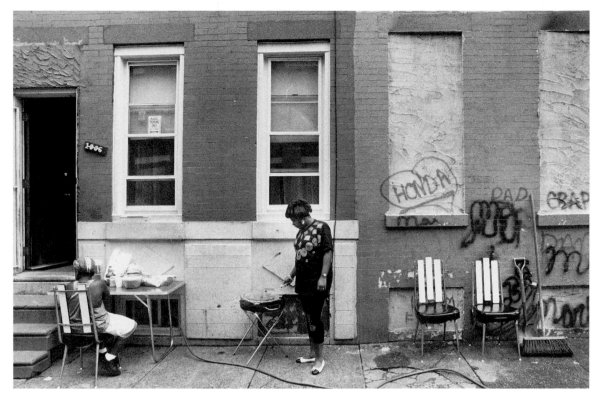

Christine Carter grills hamburgers. Next door, an abandoned house stands boarded up.

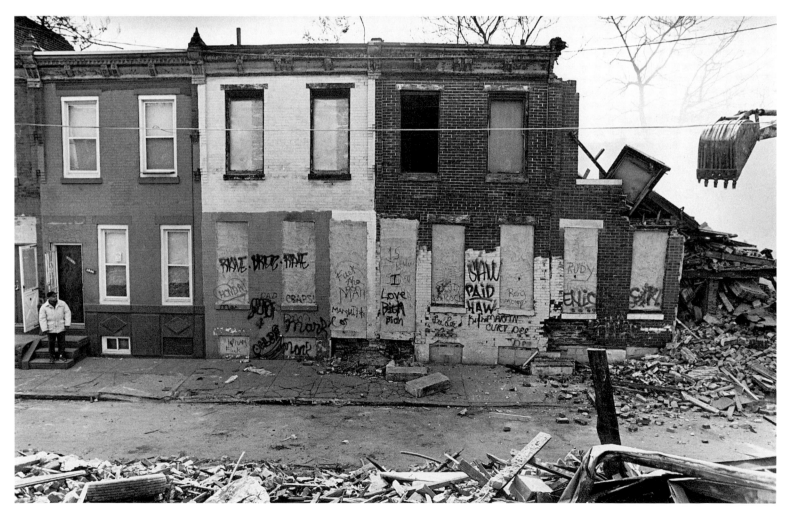

Mark Carter watches from the steps of his house as an ominous claw chews away at a house three doors down.

NEWSPAPER NEWS PICTURE STORY • *Ron Tarver, Third Place, The Philadelphia Inquirer*

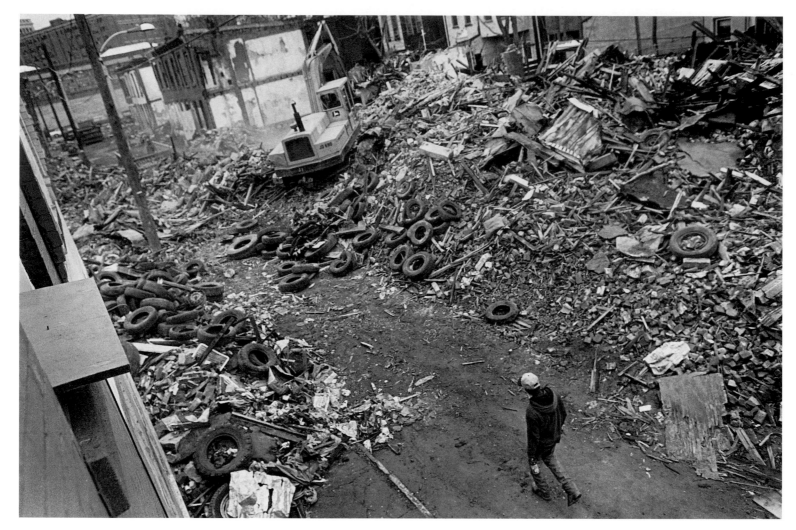

Two weeks after the city's cleanup effort began, the view from the Carters' second-floor window offered a new version of Stella Street.

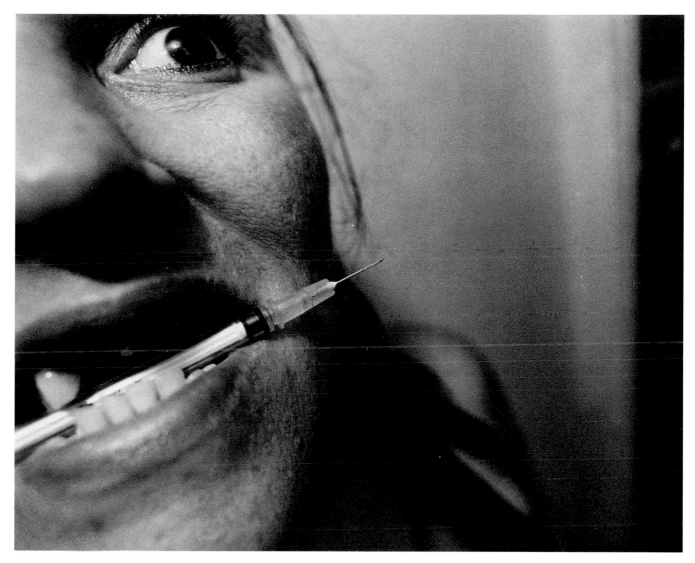

Years of shooting heroin have left Carmella without her upper teeth. The drug leeches calcium from the body.

Trouble in Paradise

Though politicians have won elections by fighting the war on drugs, the true battle continues fiercely, hidden behind everyday lives in urban America. In a stretch of Brooklyn known as East New York, whole blocks are controlled by drug gangs; babies are regularly born addicted; young prostitutes, many with AIDS, sell sex for the price of a vial of crack. Students are checked for weapons as they enter schools and innocent people live in terror of drive-by shootings. The war wages on.

Donna, 24, is a crack addict and prostitute. She performs oral sex for five dollars, the price of a vial of crack.

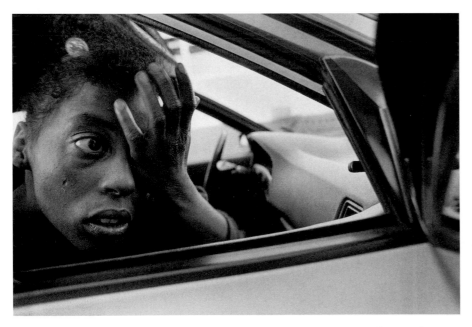

After consuming the drug, Donna wonders where her next hit will come from.

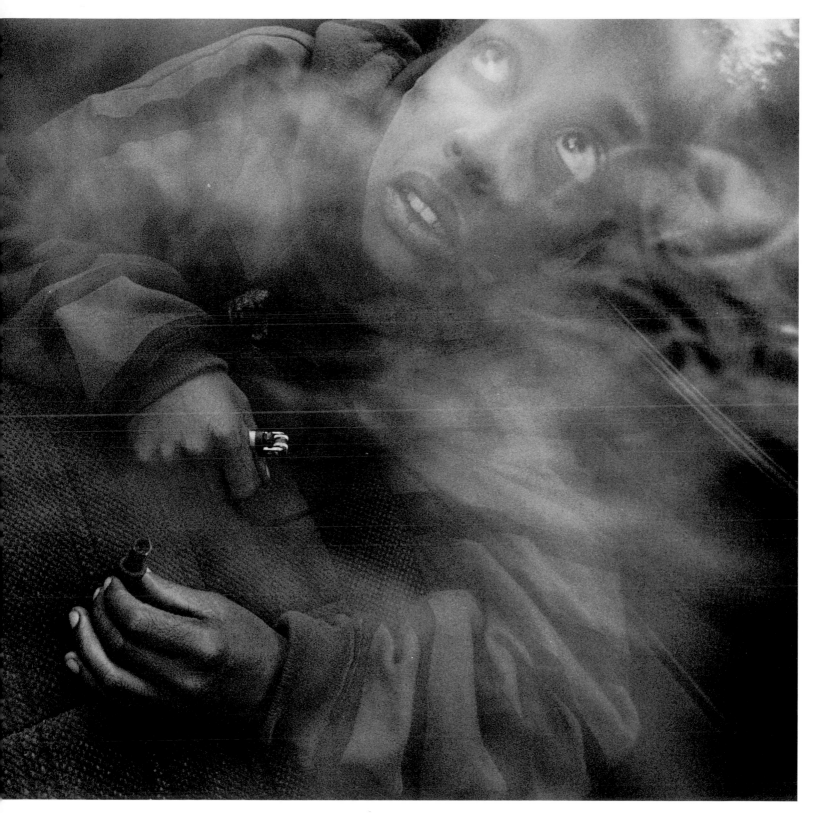

On the floor of a car, Donna pulls on a crack pipe.

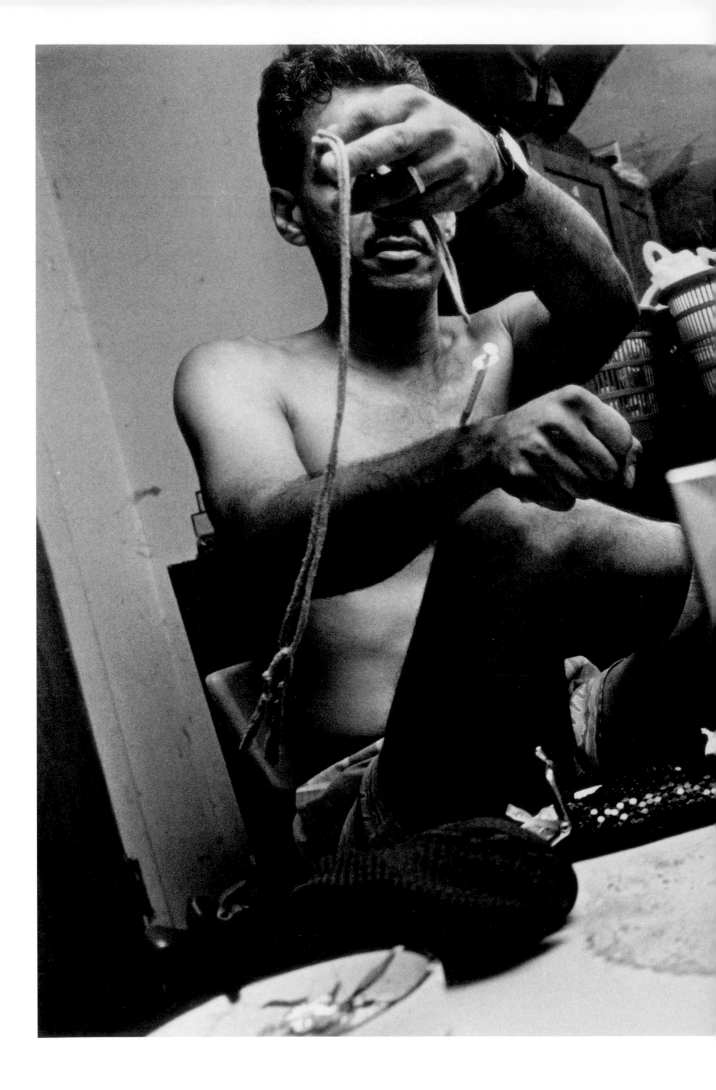

John, 38, an addict since 15, binds his arm to find a vein. On prominent display in his bedroom is a photo of his son.

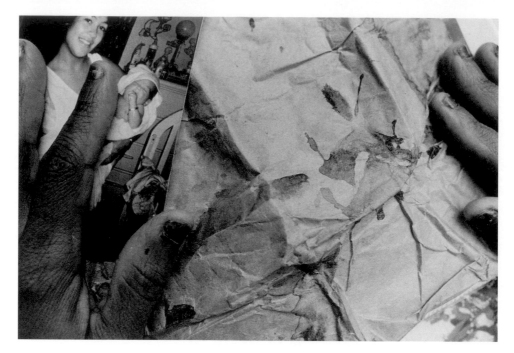

In the Morales family album, alongside a picture of Lisa is a bloody paper bag, a remembrance of her death. The 19-year-old was killed by a bullet intended for her boyfriend.

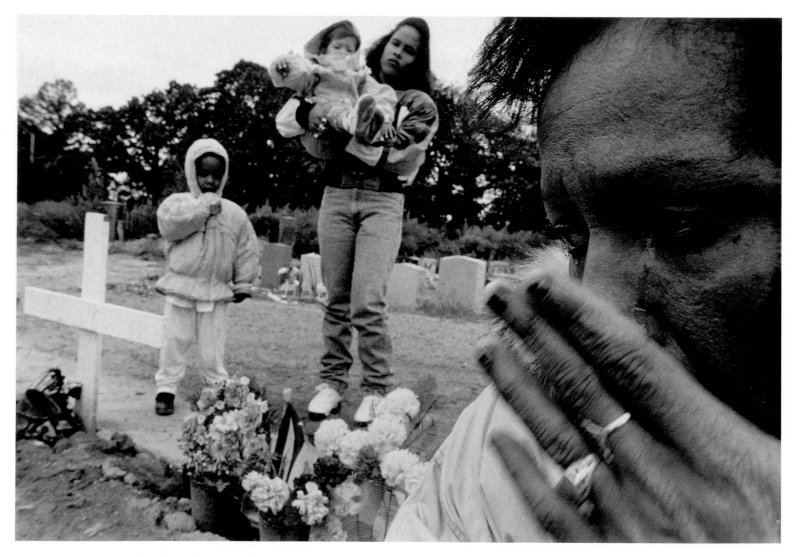

At a cemetery, Abigail Morales weeps for her daughter Lisa. Behind Abigail is her daughter Gracila, Gracila's child and Lisa's child.

MAGAZINE PICTURE STORY • *Eugene Richards, First Place, Magnum Photos*

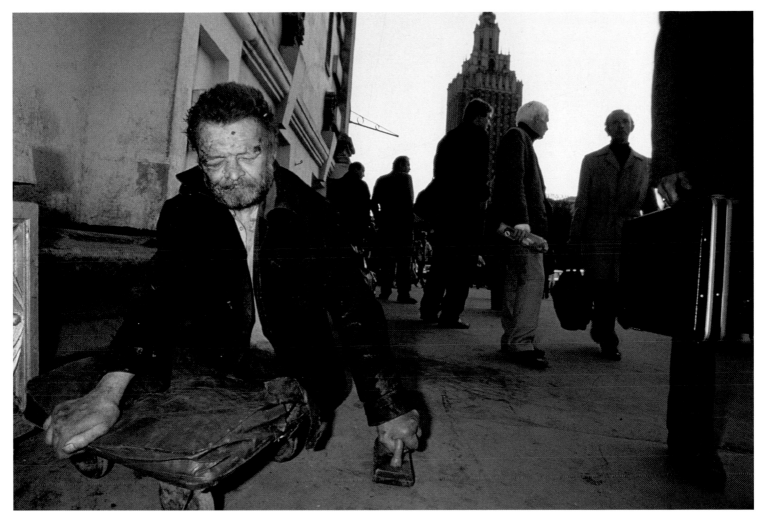

A handicapped and homeless man behind Kasan train station in Moscow.

Moloch Moscow

To the eyes of most tourists visiting Moscow, the city seems much as it was before the disintegration of the Soviet Union. But beneath the surface, Russia's capital is a city undergoing dramatic change. In the wake of capitalism, poverty and crime are rising. Girls sell themselves for pennies, drunks live in gutters, children search garbage dumps for food. Where socialism once ruled, now chaos reigns.

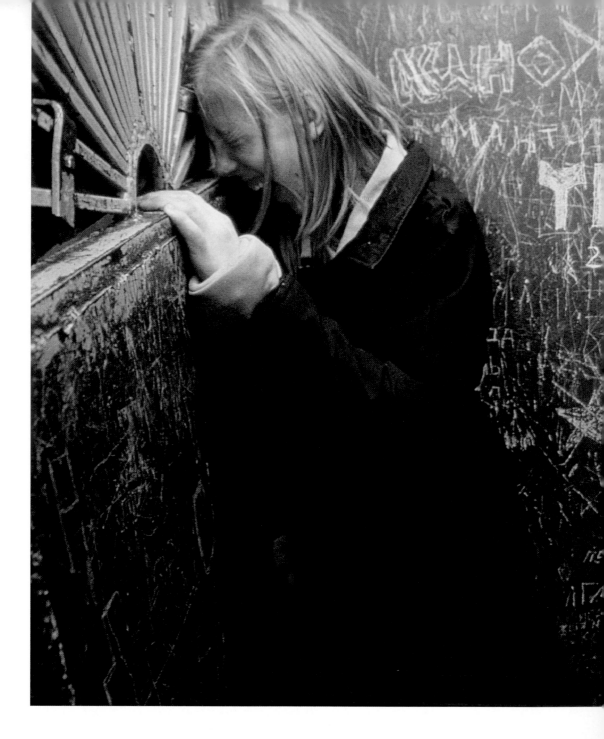

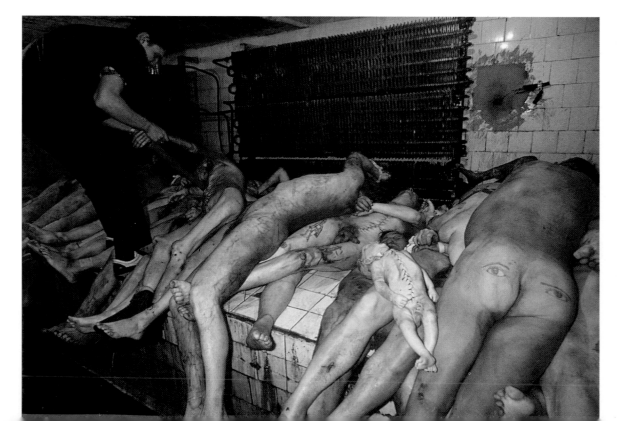

A holding cell for minors picked up in Moscow. At a Moscow morgue, victims of accidents or violence await tending (below far left).

Gang members use a minor runaway behind a public restroom at a Leningrad train station (below right). Heavy-metal fans at a concert of "Electro Shock Therapy" (center).

MAGAZINE PICTURE STORY • *Hans-Juergen Burkard, Second Place, Stern Magazine*

A girl prepares for a striptease contest.

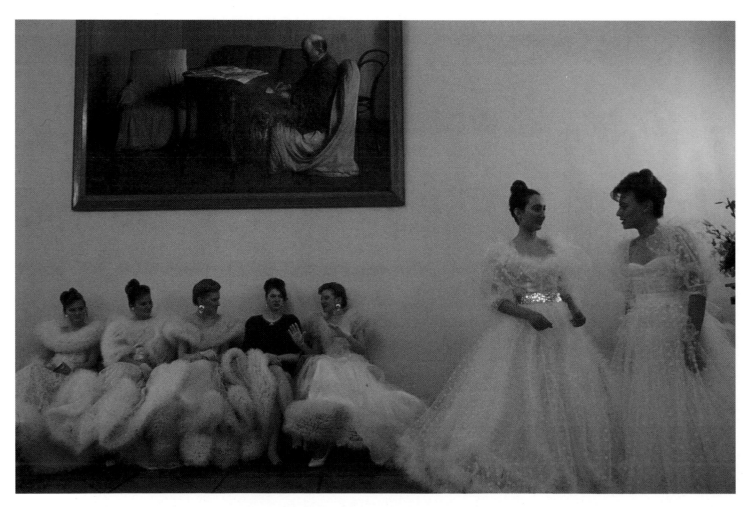

A party is held in a former Czarist palace in Russia.

MAGAZINE PICTURE STORY • *Hans-Juergen Burkard, Second Place, Stern Magazine*

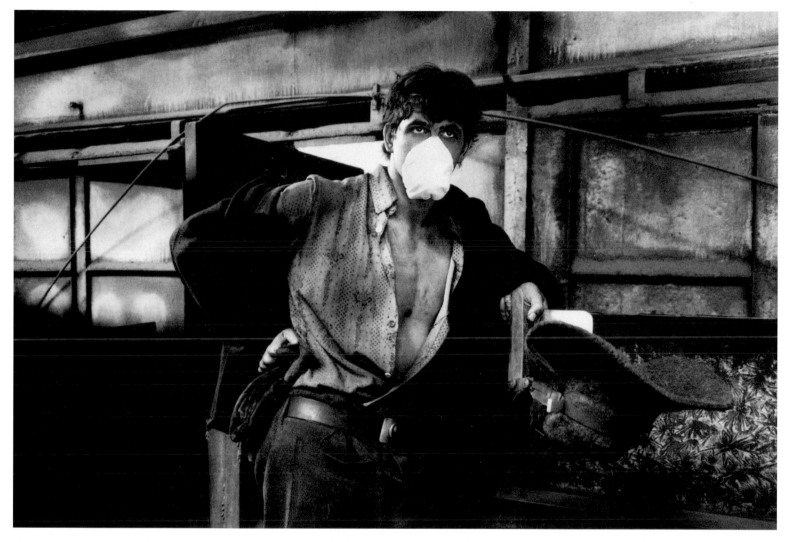

A worker rests inside an iron tapping plant in Magnitogorsk, Russia. Conditions in the factory remain as they were when it was built in 1931.

Russia's Industrial Wastelands

In the early 1930s, geologists in the Soviet Union discovered the richest iron ore in the world. The country exploded with industrialization, building blast furnaces where once had been only primitive villages. During the next 60 years, the factory at Magnitogorsk was expanded but never improved, and Russians today are left with the pollution and harsh lifestyle that is a steelworker's legacy.

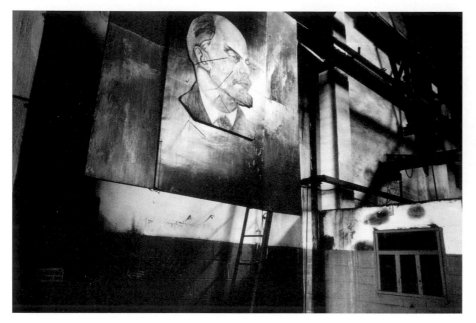

A portrait of Lenin — spiked by vengeful workers — still hangs in the Tractorstroy factory in Volgograd, Russia.

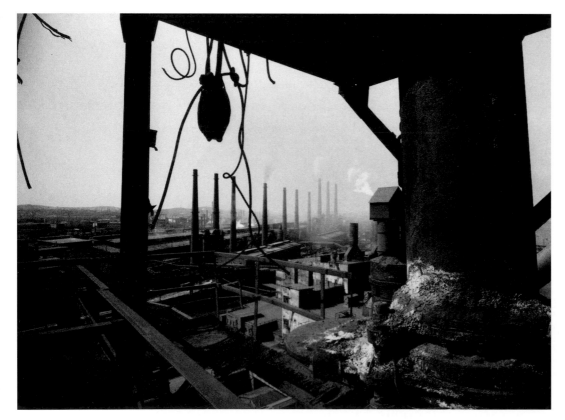

A view from blast furnace No. 1 in Magnitogorsk, Russia.

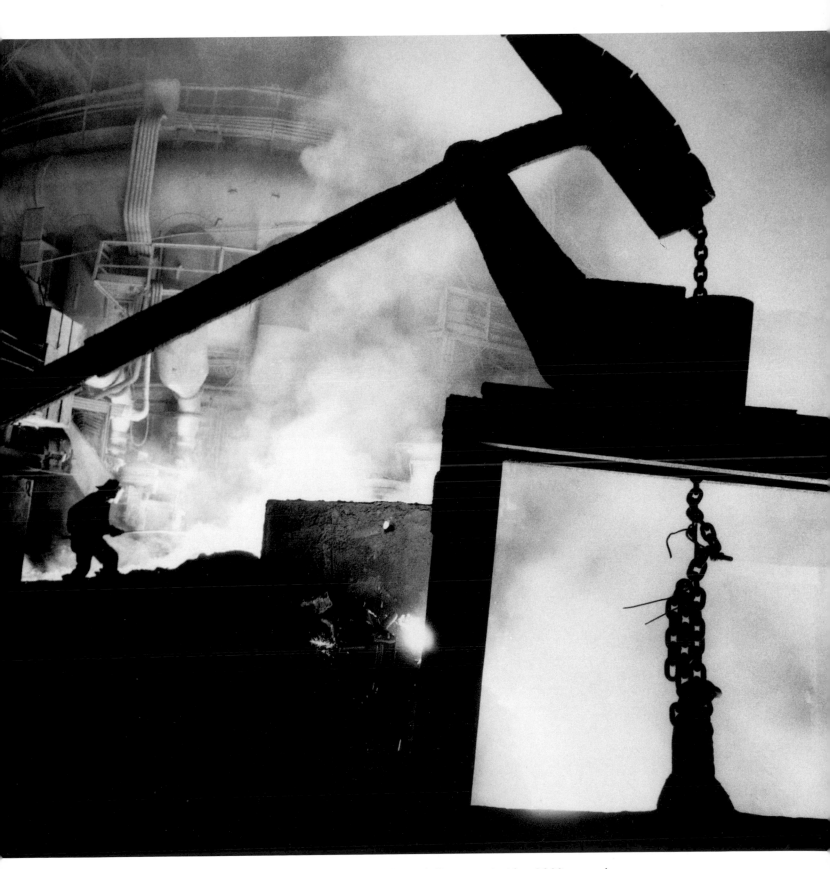

A worker guides melted iron ore through flow gates inside a 1930s-era coke oven.

MAGAZINE PICTURE STORY • *Anthony Suau, Third Place, Time Magazine*

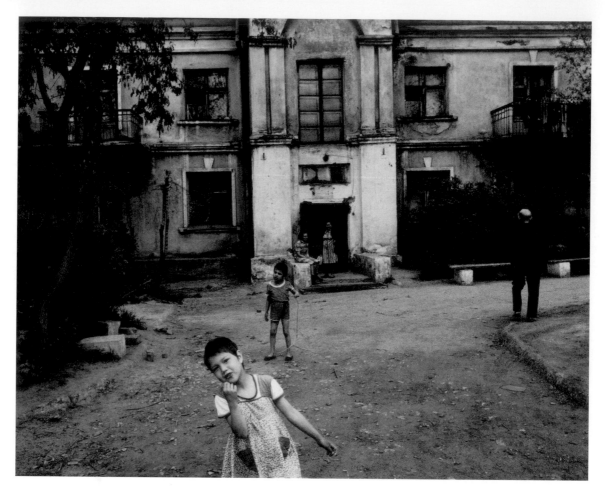

Housing that was built for steel workers in the 1930s is still inhabited.

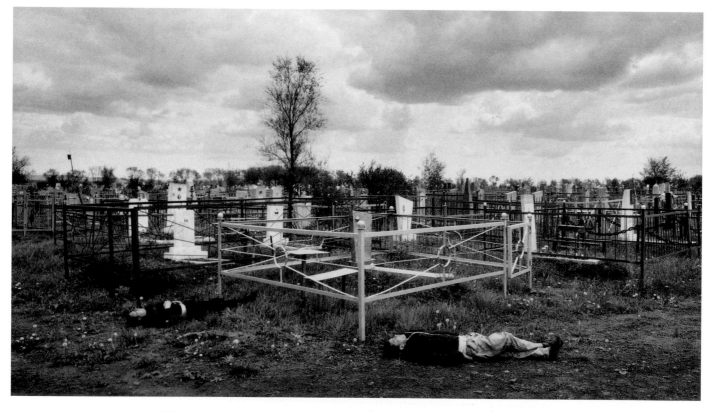

Two cemetery workers lie drunk among tombstones in Magnitogorsk.

Bill Leheny greets his adoptive children after they arrive from Poland.

International Family

Chris and Bill Leheny of Independence, Pa., were childless when they learned about a program to adopt children from Poland. Through their church, the couple adopted three siblings who had been in a Polish orphanage for years. The Lehenys did not speak Polish; Dominika, Robert and Scott spoke no English, but on Christmas Eve 1990 they became a family. In October of 1991, the three children became American citizens.

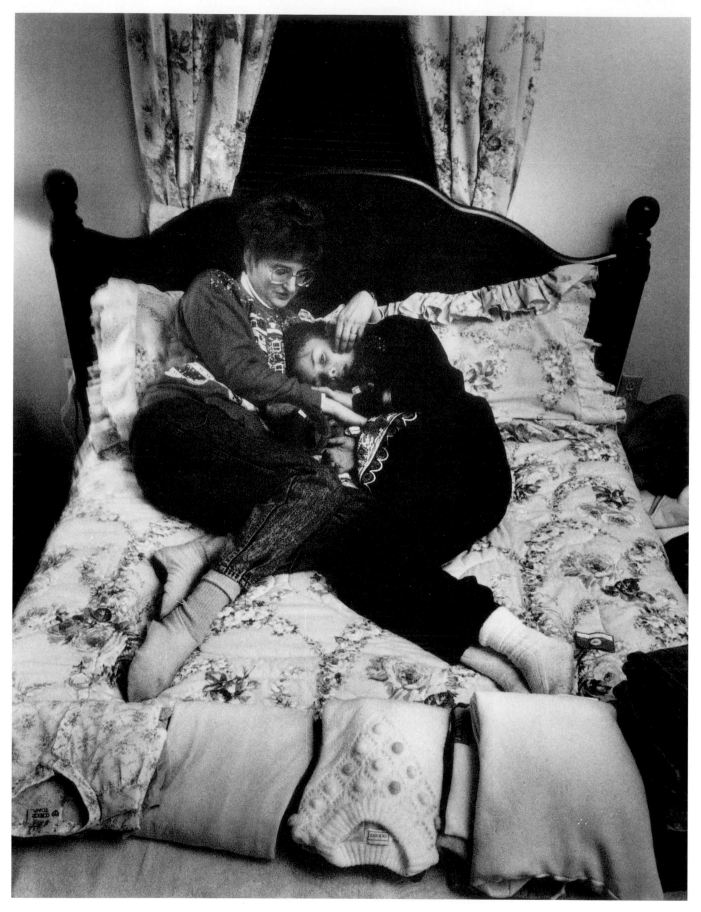

Dominika becomes emotional after learning she has a room of her own.

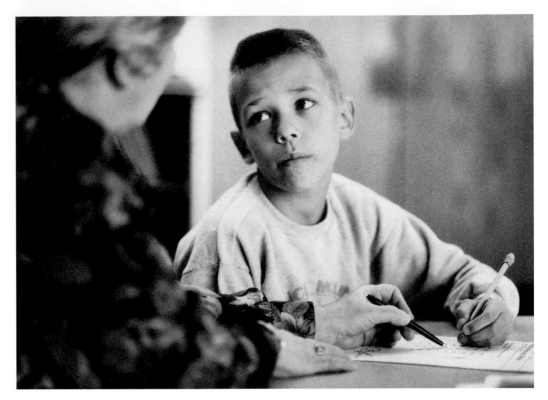

Scott struggles to learn English.

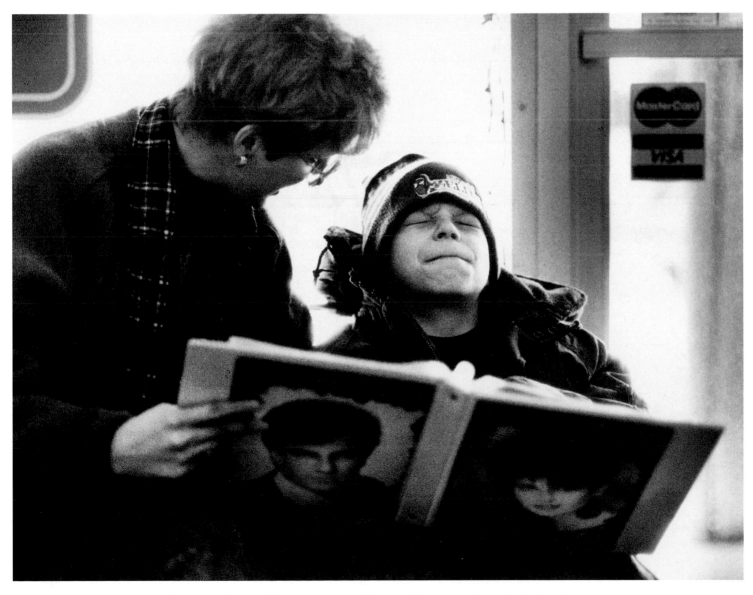

Robert refuses as Chris tries to coax him to pick a hairstyle at the barber shop.

NEWSPAPER FEATURE PICTURE STORY • *Patrick Tehan, First Place, The Pittsburgh Press*

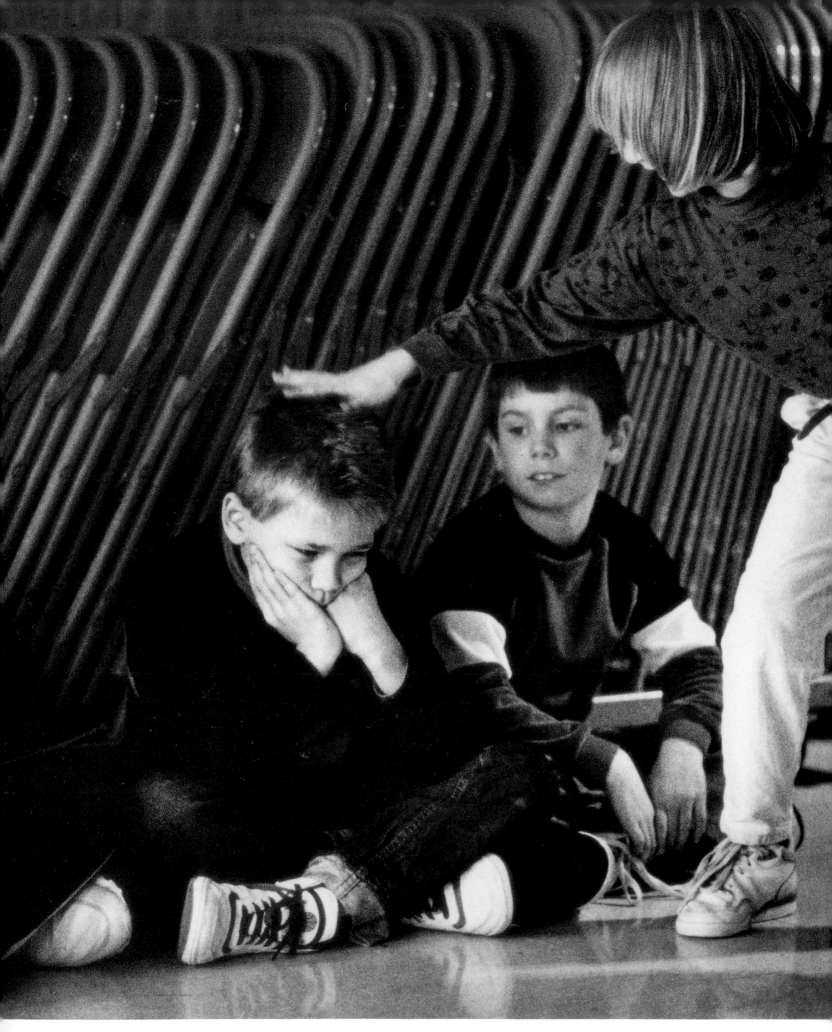

On his second day at Rhema Christian School in Hopewell Township, Scott, unable to understand English, misinterprets flirtation for teasing.

As part of a ceremony recognizing Dominika's U.S. citizenship, Casey DeSantis, dressed as the Statue of Liberty, leads their class in singing "God Bless the USA."

Scott races around the gymnasium after an assembly in his honor at Independence Elementary School.

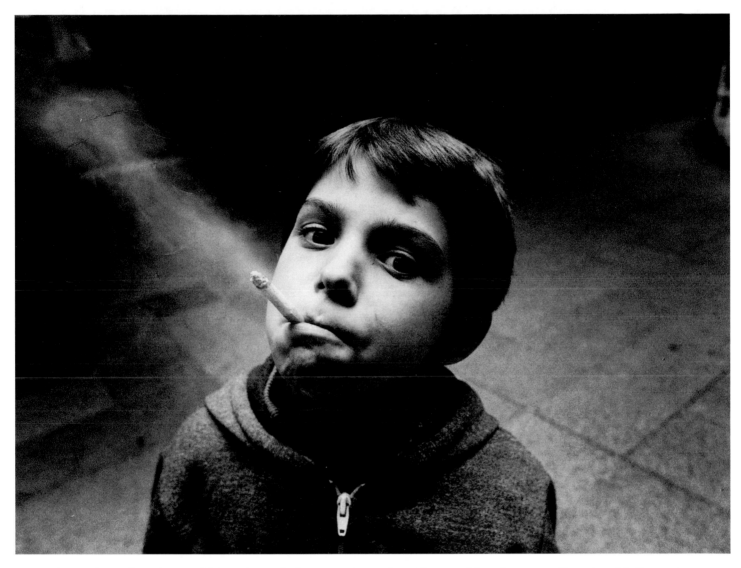

Homeless and penniless, 8-year-old Sergei spends the money he steals and begs on his only source of prestige: Marlboro cigarettes. A pack costs about two days' pay for the average Russian.

Sergei: A Child Alone

Sergei Mayorov, homeless at the age of 8, is one of many children lost in Russia's rocky transition toward democracy. He has lived in St. Petersburg's airport for nearly three years, stealing and begging to stay alive, sleeping with a screwdriver in hand for protection. He says he left home because of his father's drinking. Although he sometimes takes solace at a shelter, he stays only a few days before returning to the airport.

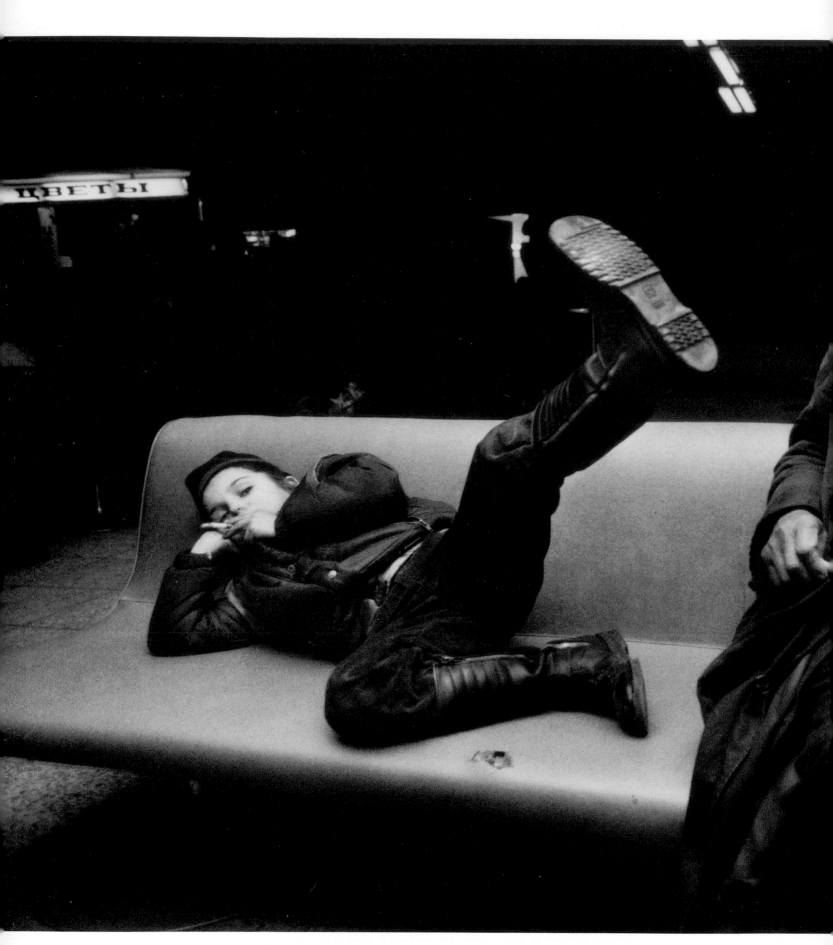

He takes out his frustrations by hassling an old man who was sitting on a bench claimed by homeless children.

At the airport, Sergei steals the wallet of a sleeping man.

Sergei's latest toy: a hypodermic needle he says he found.
He denies using drugs, saying, "I just squirt water
out of the needle for fun."

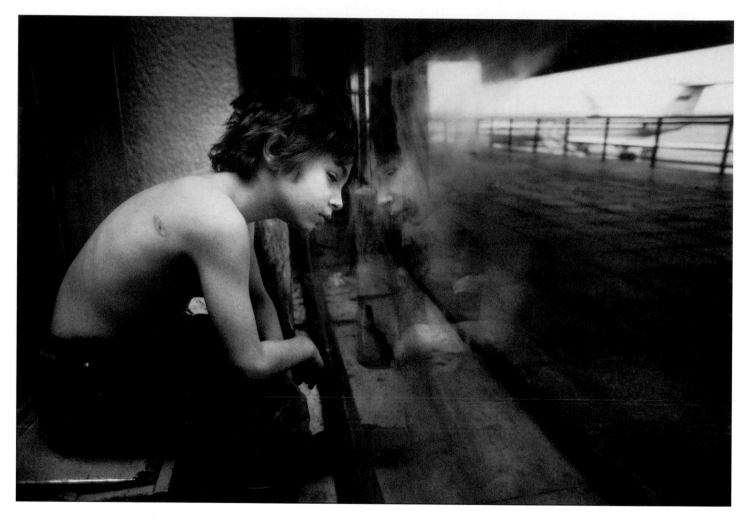

Upon awakening, Sergei is depressed as he begins a third year of living at the airport.

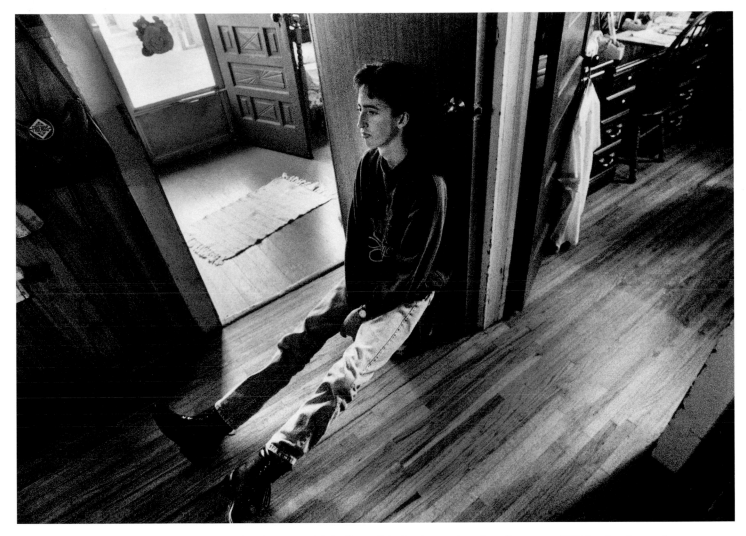

John tries to keep busy during the day to avoid dealing with the depression that threatens. "If I let the depression take hold of me, I lose any sense of hope."

Before He Leaves

Nineteen-year-old John Keets of Canton, Ill., believes it is his mission to educate the public about acquired immune deficiency syndrome, the disease that is stealing his life. Diagnosed with full-blown AIDS in 1989 after numerous blood transfusions for hemophilia, John had to come to terms with a disease that is little-known and rarely talked about in his small community. After nearly dying from an AIDS-related infection, John told his mother he wanted to speak out on AIDS. His message, taken to any group that would hear him, was sincere, and people responded. John's message soon reached a larger audience. He was named the nation's Most Outstanding Teen by the Noxema Extraordinary Teen Awards Program, and Youthquake, a nationally syndicated talk show aimed at teens, featured John's experience of life with AIDS. At home in Canton, John organized a march that drew 2,600 participants and raised more than $20,000 for AIDS research. "At the beginning, the march was just a dream," he says. "But the real dream hasn't come true yet. The dream is getting the vaccine."

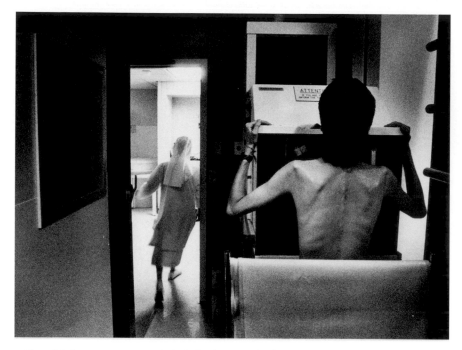

Fearful that an opportunistic infection might be setting in as John is plagued with chest congestion, doctors order a chest X-ray for the 15th time in two years.

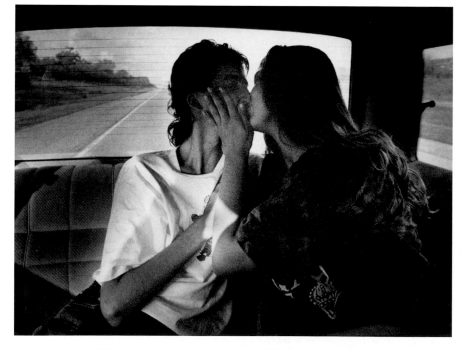

After several failed relationships, John started dating Kelly Wieland. "I never expected it to happen," he says. Though medical experts say you cannot get AIDS from saliva or casual kissing, John says, "The fear of AIDS is still strong for many people."

John started addressing local groups but soon was reaching audiences on a national level. His main message is that people need to care about those with AIDS. "Just because I have AIDS doesn't mean that I am AIDS," he says. "I'm still human."

NEWSPAPER FEATURE PICTURE STORY • *Fred Zwicky, Award of Excellence, Peoria Journal Star*

John plays with Doug Gayton, 7, who also has hemophilia and AIDS. Doug is undergoing chemotherapy for AIDS-related cancer.

When the pressure is too high, John escapes to a mostly forgotten graveyard outside Canton. Although he doesn't know anyone buried there, he says, "It's a place to collect my feelings. A place to hide."

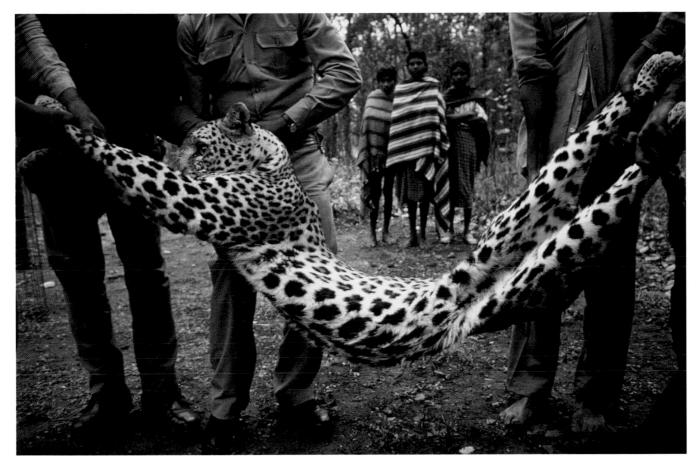

1ST PLACE
Raghu Rai, National Geographic Magazine
Too little room for humans and animals: A leopard is drugged after killing two villagers in India. The big cat will be taken to a wildlife sanctuary.

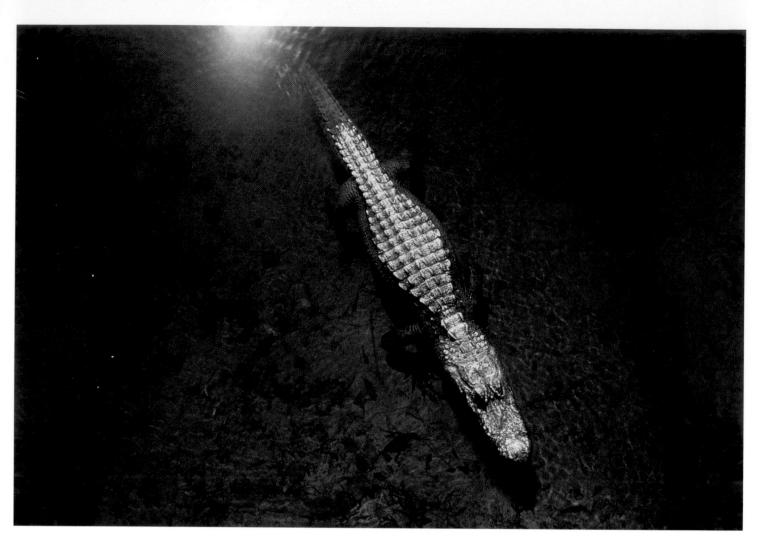

3RD PLACE
Melissa Farlow for National Geographic Magazine
An American alligator in the Okefenokee National Wildlife Refuge in Georgia.

AWARD OF EXCELLENCE
Joel Sartore, National Geographic Magazine
Draped crusaders.

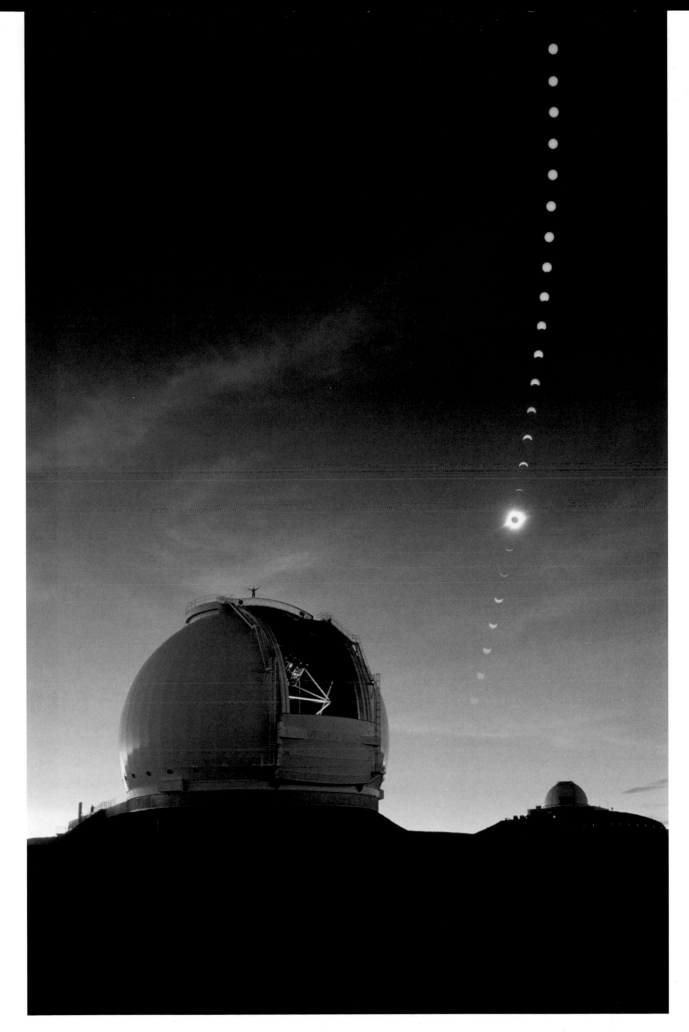

2ND PLACE
Roger Ressmeyer for National Geographic Magazine
A multiple exposure records the July 11, 1991, total solar eclipse atop Mauna Kea Observatory, Hawaii.

MAGAZINE SCIENCE/NATURAL HISTORY

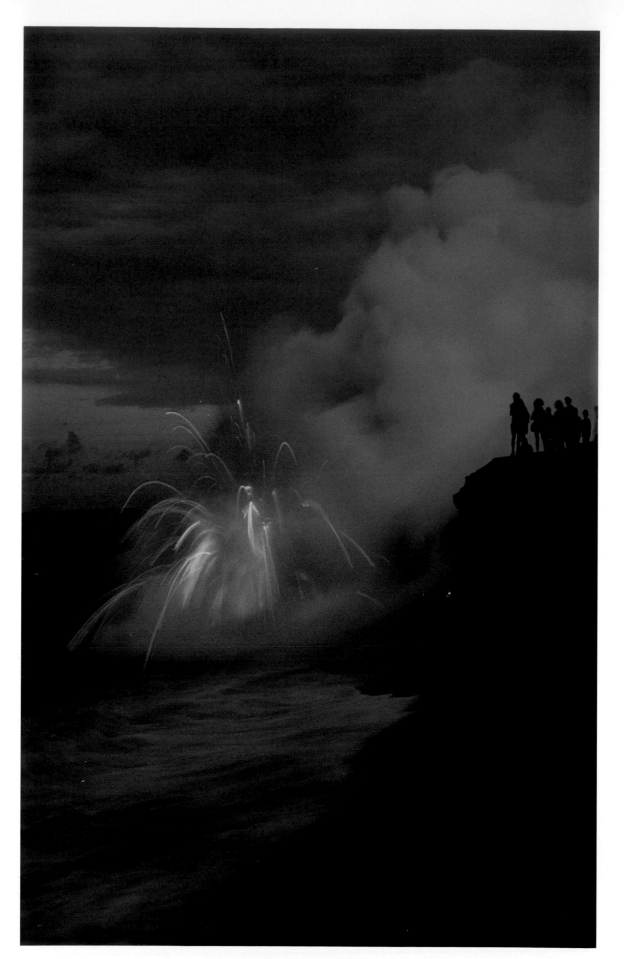

MAGAZINE SCIENCE/NATURAL HISTORY

Mona Reeder, First Place, The Daily Republic

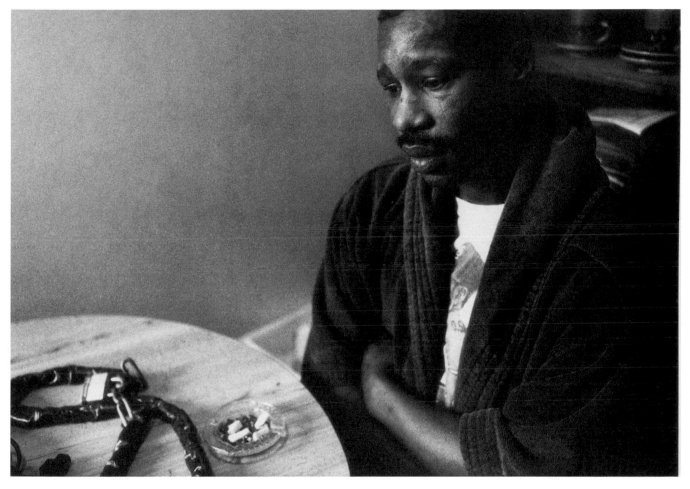

Raymond Stafford, 35, is afraid to leave his apartment in the Crescent neighborhood of Suisun City, Calif., after being beaten and left for dead one block from his home. The Crescent neighborhood, notorious for its drug deals, high crime and low-income housing, has been slated for redevelopment by the city's planning commission. All but the apartment complex Stafford lives in has been leveled.

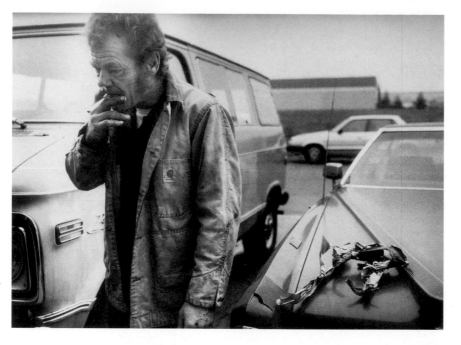

With the duct tape that bound him during a robbery discarded nearby, John Lackey drags on a cigarette to calm his nerves. Lackey was working in his one-man auto repair shop in Fairfield, Calif., when two men overpowered him and robbed him of several thousand dollars.

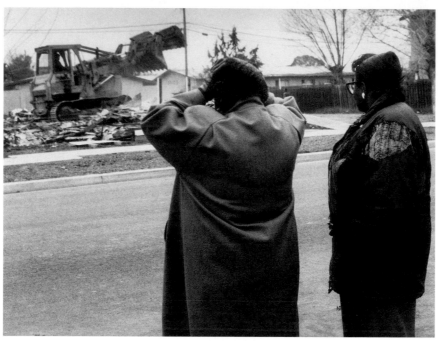

"It's like losing your best friend," Sister Noddy says as she watches a bulldozer turn Macedonia Church on Louisiana Street in Suisun City, Calif., into a pile of rubble. The church fell victim to the Crescent neighborhood redevelopment.

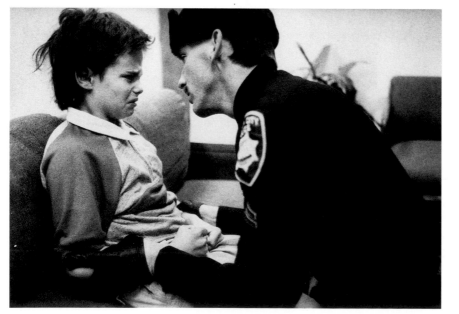

Suisun City police Officer Kurtis Cardwell calms an 11-year-old boy in the station lobby. The boy and his mother fled to the police station after she was beaten by her boyfriend, but when the mother became belligerent, the police arrested her for public drunkenness.

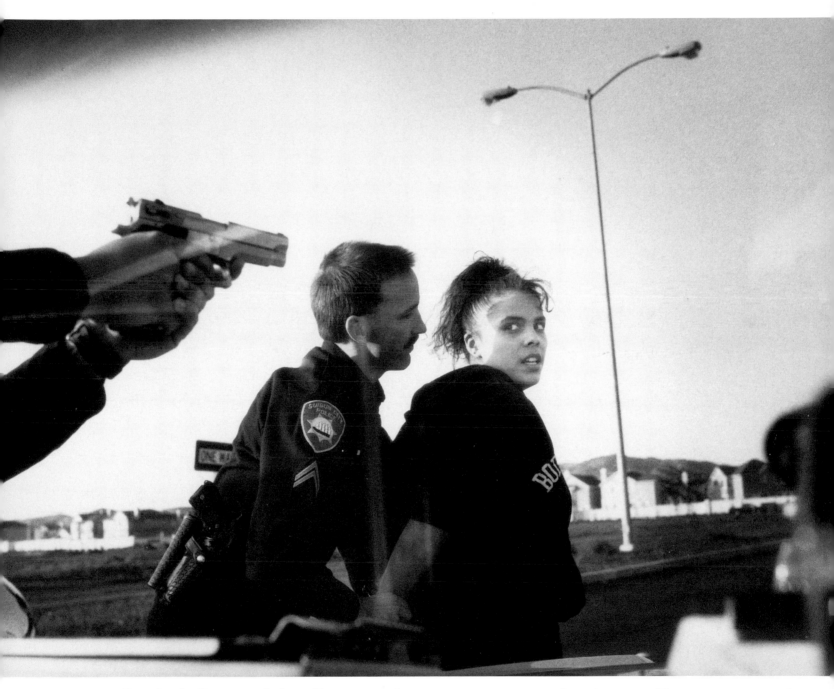

Suisun City officers handcuff a woman during a felony car stop; her passenger was an attempted murder suspect. The suspect was arrested; the woman was questioned and released.

Mona Reeder, Second Place, The Daily Republic

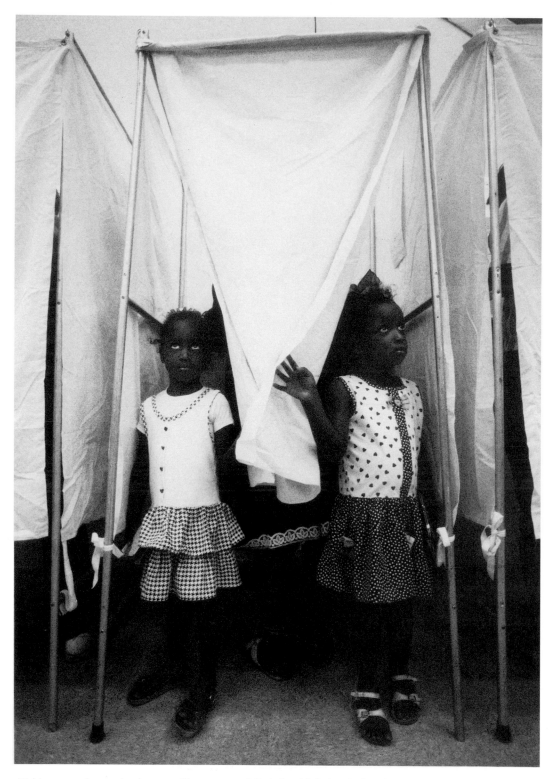

Taking a peek at other voters, Shawnay and Laissha Abdul wait for their mother to finish voting in Vacaville, Calif., on Election Day, 1992.

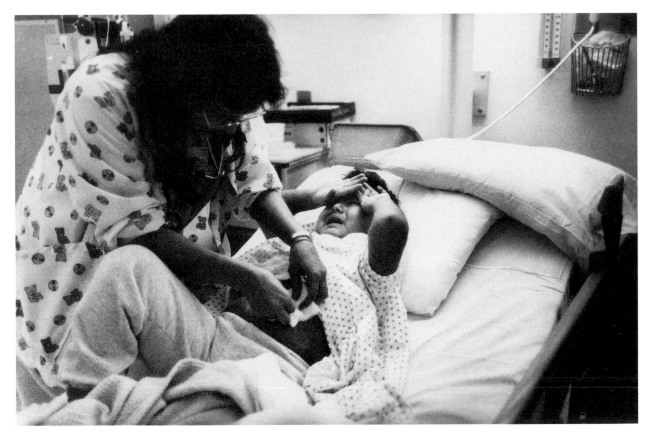

Six-year-old Bernardo Galindo cries in pain as a nurse at Oakland Children's Hospital in California changes the dressing on an incision. Bernardo has a rare auto-neural disorder, making it necessary for him to be fed through a stomach tube.

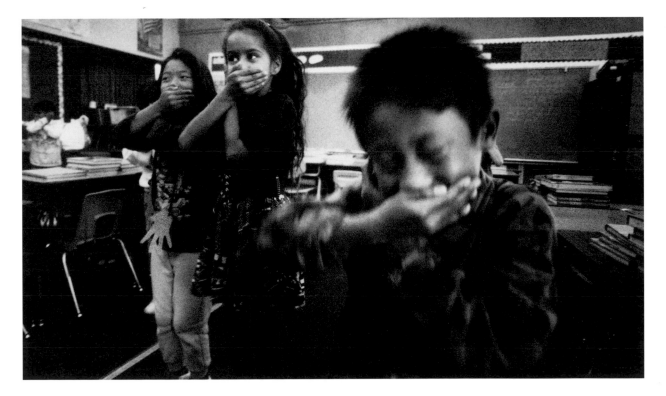

Asian immigrant pupils at Crescent Elementary School in Suisun City, Calif., play Simon Says as a way of learning English.

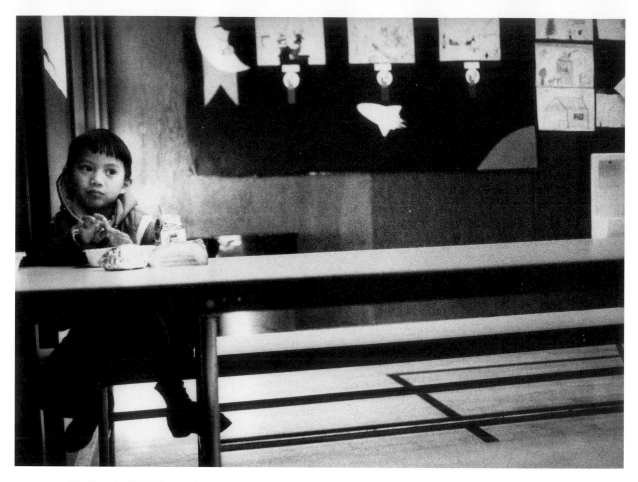

Finding it difficult to adjust to his new school in a new country, Hau Li often eats by himself at Crescent Elementary School.

Exhausted after a nasty re-election campaign, Suisun City Council incumbent, John Rundlett, doesn't wait for election returns before rolling up posters. He won the 1992 election.

WINNERS OF THE 50TH ANNUAL PICTURES OF THE YEAR COMPETITION

Judged February 15 through February 24 at the University of Missouri—Columbia. Sponsored by the National Press Photographers Association and The University of Missouri School of Journalism, with grants from: Canon U.S.A. Inc. and Professional Imaging, Eastman Kodak Co.

THE JUDGES

George Benge, *The News Leader* (Springfield, MO); Mark Godfrey, *U.S. News & World Report*; Annie Griffiths Belt, *National Geographic*; Mike Jenner, The Jenner Group; Maria Mann, *Agence France Presse*; Michelle McDonald, *Boston Globe*; Bryan Moss, White Cloud Workshop; Randy Olson, Freelance; Patty Reksten, *University of Montana*; April Saul, *The Philadelphia Inquirer*

The Los Angeles Times
1st Place, Picture Editing / News Story / Single Page

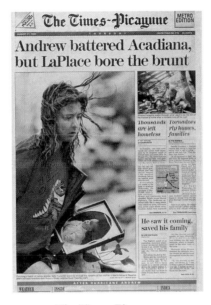

The Times-Picayune
2nd Place, Picture Editing / News Story / Single Page

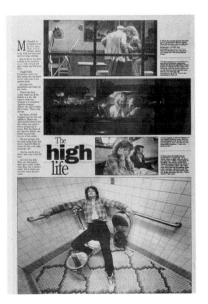

The Hartford Courant
1st Place, Picture Editing / Feature Story / Single Page

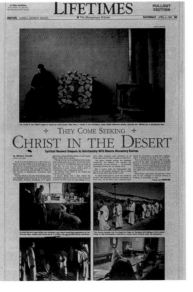

The Albuquerque Tribune
2nd Place, Picture Editing / Feature Story / Single Page

Newspaper Photographer of the Year

Carol Guzy, First Place, Washington Post
Patrick Tehan, Second Place, Pittsburgh Press
Brian Plonka, Third Place, Journal Tribune
Ronald Cortes, Award of Excellence, Philadelphia Inquirer

Magazine Photographer of the Year

James Nachtwey, First Place, Magnum
Paul Lowe, Second Place, Network Photographers
Christopher Morris, Third Place, Time Magazine/ Black Star
Joel Sartore, Award of Excellence, National Geographic

Canon Photo Essayist Award

James Nachtwey, First Place, Magnum, "Famine in Somalia"
Maryann Bates, Judge's Special Recognition, Macon Telegraph, "Lest We Forget"
Marcus Halevi, Judge's Special Recognition, Freelance, "Life Sentence - No Parole"
John Kaplan, Judge's Special Recognition, Block Newspapers, "Russia's Ruined Youth"
Viviane Moos, Judge's Special Recognition, SABA , "The Girls of Recife"
Anthony Suau, Judge's Special Recognition, Time Magazine, "Russia's Industrial Wasteland"

Kodak Crystal Eagle Award

Stephen Shames, First Place, Matrix, "Outside the Dream"

Overall Excellence in Editing Award for Newspapers

Richard Murphy, Anchorage Daily News

Anchorage Daily News
Overall Excellence in
Editing/Newspapers

Anchorage Daily News
Overall Excellence in
Editing/Newspapers

Anchorage Daily News
Overall Excellence in
Editing/Newspapers

Anchorage Daily News
Overall Excellence in
Editing/Newspapers

Anchorage Daily News
Overall Excellence in
Editing/Newspapers

The Albuquerque Tribune
3rd Place, Picture Editing / Feature
Story / Single Page

Newspaper Spot News

Dayna Smith, First Place, Washington Post, "Wiped Out"

David Brauchli, Second Place, Freelance for Agence France Presse, "Body - Washing"

Mary Calvert, Third Place, Oakland Tribune, "Checking for Tracks"

Hassan Amini, Award of Excellence, Associated Press, "Lifeless Body"

Jim Laurie, Award of Excellence, Las Vegas Review Journal, "Accosted by Protestor"

Tom Marks, Award of Excellence, Lexington Herald - Leader, "Trapped by Flood Water"

Gregory Mellis, Award of Excellence, State Journal - Register, "Three Time Loser"

Craig Orosz, Award of Excellence, Trentonian, "School Bus Slur"

Mike Persson, Award of Excellence, Freelance for Agence France Presse, "Sarajevo, A City on Its Knees"

Newspaper General News

Howard Castleberry, First Place, Houston Chronicle, "Father Buries Daughter"

Bruce Strong, Second Place, Orange County Register, "Albanian Bread Line"

Dayna Smith, Third Place, Washington Post, "Friend or Foe?"

Benjamin Brink, Award of Excellence, Oregonian, "Somali Refugee"

Yunghi Kim, Award of Excellence, Boston Globe, "Parched Land"

John Trotter, Award of Excellence, Sacramento Bee, "Somali Refugee Cries Out"

David Yee, Award of Excellence, Oakland Tribune, "Fired Up"

Newspaper Feature Picture

Steven Smith, First Place, Pierce County Herald, "Eavesdropping Princesses"

Fred Zwicky, Second Place, Peoria Journal Star, "Surprise Attack"

Nancy Andrews, Third Place, Washington Post, "Grandma's Review"

Newspaper Sports Action

Mark Phillips, First Place, Agence France Presse, "Safe"

Todd Anderson, Second Place, Jackson Hole Guide, "Pole Vault"

Jean-Loup Gautreau, Third Place, Agence France Presse, "Torrential Scream"

Peter Haley, Award of Excellence, Morning News Tribune, "Overhead Slide to Second"

Robert Hanashiro, Award of Excellence, USA Today, "Collision"

Mark Henle, Award of Excellence, Phoenix Gazette, "Hairy Tumble"

Newspaper Sports Feature

Kristy MacDonald, First Place, Albuquerque Tribune, "Little Big Man"

April Saul, Second Place, Philadelphia Inquirer, "T-Ball Slugger"

Teresa Hurteau, Third Place, Journal Tribune, "Lost to Rivals"

Daniel Anderson, Award of Excellence, Orange County Register, "A Heavenly Performance"

Daniel Anderson, Award of Excellence, Orange County Register, "Relay Rewards"

Michael Rondou, Award of Excellence, San Jose Mercury News, "Cold Lesson"

Newspaper Portrait/Personality

Scott Sharpe, First Place, News & Observer (NC), "Voodoo Ceremony"

Genaro Molina, Second Place, A Century of Memories, "100 Years of Entertainment"

Ron Tarver, Third Place, Philadelphia Inquirer, "Addicted Gaze"

John Kaplan, Award of Excellence, Block Newspapers, "Smoking for Status"

Yunghi Kim, Award of Excellence, Boston Globe, "Precious Sip"

Yunghi Kim, Award of Excellence, Boston Globe, "Sunday Dinner"

April Saul, Award of Excellence, Philadelphia Inquirer, "Maternity Ward"

Tim Zielenbach, Award of Excellence, Louisville Courier - Journal, "Displaced Child"

Newspaper Pictorial

Greg Lovett, First Place, Palm Beach Post, "Hat Walk"

Robert Gauthier, Second Place, San Diego Union - Tribune, "Gate of Steel"

Michael Wirtz, Third Place, Philadelphia Inquirer, "Sidewalk Mirrors"

Newspaper Product Illustration

Patrick Tehan, First Place, Pittsburgh Press, "Beans"

William Tiernan, Second Place, Virginian - Pilot, "White Lace"

Mark Sluder, Third Place, Charlotte Observer, "Landscaping"

Michael Keating, Award of Excellence, Cincinnati Enquirer, "Mimic"

Jay Koelzer, Award of Excellence, Rocky Mountain News, "Swimmin' with the Fish"

Melanie Stetson Freeman, Award of Excellence, Christian Science Monitor, "Artful Affordables"

Newspaper Issue Illustration

Jay Koelzer, First Place, Rocky Mountain News, "Neverending Deadlines"

Tom Reese, Second Place, Seattle Times, "State of the Economy"

Beth Bergman, Third Place, Virginian - Pilot, "Guardian Angel"

The Times-Picayune
Award of Excellence, Picture Editing / Feature Story / Single Page

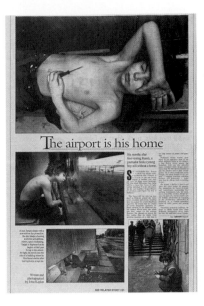

Block Newspapers
2nd Place, Picture Editing / Feature Story / Multiple Page

The Miami Herald
1st Place, Picture Editing / Series

The Miami Herald
1st Place, Picture Editing / Series

The Miami Herald
1st Place, Picture Editing / Series

The Spokesman Review
3rd Place, Picture Editing / Series

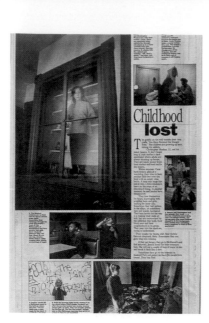

The Hartford Courant
2nd Place, Picture Editing / Series

The Hartford Courant
2nd Place, Picture Editing / Series

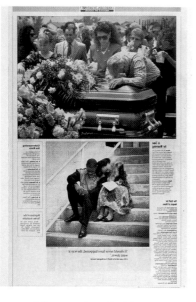

The Los Angeles Times
2nd Place, Picture Editing / News
Story / Newspaper / Multiple page

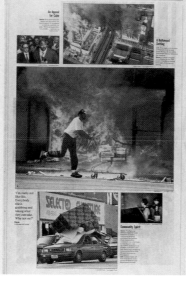

The Los Angeles Times
2nd Place, Picture Editing / News
Story / Newspaper / Multiple page

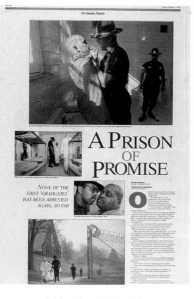

Columbus Dispatch
Award of Excellence, Picture Editing /
News Story / Newspaper / Multipage

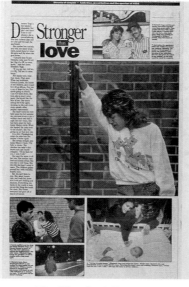

The Hartford Courant
Award of Excellence, Picture Editing /
Feature Story / Single Page

Jay Koelzer, Award of Excellence, Rocky Mountain News, "Reflections on my Father"

Jay Koelzer, Award of Excellence, Rocky Mountain News, "Buffalo Spring"

Newspaper Campaign '92

Dan Habib, First Place, Impact Visuals, "Weary Clinton"

Betty Udesen, Second Place, Seattle Times, "Soapbox Candidate"

Dan Habib, Third Place, Impact Visuals, "Waving to No One"

Jim Bourg, Award of Excellence, Reuters News Pictures, "Dan's Fan"

Michael Nelson, Award of Excellence, Agence France Presse, "The First Cat"

Stephen Savoia, Award of Excellence, Associated Press, "Presidential Hopeful"

Erich Schlegel, Award of Excellence, Dallas Morning News, "Governor Ann Richards does New York"

Newspaper News Picture Story

Carol Guzy, First Place, Washington Post, "Tbilisi"

Dan Habib, Second Place, Impact Visuals, "Clinton Survives New Hampshire"

Ron Tarver, Third Place, Philadelphia Inquirer, "On the Street Where Heroin Lived"

David Brauchli, Award of Excellence, Freelance for Agence France Presse, "Hillside Massacre"

John Gaps III, Award of Excellence, Associated Press, "Hassan's Pain"

Kirk McKoy, Award of Excellence, Los Angeles Times, "Los Angeles Riots"

Dayna Smith, Award of Excellence, Washington Post, "Restore Hope"

Newspaper Feature Picture Story

Patrick Tehan, First Place, Pittsburgh Press, "Adopted Polish Kids"

John Kaplan, Second Place, Block Newspapers, "The Airport is His Home"

Patrick Tehan, Third Place, Pittsburgh Press, "Facilitated Communication"

Carol Guzy, Award of Excellence, Washington Post, "Andrew's Legacy"

Rita Reed, Award of Excellence, Minneapolis Star - Tribune, "Growing Up Lesbian"

Ron Tarver, Award of Excellence, Philadelphia Inquirer, "The Salvation of Chocolate"

Fred Zwicky, Award of Excellence, Peoria Journal Star, "Before He Leaves: A teen and his mission"

Newspaper Sports Portfolio

Ronald Cortes, First Place, Philadelphia Inquirer

Michael Rondou, Second Place, San Jose Mercury News

Daniel Anderson, Third Place, Orange County Register

Jeff Horner, Award of Excellence, Walla Walla Union - Bulletin

Gerard Michael Lodriguss, Award of Excellence, Philadelphia Inquirer

Newspaper One Week's Work

Mona Reeder, First Place, Daily Republic (CA)
Mona Reeder, Second Place, Daily Republic (CA)
Suzanne Kreiter, Third Place, Boston Globe
Mark Garfinkel, Award of Excellence, Freelance

Magazine News Picture

James Nachtwey, First Place, Magnum, "Who Can Save Her?"

Ed Carreon, Second Place, Freelance, "Hell Fire"

David Wells, Third Place, JB Pictures, "Broken Window"

Andrew Holbrooke, Award of Excellence, Black Star, "The Silent Cry"

Paul Lowe, Award of Excellence, Network Photographers, "Watching a Child Die"

Stephen Shames, Award of Excellence, Matrix, "12 - Year - Old's Funeral"

Chris Steele-Perkins, Award of Excellence, Magnum for Life Magazine, "Woman Weeping"

Magazine Feature Picture

Ed Kashi, First Place, National Geographic Magazine, "Terrorist Court"

James Nubile, Second Place, JB Pictures Ltd., "Orphanage"

Gianni Giansanti, Third Place, Sygma for Time Magazine, "Beyond Hope, Beyond Life"

Hans-Juergen Burkard, Award of Excellence, Stern Magazine, "Moscow Train Station"

David Harvey, Award of Excellence, National Geographic Magazine, "Flood of Suds"

Ed Kashi, Award of Excellence, National Geographic Magazine, "Snow and Rubble"

James Nubile, Award of Excellence, JB Pictures Ltd., "Homeless Man, Frozen to Death"

Eugene Richards, Award of Excellence, Magnum Photos, "Carmella"

Joel Sartore, Award of Excellence, National Geographic, "Yes Sir! Comfortable Sir!"

Magazine Sports Picture

Bill Frakes, First Place, Sports Illustrated, "Ode to Joy"

Jose Azel, Second Place, Aurora for Time, "Horse Power"

Bill Frakes, Third Place, Sports Illustrated, "Triumph in Third"

Mike Powell, Award of Excellence, Allsport USA, "Luge Doubles"

Mike Powell, Award of Excellence, Allsport USA, "Carl Lewis - Santa Monica Track Club"

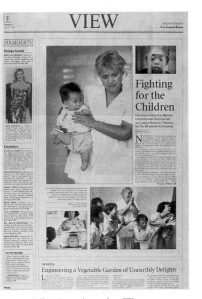

The Los Angeles Times
Award of Excellence, Picture Editing / Feature Story / Single page

Journal Tribune
1st Place, Best use of photographs / Newspapers, circulation under 25,000

Concord Monitor
2nd Place, Best use of photographs / Newspapers, circulation under 25,000

The Herald
3rd Place, Best use of photographs / Newspapers, circulation under 25,000

The Phoenix Gazette
3rd Place, Best use of photographs / Newspapers, circ. 25,000 - 150,000

San Jose Mercury News
2nd Place, Best use of photographs / Newspapers, circulation over 150,000

The Spokesman-Review
1st Place, Newspaper Picture Editing /
Individual Portfolio

The Spokesman-Review
1st Place, Newspaper Picture Editing /
Individual Portfolio

The Hartford Courant
2nd Place, Newspaper Picture Editing
/ Individual Portfolio

The Hartford Courant
2nd Place, Newspaper Picture Editing
/ Individual Portfolio

The Sacramento Bee
3rd Place, Newspaper Picture Editing /
Individual Portfolio

The Sacramento Bee
3rd Place, Newspaper Picture Editing /
Individual Portfolio

Magazine Portrait/Personality

Scott Thode, First Place, Freelance, "Venus Rising"
Antonin Kratochvil, Second Place, Dot Pictures for The New York Times Magazine, "Points of No Return"
Susie Post, Third Place, Freelance, "Fred"
Chris Johns, Award of Excellence, National Geographic Magazine, "Working Girls"
Chris Johns, Award of Excellence, National Geographic Magazine, "Cowboy Cheth"
George Lange, Award of Excellence, Fortune Magazine, "Ross Perot"
Susie Post, Award of Excellence, Freelance, "Orphan"

Magazine Pictorial

Linda Troeller, First Place, Agence Vu, "Jacuzzi, Calistoga Springs"
Anthony Suau, Second Place, Time Magazine, "Coke Worker"
Thomas Dallal, Third Place, Freelance, "End of the Day"
George Steinmetz, Award of Excellence, Freelance, "Georgian Banquet"

Magazine Science/Natural History

Raghu Rai, First Place, National Geographic Magazine, "Drugged Cat"
Roger Ressmeyer, Second Place, National Geographic Magazine, "The Great Eclipse of 1991"
Melissa Farlow, Third Place, Freelance, "Alligator in Red Water"
Joe McNally, Award of Excellence, SYGMA for National Geographic, "Night Hunter"
Roger Ressmeyer, Award of Excellence, National Geographic Magazine, "Volcano, Tourists, Moonlight"
Joel Sartore, Award of Excellence, National Geographic, "Pelicans over Barrier Island"
Joel Sartore, Award of Excellence, National Geographic, "Draped Crusaders"

Magazine Product Illustration

Carmen Troesser, First Place, University of Missouri, "Tomato on Drawing"
John Samora, Second Place, Arizona Republic, "Scarves"

Magazine Issue Illustration

George Steinmetz, First Place, Freelance, "Mother and Son with Fetal Alcohol Syndrome"

Magazine Campaign '92

P.F. Bentley, First Place, Time Magazine, "Steam Room Break"
P.F. Bentley, Second Place, Time Magazine, "The Toll of the Road"
Tomas Muscionico, Third Place, Contact Press Images for Time Magazine, "Campaign Busing"

P.F. Bentley, Award of Excellence, Time Magazine, "Home Run"

P.F. Bentley, Award of Excellence, Time Magazine, "After Rally Rallying"

P.F. Bentley, Award of Excellence, Time Magazine, "Midnight Caller"

P.F. Bentley, Award of Excellence, Time Magazine, "Bus Trip Buddies"

P.F. Bentley, Award of Excellence, Time Magazine, "Bill & Jesse"

David Burnett, Award of Excellence, Contact Press Images, "Photo Op Swim"

Rick Friedman, Award of Excellence, Black Star, "Snoozing Candidate"

Dirck Halstead, Award of Excellence, Time Magazine, "Realization of Defeat"

Magazine Picture Story

Eugene Richards, First Place, Magnum Photos, "East New York"

Hans-Juergen Burkard, Second Place, Stern Magazine, "Moloch Moscow: Behind the Kremlin and Red Square"

Anthony Suau, Third Place, Time Magazine, "Russia's Industrial Wastelands"

P.F. Bentley, Award of Excellence, Time Magazine, "Bill Clinton: The Private Campaign"

Luc Delahaye, Award of Excellence, Sipa for Newsweek, "Sarajevo: Life in a War Zone"

Lynn Johnson, Award of Excellence, Black Star for Newsweek, "To Heal the Burn"

Joseph Rodriguez, Award of Excellence, Black Star, "The Los Angeles Gangs"

Scott Thode, Award of Excellence, Freelance, "Venus Rising"

Dongping Yuan, Award of Excellence, Nationality Pictorial, "A Place Buried in Oblivion"

Magazine Sports Portfolio

Rick Rickman, First Place, Freelance

Bill Frakes, Second Place, Sports Illustrated

Picture Editing/News Story/Single Page

Con Keyes and **Lily Kuroda,** First Place, Los Angeles Times, "Images of Chaos"

Kurt Mutchler, Second Place, Times - Picayune, "Andrew Battered Acadiana"

Con Keyes, Lily Kuroda, Third Place, Los Angeles Times, "Understanding the Riots"

Con Keyes, Lily Kuroda, Award of Excellence, Los Angeles Times, "Understanding the Riots"

Con Keyes, Lily Kuroda, Award of Excellence, Los Angeles Times, "Understanding the Riots"

Alex Burrows, Award of Excellence, Virginian - Pilot, "I-664: The Final Link"

Michael Gallegos, Award of Excellence, Albuquerque Tribune, "Where the Anguish Begins"

Con Keyes, Lily Kuroda, Award of Excellence, Los Angeles Times, "Understanding the Riots"

The Virginian-Pilot
Award of Excellence, Newspaper
Picture Editing / Individual Portfolio

San Jose Mercury News
Award of Excellence, Newspaper
Picture Editing / Individual Portfolio

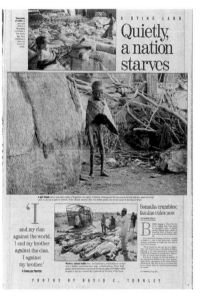

The Detroit Free Press
Award of Excellence, Picture Editing /
Special Section

San Jose Mercury News
3rd Place, Newspaper Picture Editing /
Team Portfolio

The Orange County Register
Award of Excellence, Newspaper
Picture Editing / Team Portfolio

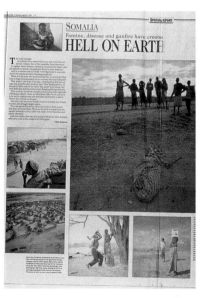

The Sacramento Bee
Award of Excellence, Newspaper
Picture Editing / Team Portfolio

The New York Times Magazine
1st Place, Newspaper-produced
Magazine Picture Editing

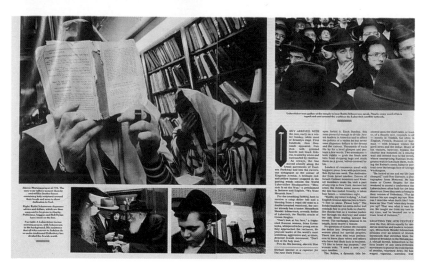

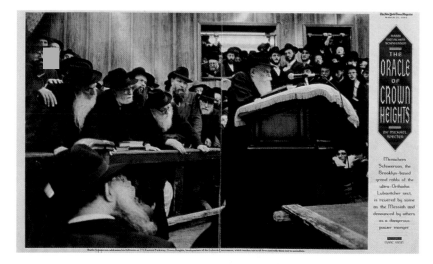

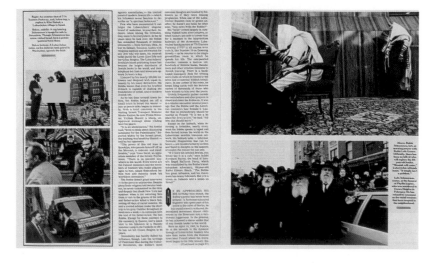

Picture Editing/Feature Story/Single Page

Randy Cox, First Place, Hartford Courant, "The High Life"

Mike Davis, Second Place, National Geographic Magazine, "Christ in the Desert"

Mike Davis, Third Place, Albuquerque Tribune, "Throwaway Pets"

Randy Cox, Award of Excellence, Hartford Courant, "Stronger Than Love"

Colin Crawford, Award of Excellence, Los Angeles Times (Orange County), "Fighting for the Children"

Doug Parker, Award of Excellence, Times - Picayune "Triple Play"

Picture Editing/News Story/Newspaper/Multiple Page

Rick Shaw, Mark Morris, First Place, Sacramento Bee, "Hell on Earth"

Con Keyes, Lily Kuroda, Second Place, The Los Angeles Times, 'Images of Chaos'

S. Bowen, D. Copeland, T. Gralish, R. Lyskowski, Rice, J. Van Beekum, Third Place, The Miami Herald, 'Hurricane Special'

Craig Holman, Barth Falkenberg, Fred Squillante, Barth Falkenberg, Award of Excellence, Columbus Dispatch, "A Prison of Promise"

Picture Editing/News Story/Magazine/Multiple Page

Kathy Ryan, First Place, New York Times Magazine, "Somalia 1992"

David Friend, Second Place, LIFE Magazine, "The Tragedy of Somalia"

Bert Fox, Third Place, Philadelphia Inquirer Magazine, "Keeping Hate Alive"

John Echave, Award of Excellence, National Geographic Magazine, "Georgia Fights for Nationhood"

Bert Fox, Award of Excellence, Philadelphia Inquirer Magazine, "On the Street Where Heroin Lived"

Picture Editing/Feature Story/ Newspaper/Multiple Page

Alex Burrows, First Place, Virginian - Pilot, "Trina's Triumph"

John Kaplan, Second Place, Block Newspapers, "The Airport is his Home"

Scott Sines, Third Place, Spokesman-Review, "The Way Station"

Mike Davis, Award of Excellence, Albuquerque Tribune, "Hoodavile"

Latane Jones, Award of Excellence, Virginian - Pilot & Ledger - Star, "A Tough Way to Make a Living"

Picture Editing/Feature Story/Magazine/Multiple Page

William Douthitt, First Place, National Geographic Magazine, "The Sense of Sight"

Sandra Eisert, Second Place, San Jose Mercury News "A Place of Their Own"

John Echave, Third Place, National Geographic
Magazine, "Hard Harvest of the Bering Sea"

Robin Avni, Gary Settle, Award of Excellence,
Seattle Times, "Molly's Cancer"

Lucy Bartholomay, Award of Excellence, Boston
Globe, "The Lie at the Top of the World"

Lesley Becker, Award of Excellence, Dallas Life
Magazine/Dallas Morning News, "One Year Later"

Elizabeth Biondi, Award of Excellence, Stern
Magazine, "Ballet"

Bert Fox, Award of Excellence, Philadelphia Inquirer
Magazine, "Baby Makes Five"

Larry Nighswander, Award of Excellence, National
Geographic Magazine, "The New World of Spain"

Larry Nighswander, Award of Excellence, National
Geographic Magazine, "Pizarro Conqueror of the
Inca"

Dieter Steiner, Award of Excellence, Stern Magazine,
"Somalia"

Picture Editing/Series

S. Bowen, D. Copeland, T. Gralish, R. Lyskowski, S.
Rice, J. Van Beekum, First Place, Miami Herald
"Hurricane Special - Andrew's Aftermath"

Randy Cox, Second Place, Hartford Courant, "Streets
of Despair "

Scott Sines, Third Place, Spokesman-Review,
"Marshal's Killing"

Geoff Forester, Award of Excellence, Concord
Monitor, "Primary Album"

Frederic Nelson, Award of Excellence, Seattle Times,
"Lifers without"

Rick Shaw, Award of Excellence, Sacramento Bee,
"Men and Women at Work"

Picture Editing/Special Section

John Kaplan, First Place, Block Newspapers, "Before
He Leaves"

Mike Healy, Second Place, Star Tribune, "Growing
Up Gay"

Lisa Roberts, Third Place, Sacramento Bee, "Book of
Dreams"

Randy Cox, Award of Excellence, Hartford Courant,
"The Agony of Somalia"

Marcia Prouse, Award of Excellence, Detroit Free
Press, "Quietly, a nation starves"

Scott Sines, Award of Excellence, Spokesman-Review,
"The Lessons of Ruby Ridge"

Scott Sines, Award of Excellence, Spokesman-Review,
"Feeding a Dream"

Best use of Photographs/Newspapers: Circulation of under 25,000

First Place, Journal Tribune (Biddeford, ME)
Second Place, Concord Moniter (NH)
Third Place, The Herald (Jasper, IN)

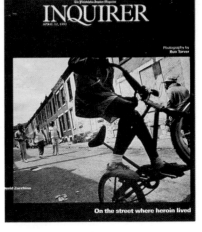

Philadelphia Inquirer Magazine
2nd Place, Newspaper-produced
Magazine Picture Editing

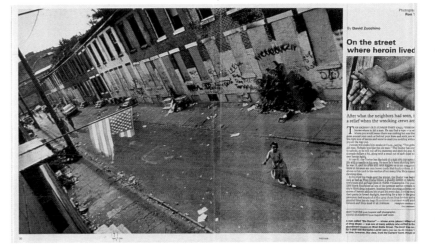

Seattle Times
Award of Excellence, Newspaper-
produced Magazine Picture Editing

Audubon Magazine
2nd Place, Picture Editing / Magazine

Audubon Magazine
2nd Place, Picture Editing / Magazine

Audubon Magazine
2nd Place, Picture Editing / Magazine

Best use of Photographs/Newspapers: Circulation of 25,000 to 150,000

First Place, Anchorage Daily News
Second Place, Spokesman-Review (Spokane, WA)
Third Place, The Phoenix Gazette

Best use of Photographs/Newspapers: Circulation of more than 150,000

First Place, Palm Beach Post
Second Place, San Jose Mercury News

Best use of Photographs/Magazine

W. Allan Royce, First Place, National Geographic Magazine
Ruth Eichhorn, Second Place, Geo Wissen
Peter Howe, Third Place, Audubon Magazine
Heinz Kluetmeier, Award of Excellence, Sports Illustrated
Michele Stephenson, Award of Excellence, Time Magazine

Newspaper Picture Editing Award/Individual Portfolio

Scott Sines, First Place, Spokesman-Review
Randy Cox, Second Place, Hartford Courant
Alex Burrows, Award of Excellence, Virginian - Pilot
Sue Morrow, Award of Excellence, San Jose Mercury News
Frederic Nelson, Award of Excellence, Seattle Times

Newspaper Picture Editing Award/Team Portfolio

First Place, Anchorage Daily News
Second Place, Los Angeles Times
Third Place, San Jose Mercury News
Award of Excellence, Orange County Register
Award of Excellence, Sacramento Bee

Newspaper-produced Magazine Picture Editing Award

Kathy Ryan, First Place, New York Times Magazine
Bert Fox, Second Place, Philadelphia Inquirer Magazine
Lesley Becker, Third Place, Dallas Life Magazine/Dallas Morning News
Robin Avni, Gary Settle, Award of Excellence, Seattle Times
Anestis Diakopoulos, Award of Excellence, Providence Journal

Picture Editing Award/Magazine

Larry Nighswander, First Place, National Geographic Magazine
Peter Howe, Second Place, Audubon Magazine
Dennis Dimick, Third Place, National Geographic Magazine
Heinz Kluetmeier, Award of Excellence, Sports Illustrated
John Nuhn, Award of Excellence, National Wildlife Magazine

Index

Notes and Acknowledgments

This book was produced by the following method: Images were scanned by American Color (Nashville, Tenn.) and placed on optical disks. At the same time, a low-resolution image was created for design work and placed on removable disk drives. QuarkXpress was used for page design; Microsoft Word was used for text input. After linking high-resolution scans with the Quark documents, 3M Rainbow proofs were analyzed. Final output of film was accomplished through an Optronics ColorSetter 4000 and proofed on a 3M Matchprint. After checking for image quality, film was shipped to Jostens for platemaking and printing.

This project could not have been accomplished without the technical assistance and support from the following people:

Fran Williams, American Color, Nashville, Tenn.
Cindy Hutchinson, American Color, Nashville, Tenn.
Anne Wilson, Apple Computer, Phoenix, Ariz.
Dave Klene, Jostens, Topeka, Kan.